LOST

TOWNS OF THE

HUDSON VALLEY

LOST
TOWNS OF THE
HUDSON VALLEY

WESLEY GOTTLOCK &
BARBARA H. GOTTLOCK

THE
History
PRESS

Published by The History Press
Charleston, SC 29403
www.historypress.net

First published 2009
Second printing 2012

ISBN 9781540220325

Library of Congress Cataloging-in-Publication Data

Gottlock, Wesley.
Lost towns of the Hudson Valley / Wesley Gottlock and Barbara H. Gottlock.
p. cm.

1. Hudson River Valley (N.Y. and N.J.)--History, Local. 2. New York (State)--History,
Local. 3. Cities and towns--Hudson River Valley (N.Y. and N.J.) 4. Cities and towns--
New York (State) I. Gottlock, Barbara H. II. Title.
F127.H8G69 2009
974.7'3--dc22
2009025563

CONTENTS

ACKNOWLEDGEMENTS

The broad scope of this book led us to many places of interest, and we were privileged to have met so many wonderful individuals who value the past. We are extremely grateful to all of the people who have assisted us by providing recollections and photographs or by merely pointing us in the right direction.

To Sylvia Rozzelle, town clerk of the Town of Olive, we express our sincere appreciation. Without her exceptional assistance, our research into the history of the Ashokan region would have been much more difficult. Special thanks to Eleanor Arold for graciously sharing her memories and photographs. We appreciate all of the effort by Mark DuBois and Loni Gale in preserving vintage photographs of the area. Thanks also to Deana Decker.

For the Roseton chapter, special thanks go to William Lamey, who, with pride and good humor, shared experiences from his formative years at the hamlet. Thomas Gaffney was most helpful in leading us to Roseton sources. Thanks to William Mocko for meeting with us to discuss his perspective. We also appreciate the help of the Newburgh Free Library. At the Marlboro Free Library our thanks go to Emily Amadeo and Joanne Pagnotta. The New York Public Library branch of Science, Industry and Business and the New York University Library were also helpful. Newburgh city historian Mary McTameny, Carla Decker, Valerie DeMoressay, Donald Chase and Marylou Mahan also merit our gratitude.

We are grateful to Rockland County historian Robert Knight for once again sharing his wonderful collection of vintage postcards. We are also indebted to the New City Library staff for sharing its digital collection of Rockland Lake postcards.

Acknowledgements

The chapters on Camp Shanks and Shanks Village would have been much more difficult were it not for Scott Webber. His twenty-five years of original research on Camp Shanks and Shanks Village filled a tremendous void. To Jerry Donnellan, County of Rockland Veterans Service Agency director, we owe a debt of gratitude for opening the Camp Shanks Museum just for us on several occasions. Mary Cardenas, director of the Orangetown Historical Museum and Archives, graciously assisted us in our research. Carol Weiss of the Nyack Public Library deserves a special thank-you for all of her help. Robert Guttman and Celeste Bocian were kind enough to share pictures and recollections of their early lives at Shanks Village.

INTRODUCTION

At the turn of the twentieth century, the proprietor of an Ashford shop opens his business for the day. His ancestors settled here at the foot of the Catskill Mountains, almost due west of Kingston. Most were farmers, while some worked in nearby quarries. His shop is a town fixture, a combination general store and post office. Locals stop by, make small purchases and linger to chat and warm themselves by the wood stove. Smiling children enter with coins held tightly in their hands, hoping to find a favorite sweet treat. There is always ample time for some games of checkers or tick-tack-toe.

But starting about 1905, the gossip and news dispensed in the shop begins taking on a more serious tone. New York City is looking at the region as a possible solution to its water-supply deficiencies. Residents of Ashford and numerous other towns just like it will face years of uncertainty before the inevitable becomes a reality. Dams, aqueducts and reservoirs will soon dominate the landscape. While some towns will be relocated, others will be lost forever.

Around the same time, the brick-making business along the Hudson Valley is rapidly becoming the largest in the world. Brickyards dot both sides of the river's banks. Companies compete fiercely to reap the benefits of the banks' rich clay deposits. The Hudson River offers convenient barge transportation downriver to New York City. Manhattan's building boom provides a steady demand for brick, the favored construction material.

In 1906, a laborer for the Rose Brick Company, an immigrant from Hungary, toils in the oppressive heat and humidity on a summer's day. He racks pallets of finished bricks soon to be transferred to New York City directly from the yard's pier in Roseton, a Hudson Valley hamlet just a few miles north of Newburgh. The work is arduous and the hours are long. A red residue from the bricks covers his work clothes, hands and face.

INTRODUCTION

At day's end, he returns to a company-owned rooming house that his family shares with other working families from the brickyard. The hamlet of Roseton is built around the brick industry. His children attend a new school built to educate the growing number of children in Roseton. They all have a short walk to and from the school, which provides for their primary school education. His wife shops in the hamlet's markets or at the company-owned general stores. In the winter, he travels southward to Rockland Lake, where he finds employment in the ice industry. He resumes work at Roseton in the early spring.

The brickyards at Roseton provide a living and a way of life for several generations. But Roseton is not immune to the problems that permeate the whole industry starting about 1920. By 1960, the town is essentially gone. The arrival of large energy plants leaves only a few reminders of a once vital town.

Just past the midpoint of the nineteenth century, a young, muscular man walks behind a horse-drawn ice cutter to create a grid pattern on the surface of a frozen Rockland Lake. Later in the day, he wields an ice saw as he cuts the ice into blocks called "floats." These ice blocks will then be floated to land and stacked in icehouses, where they will be stored pending their delivery downriver. He is just a small part of the growing ice industry that supplies New York City with refrigeration.

As the years pass, two of his sons follow in his footsteps as the industry continues to prosper. Another son works at a quarry along Hook Mountain, while his youngest manages a small resort hotel. Rockland Lake has become a summer tourist destination. The young manager registers families from New York City who hope to find some quiet and fresh air along the lake's shore. The visitors stroll along the small town's streets, laze by the shore and enjoy some games of chance and amusement in the evening. But eventually, electric refrigeration signals the end to the once mighty ice industry. About the same time, local rock quarry owners finally yield to the protestations of conservation groups. Although the town of Rockland Lake has passed its prime, the Palisades Interstate Park Commission won't purchase the property until 1958.

In the winter of 1944, a soldier from Ohio, barely out of his teens, arrives by train in Orangeburg in Rockland County. The biting wind whistling along the Hudson Valley stings his face while he lugs his duffel bag for the short walk to Camp Shanks. Upon his arrival, the nervous GI is quickly assigned a barracks but barely has time to greet his new bunkmates. The next eight days or so are designed to facilitate final preparations before he sails across the Atlantic to a foreign land to engage an enemy that threatens the very

core of international freedom and democracy. He is checked medically, issued equipment that must be tested, fitted with a uniform and oriented about a war the likes of which the world has never seen.

To ease his apprehensions, he does have some time to relax and recreate. But always lurking is the thought that his return from overseas is uncertain. Many thousands who are deployed from Camp Shanks never return to tell their tales. The camp is their last home on American soil. Over 1.3 million troops are staged at Camp Shanks during World War II. An even greater number of returning troops and prisoners of war will be processed there. Together with Camp Kilmer in New Jersey, Camp Shanks has become the largest point of embarkation in the nation.

It is now the spring of 1947. The rifles, ammunition and transient population are nowhere to be seen. Camp Shanks has served its purpose. It is now Shanks Village. A young mother pushes a baby carriage along a village street that only a little over a year ago was crowded with military vehicles. She is on her way to the cooperative market established by residents. Earlier in the day she said goodbye to her husband, a World War II veteran, who is studying engineering at Columbia University under the GI Bill. He gladly pays his fifty-cent carpool fee for the journey to upper Manhattan.

Times are lean, but the family is thankful for the affordable housing provided for them and the sense of community they feel. More importantly, they appreciate the opportunity to advance themselves for their children's benefit.

Shanks Village becomes a vibrant community. But like Camp Shanks, it has a short tenancy. By 1956, the last residents of Shanks Village are being evicted. Buildings are torn down, and many familiar landmarks no longer exist. The government is ready to pass the land along to developers in the name of suburban development.

Camp Shanks and Shanks Village were fixtures in the area from 1942 until 1956. Today, in 2009, very little remains from that extraordinary fourteen-year period.

Each of the locations chosen for this book provides a unique tale in that the reasons for their origins and disappearances were quite disparate. Despite these differences, some commonalities existed as well. The Hudson River Valley met the needs of these towns through its ample natural resources, its scenic beauty or its strategic location. Another common bond involved New York City. The Ashokan towns were replaced to make way for the city's water-supply system. Roseton's bricks were conveniently shipped from its clay banks to Manhattan, its largest customer. The ice industry at Rockland Lake served the city's refrigeration needs. Camp Shanks was chosen as a

Introduction

World War II embarkation point for its proximity to the river and rail lines so that massive numbers of troops could be easily be transported to New York Harbor before they crossed the Atlantic. Later, Shanks Village provided housing for veterans who were studying at Columbia University.

The reasons for the demise of each site were varied. Despite their long and vocal protests, the Ashokan Reservoir towns farther up the valley finally succumbed to New York City's increasing thirst for water. Roseton met its fate when the brick industry eventually failed. The town of Rockland Lake was taken to became part of a state park. The war's end led to the abandonment of Camp Shanks. Shanks Village, in turn, lasted only ten years, until the federal government saw no need to retain the land.

Change is inevitable, and the towns discussed in this book represent the more extreme form. It is vital that we understand and appreciate the past for its value in the grand scheme of things. Our ancestors' fierce independence, resourcefulness, work ethic and heroism should forever serve as models for future generations.

CHAPTER 1

ASHOKAN RESERVOIR TOWNS

Drop by Drop

N ew York City residents' insatiable thirst for water in the early twentieth century led to the creation of one of the greatest engineering feats of modern times. The New York City Water Supply System consists of nineteen reservoirs, three lakes, three main aqueducts and over six thousand miles of water mains to deliver water throughout the city. This system was built at the cost of more than thirty towns and villages. Some of these towns were relocated, while others were flooded or razed to create the reservoirs and the buffer lands that surrounded them.

In 1905, Governor Frank Higgins of New York signed Chapters 723 and 724 of the Laws of 1905. Chapter 723 established a five-member water-supply commission to accept or reject any plans for the growth of the New York City water system. Chapter 724, the McClellan Act, provided for "pure and wholesome water for the City of New York." It also allowed the city to acquire land for its reservoirs, aqueducts and other water-system components. This act marked the beginning of the end for the villages along the Esopus Creek. The commission appointed John R. Freeman, William Burr and Fredericks Stearns as consultants and J. Waldo Smith as the chief engineer.

On August 1, 1905, Smith started work. After conducting research and surveys, the commission decided to build a reservoir dam on the Esopus Creek at Olive Bridge. By August 1907, bids were opened for the dam. The contract was awarded to Mac Arthur Brothers Company and Winston and Company of New York City on August 31, 1907. The estimated cost of the project was $12,669,775. Work on the Ashokan Reservoir began in 1908 and was completed in 1912.

The name Ashokan comes from the Esopus Indians' name for the region, *Ashocan*. The Ashokan Reservoir is the largest reservoir in the Catskill System.

It is located west of Kingston, about one hundred miles north of New York City. The villages sacrificed to create it were Ashton, Boiceville, Brodhead's Bridge, Brown's Station, Glenford, Olive, Olive Branch, Olive Bridge, Shokan, West Hurley and West Shokan. In addition, more than twenty-six hundred bodies needed to be exhumed and reburied, and over eleven miles of Ulster & Delaware Railroad tracks were removed and relocated north of the reservoir. Now, all that remains of the original villages are roadside markers and the memories of a bygone era.

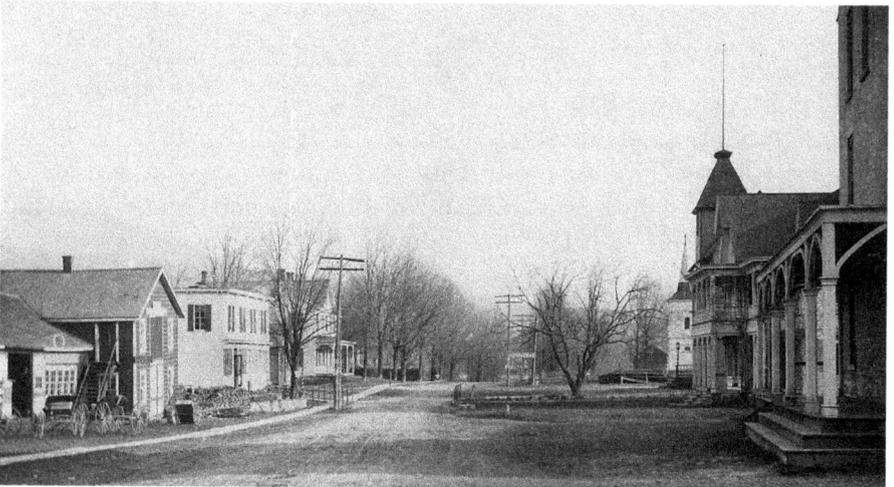

West Shokan was one of the villages that was submerged under the Ashokan Reservoir. This photograph looks east along Main Street in West Shokan. It was taken from the Ulster and Delaware Railroad tracks. Pythian Hall and the Roman Catholic church are visible on the right side of the photograph. At the left edge, you can see George Siemon's Wagon and Blacksmith Shop. *Courtesy of the Town of Olive Archives, Vera Sickler Collection.*

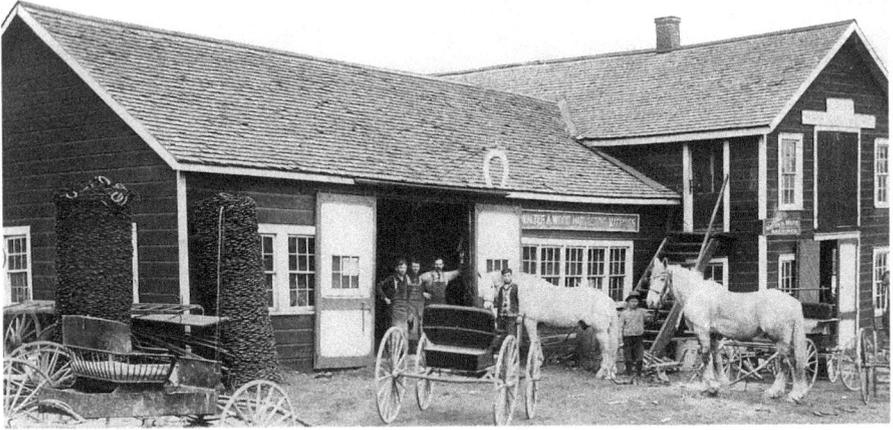

At George Siemon's Wagon and Blacksmith Shop, horses were shod, wagons were repaired and metal was molded into various shapes. *Courtesy of the Town of Olive Archives, Vera Sickler Collection.*

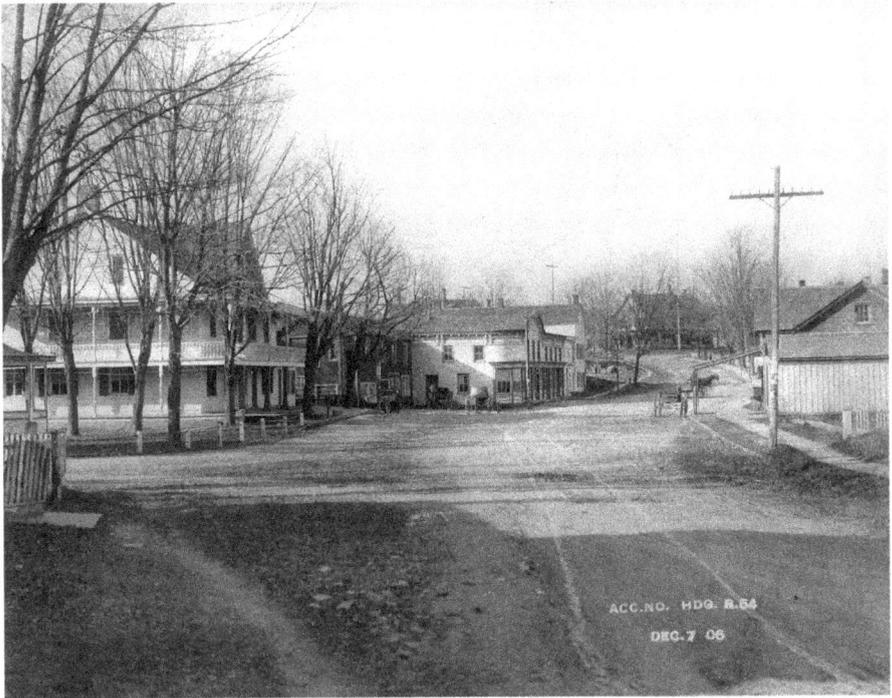

A street in West Hurley is shown in this 1906 photograph. West Hurley had to be relocated north of the reservoir. *Courtesy of the Town of Olive Archives, Lois Langthorn Collection.*

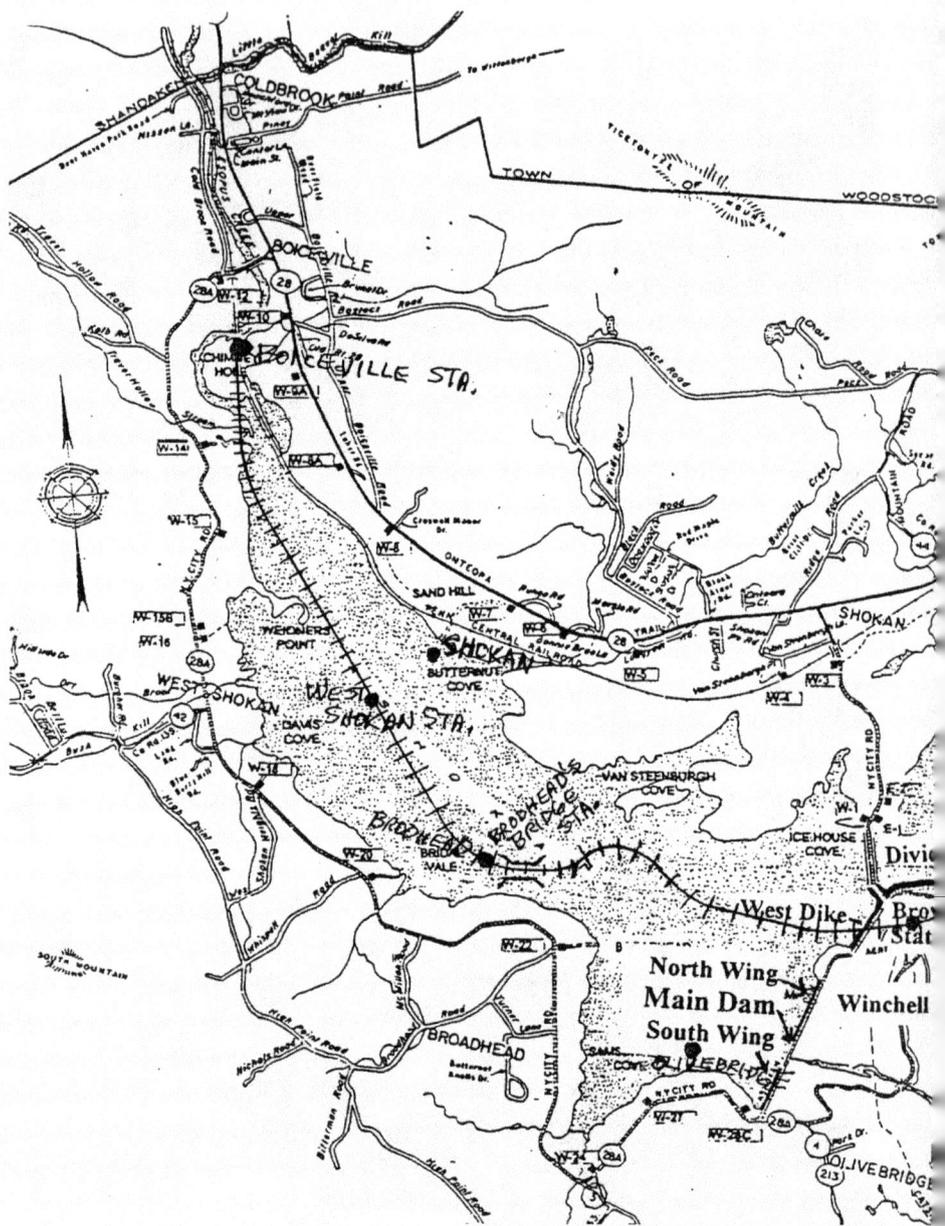

The Ashokan Reservoir is shaded black in this New York City Department of Environmental Protection map. It shows the towns that were submerged under the reservoir. The Ulster and Delaware train stations at Boiceville, West Shokan, Brodhead's Bridge, Brown's Station, Olive Branch and West Hurley were all razed, and the tracks were relocated to make way for the reservoir. In addition, the towns of West Hurley, West Shokan, Olive Bridge, Boiceville, Shokan, Ashokan and Glenford were moved from their original locations. *Courtesy of the New York City Department of Environmental Protection.*

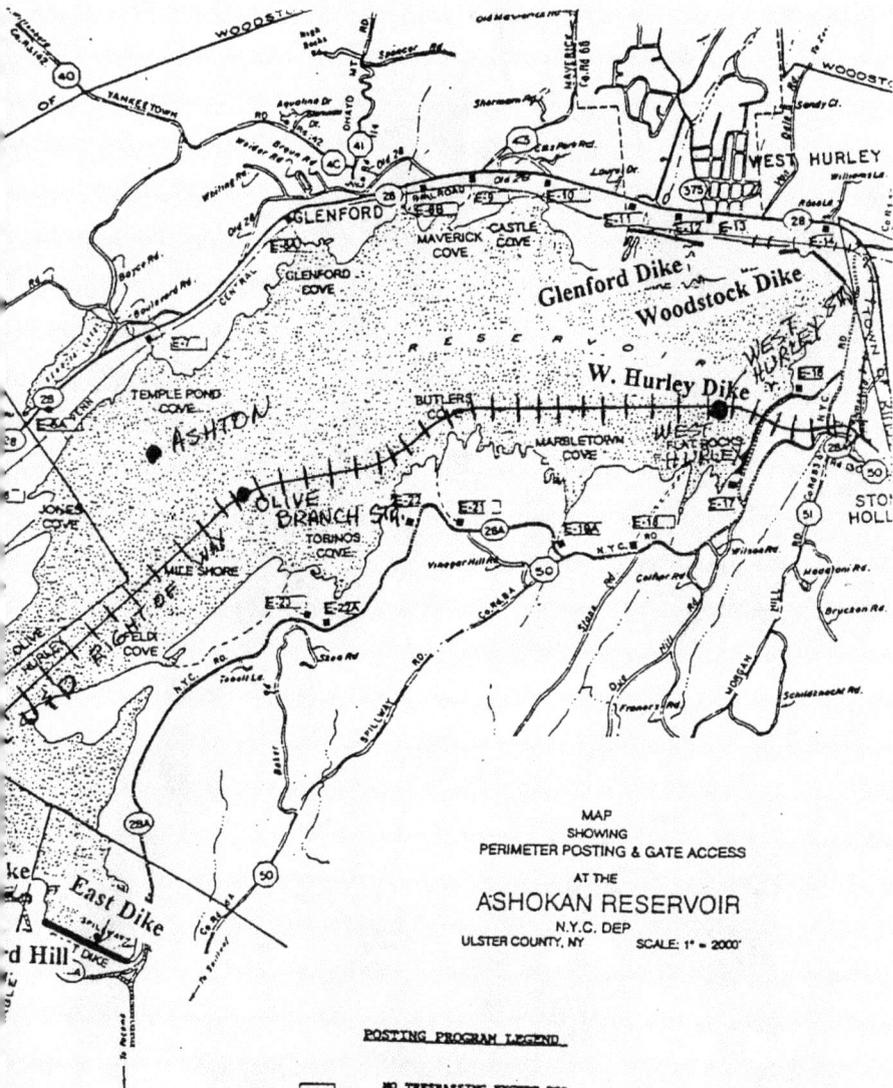

MAP
SHOWING
PERIMETER POSTING & GATE ACCESS
AT THE
ASHOKAN RESERVOIR
N.Y.C. DEP
ULSTER COUNTY, NY SCALE: 1" = 2000'

POSTING PROGRAM LEGEND

NO TRESPASSING EXCEPT FOR
FISHING UNDER PERMIT

NO ENTRANCE FOR ANY PURPOSE

ACCESS GATE

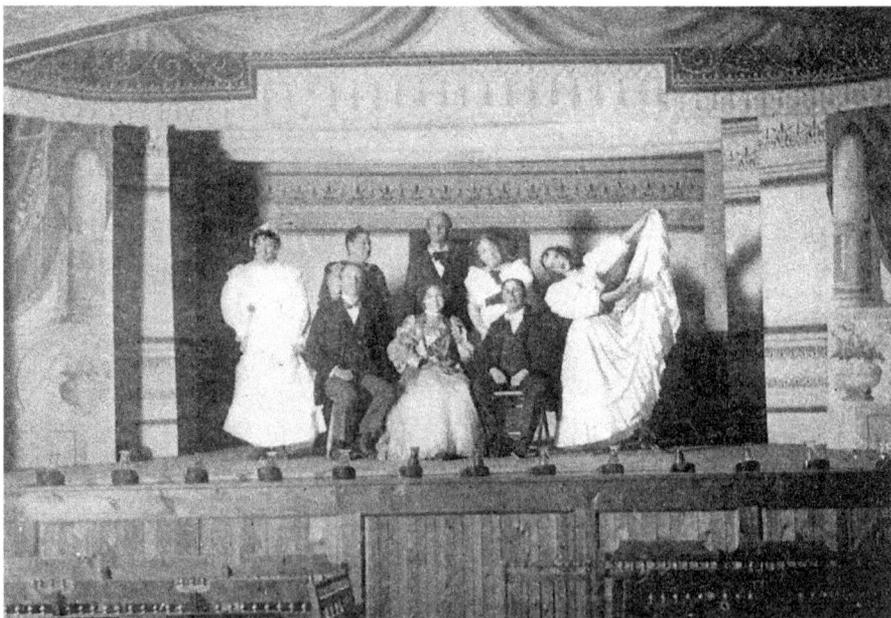

Taken in the 1890s, these photographs are of the exterior and interior of Pythian Hall in West Shokan. Pythian Hall was the town's center of activity. Plays, operas and social events were held there. *Photographs by Richard Lionel De Lisser.*

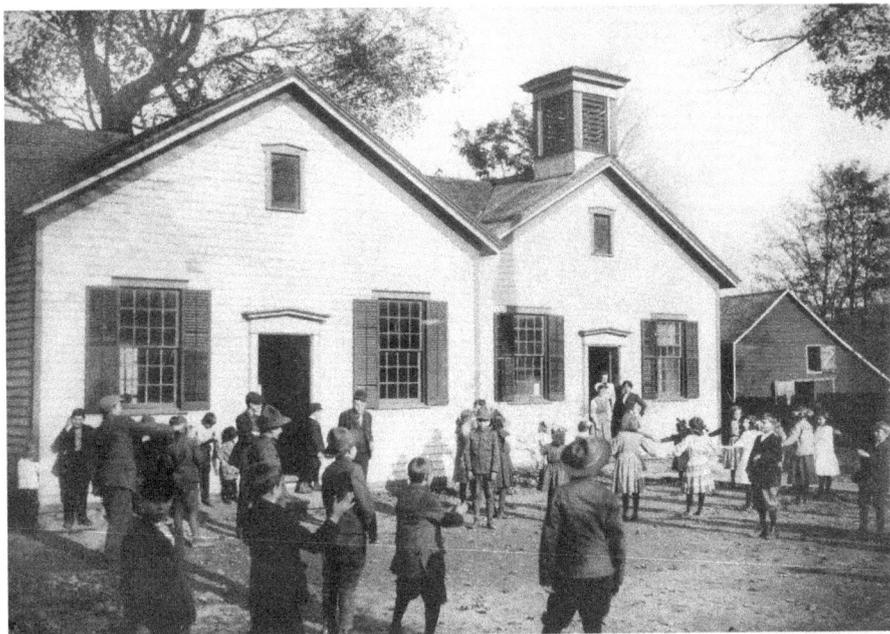

The town of West Shokan was relocated due to the impending reservoir. This photograph shows a school in West Shokan. Notice the group of Boy Scouts in the foreground. *Courtesy of the Town of Olive Archives, Robert Pleasants Collection.*

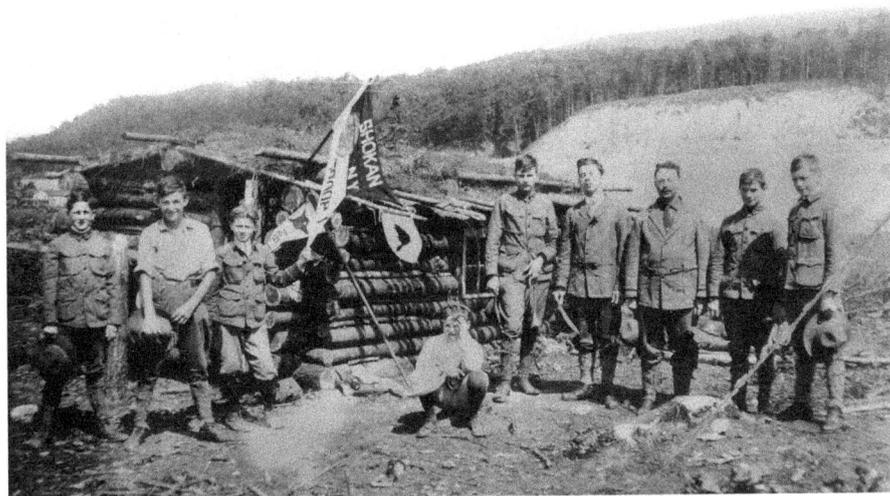

Members of Boy Scout Troop 1 of West Shokan are standing in front of their scout cabin. This troop is still in existence today and is now known as Boy Scout Troop 63. *Courtesy of the Town of Olive Archives, Robert Pleasants Collection.*

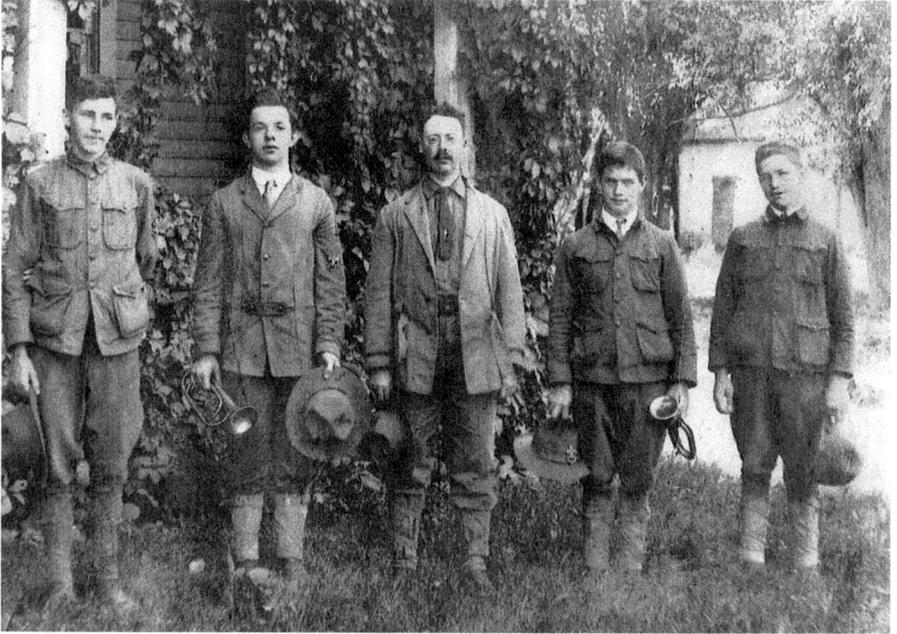

In 1912, five of the first Eagle Scouts in the country came from Troop 1. The five scouts, from left to right, are J.S. Langthorn, Robert Pleasants, Sidney Clapp (scout master), Bertram Van Vliet and Leon Van Vliet. *Courtesy of the Town of Olive Archives, Robert Pleasants Collection.*

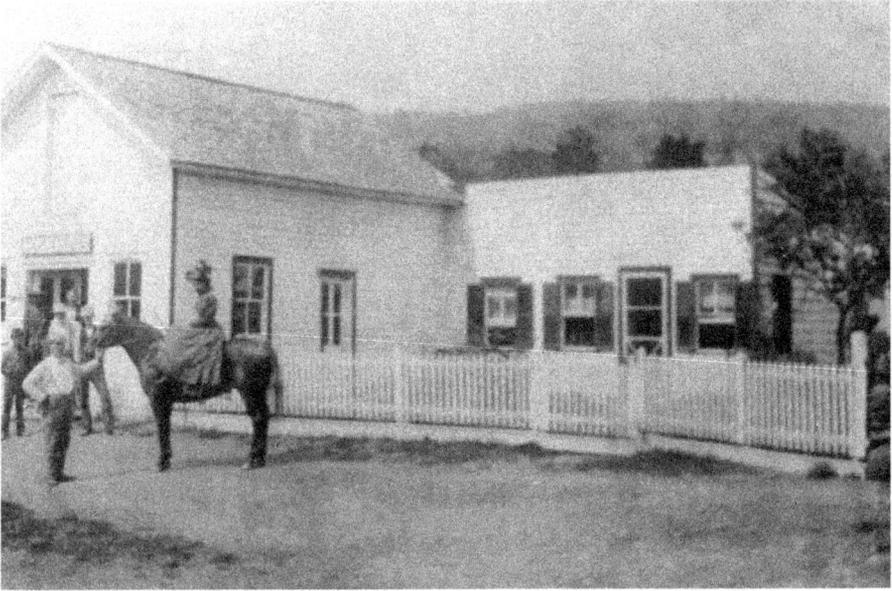

In 1894, the store in Old Glenford was owned by John Lennox, father of Tecumsah Sherman Lennox, known as T.S. or Sherm. It was located along the road leading to Yankeetown. T.S. bought out his father, and in 1898, he also became the postmaster. At that time, most post offices were located inside general stores. In June 1895, T.S. married Sarah (Satie) Ida Sagendorf, the Glenford schoolmarm, and set up housekeeping in the house attached to the store. This picture of Satie on horseback, with T.S. holding the reins, may have been taken soon after they were married. *Courtesy of the Town of Hurley Archives, Eleanor Arold Collection.*

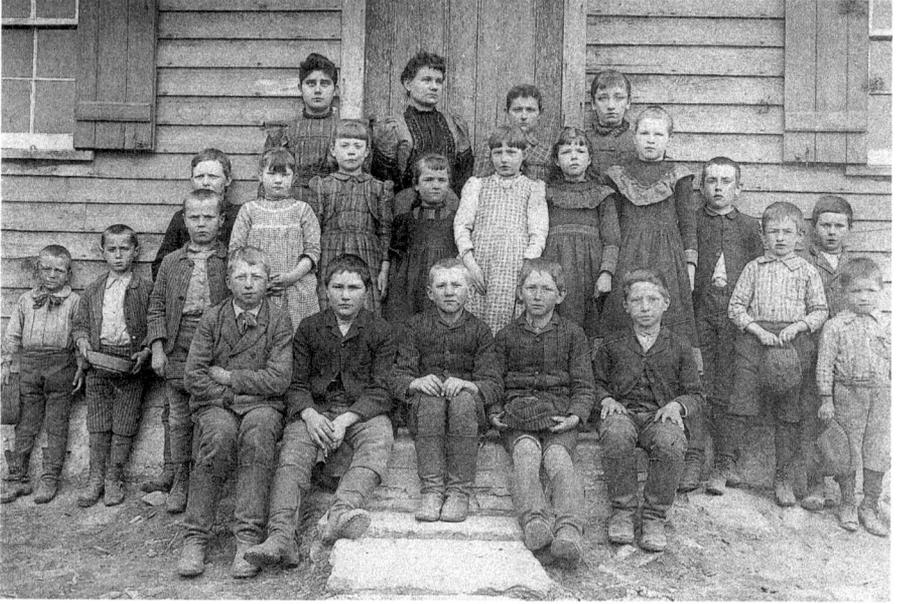

The children in this 1894 photograph pose in front of the Little Red Schoolhouse in Olive, New York. This school, along with several others, was razed in order to build the reservoir. *Courtesy of the Town of Olive Archives, Vera Sickler Collection.*

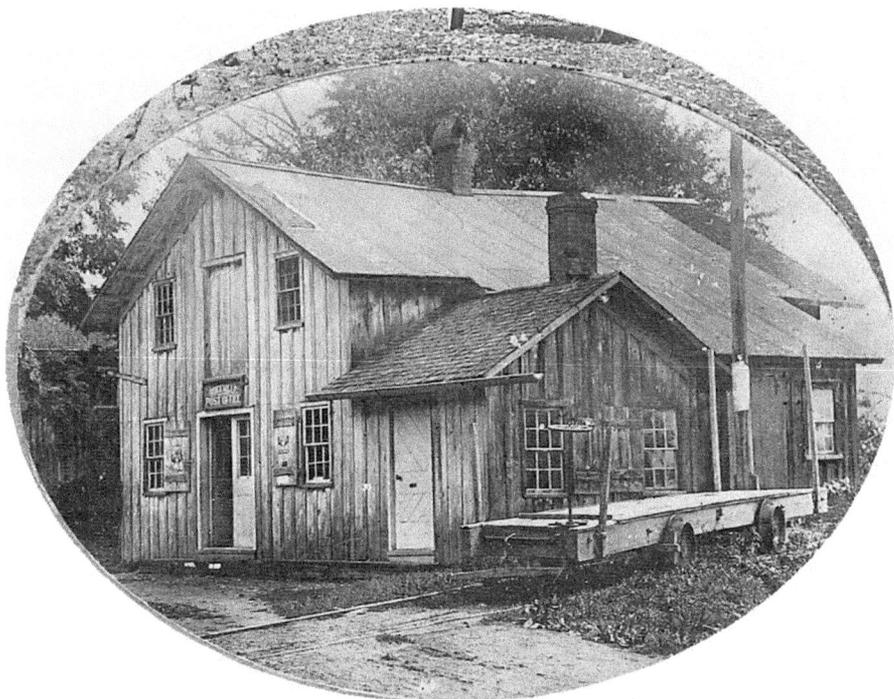

The Boiceville Post Office was eventually burned down, and its site was flooded by the dam's water. *Courtesy of the Town of Olive Archives, John Watson's photograph album donated by Peggy Mahon.*

Shokan was another of the villages that was relocated during the construction of the Ashokan Reservoir. *Photograph by R. Lionel De Lisser.*

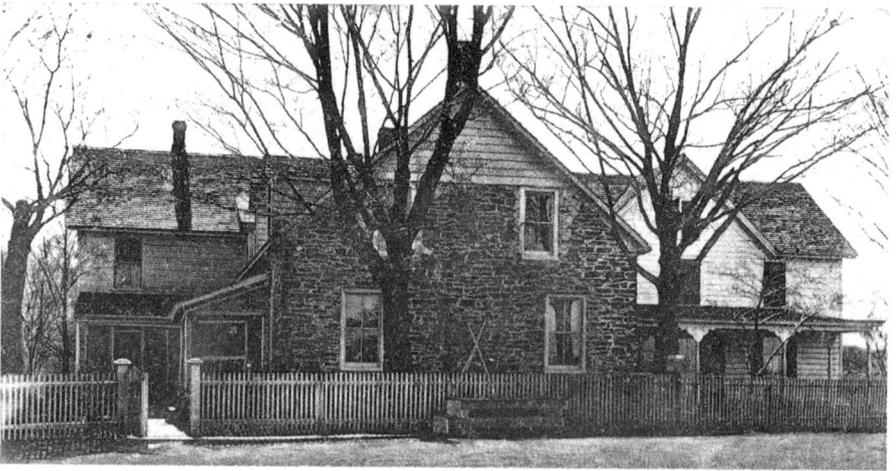

This postcard depicts the Bishop Falls House in its heyday. *Courtesy of the Town of Olive Archives, Florence Hornbeck Collection.*

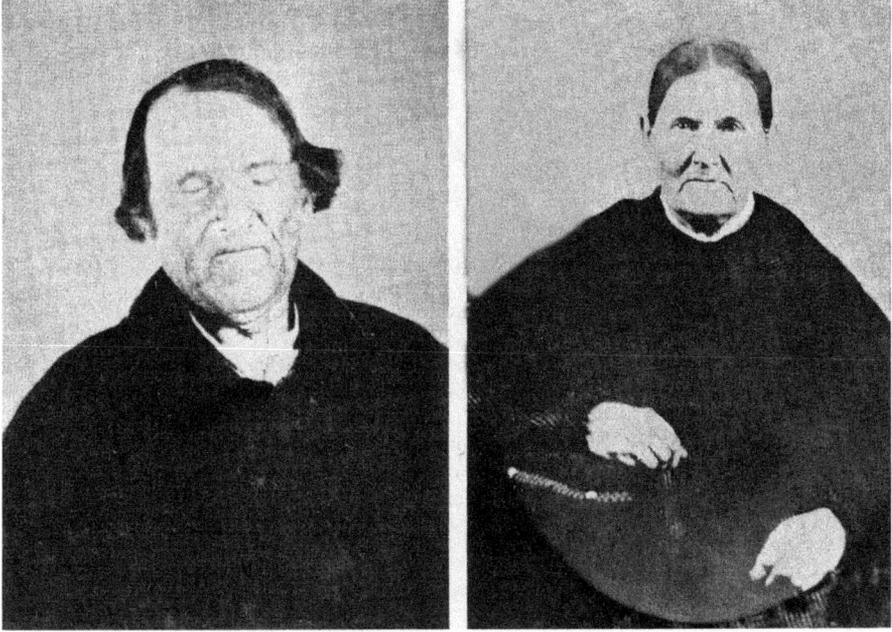

Bishop Falls was named after Asa Bishop and his wife, Rebecca Winchell, who settled near the falls about 1790. Asa was a miller by trade, and he built a gristmill and stone house there. Jacob, pictured above, was one of their ten children. At age four, Jacob was blinded when he contracted smallpox. Jacob showed an interest in milling, and thus when his father died in 1813, Jacob ran the mill. Jacob became known as the "Blind Miller," who, it is said, never made a mistake at the mill. His wife, Catherine Eckert, is pictured with him. *Courtesy of the Town of Olive Archives, Florence Hornbeck Collection.*

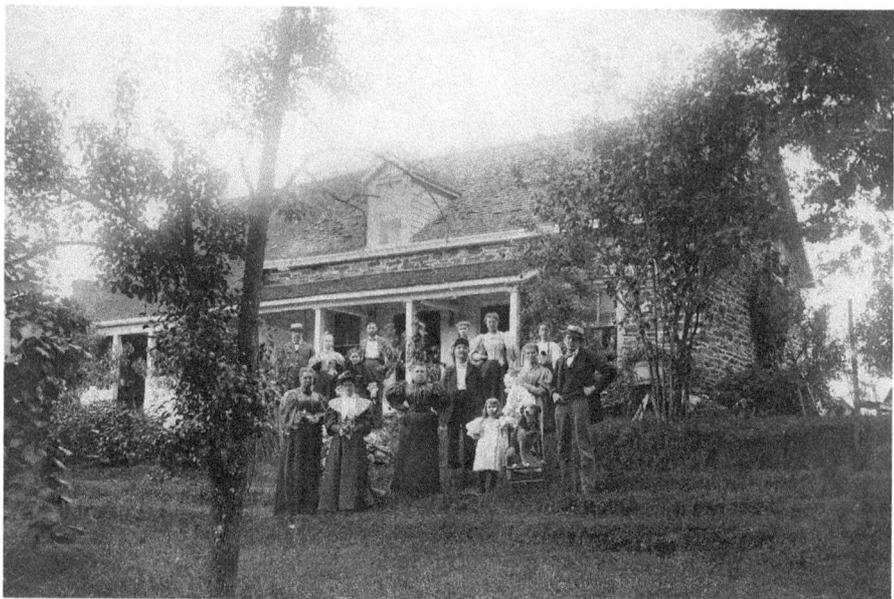

In 1895, the Bishop Falls House became a boardinghouse where visitors would come to enjoy the picturesque countryside. The back of the original house is shown in this 1899 photograph. *Courtesy of the Town of Olive Archives, Florence Hornbeck Collection.*

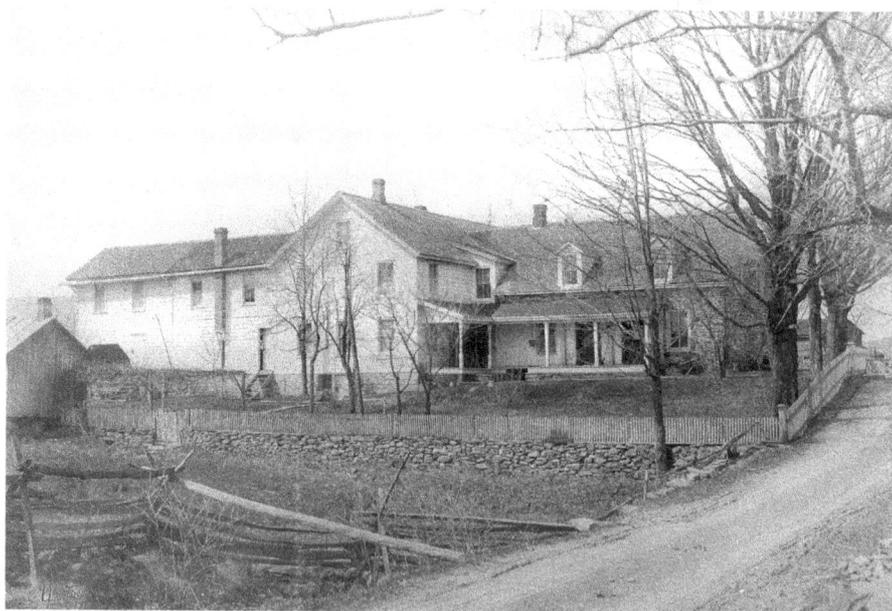

The back of the Bishop Falls House is shown after a large extension was added in 1900. *Courtesy of the Town of Olive Archives, Florence Hornbeck Collection.*

Three Hours Ride from New York.

Twenty minutes drive from Brodheads Station, five minutes walk to church, ten minutes walk to Post and Telephone Offices. The famous Bishop Falls join on the farm.

AMUSEMENTS.

Boating, bathing, hunting and fishing, dancing, croquet, etc

DRIVES.

To Shokan, Mt. Pleasant, Phoenicia, Browns Station, Krumville, Stone Ridge and Lake Mohonk.

Frank and DeForest Bishop, great-grandsons of Asa Bishop, published an advertising pamphlet in 1900. In this advertisement, the Bishops inform visitors about the amusements and driving excursions in which they can participate during their stay at the house. *Courtesy of the Town of Olive Archives, Florence Hornbeck Collection.*

TERMS:

Two persons occupying one room $6 per week.
One person occupying a room $7 to $8 per week.
Transcients $1 to $1.50 per day.
Transportation from Station 25 cts. each.

ACCESS TO BISHOP FALLS HOUSE

from New York via West Shore R. R., from foot Franklin St. or 42 St., North River to Kingston, thence by Ulster & Delaware to Brodheads. Also by Albany Day Boats from foot Desbrosses St., or 22 St. North River to Kingston Point, thence by Ulster & Delaware R. R. to Brodheads.
 Fare one way by train $2.24, Day Boat one way $1.42.
 Correspondence solicited and any further information reference, etc., will be cheerfully given. Respectfully,

No Hebrews Taken. **D. & F. V. BISHOP.**

The room rates are listed in this advertisement, showing that one week's stay, double occupancy, cost six dollars, whereas a single occupancy was seven to eight dollars per week. *Courtesy of the Town of Olive Archives, Florence Hornbeck Collection.*

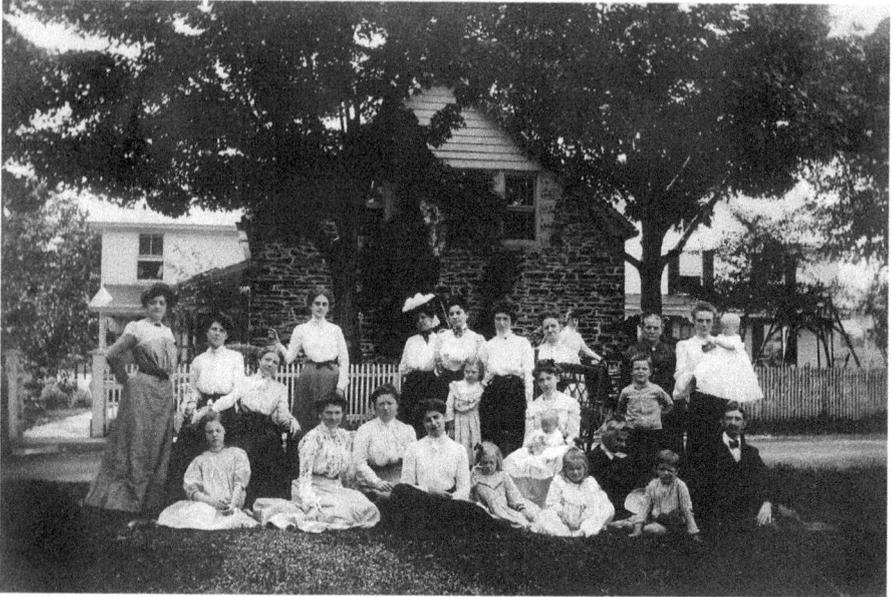

Visitors from New York City could access the Catskill Mountains via steamboat to Kingston. From there, the Ulster and Delaware Railroad would transport them to Olive Bridge. By 1900, the Bishop Falls House could accommodate sixty people. A group of boarders pose in the front yard of the Bishop Falls House in 1901. *Courtesy of the Town of Olive Archives, Florence Hornbeck Collection.*

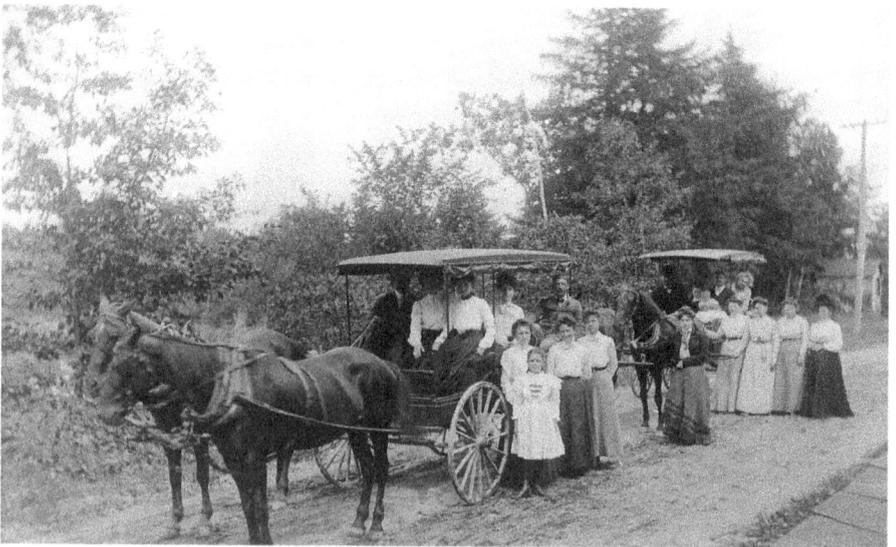

Boarders at the Bishop Falls House enjoy a wagon ride through the countryside in 1902. *Courtesy of the Town of Olive Archives, Florence Hornbeck Collection.*

AUCTION SALE

— OF —

BOARDING HOUSE FURNITURE, FARMING IMPLEMENTS, Etc.

About 1-2 mile south of Olive Bridge Post Office, near the Tongore Church, at the home of **D. & F. V. BISHOP**, the place known as

BISHOP FALLS HOUSE

WED. APRIL 29,

Commencing at 10 o'clock in the forenoon.

20 Oak and ash bed-room suits, 20 sets woven wire and coil springs, 20 mattresses extra wash stands and bureaus, 25 toilet sets, 6 cots, 100 yards matting, 100 yards carpet, 40 dining room chairs, lamps, bed spreads, rose blankets, quilts, window shades, 25 slop pails, 4 mirrors, tables, dish closets, porch chairs, porch lamp, all kinds of dishes and silverware, 4 stoves and cooking utensils, 1 ice cream freezer, 2 writing desks, 1 square piano, 1 ice box, 1 lawn mower, 1 ice water tank, 1 lawn swing, 1 acquatic cream separator, 1 churning machine, 1 iron gray horse; 6 yrs. old; weight 1200, 1 black colt; 3 yrs. old, 1 bay colt, 2 yrs. old, 2 cows, 50 fowls, 1 lumber wagon; 3 inch tire, 1 set bob sleighs, 1 low iron wheel farm wagon, 1 three seated platform wagon, 1 two seated surrey, 1 pole tongue, 1 buck board wagon, 2 top buggies, 1 neck yoke, 2 sets whipple trees, 1 Portland sleigh, 1 Osborn mowing machine, 1 hay rake, 1 hay fork and tackle blocks, 1 spring tooth harrow, 1 Oliver chilled plow, 1 side hill plow, 2 cultivators, 1 corn plow, 1 hay rigging, 1 cross cut saw, 1 ice saw, 1 pair ice tongs, 1 Mann's bone cutter, 1 grind stone, 1 corn sheller, 1 set heavy double harness, 2 sets light double harness, 2 sets single hames, 1 set light harness and traces, forks, shovels, hoes, chains and other articles to numerous to mention.

TERMS: All sums under $5.00 cash, over $5.00, five months credit on good approved notes payable at State of New York National Bank. 3 per cent off for cash on all sums over $5.00.

D. & F. V. BISHOP.

The Bishop Falls House, which had been owned and occupied by five generations of Bishops, was the first house destroyed in order to build the Ashokan Dam. On April 29, 1908, the Bishops conducted an auction to sell off their boardinghouse furniture and miscellaneous goods. Shown here is one of the signs they posted advertising the sale. They made a total of $424.90 on the sale. In May 1908, Anna Bishop received $17,746.53 from New York City for the 106 acres she owned. In 1919, after a lengthy court battle, her sons, Frank and DeForest, finally received a settlement of $2,000.00 for their boardinghouse business. *Courtesy of the Town of Olive Archives, Mark DuBois addition to the Florence Hornbeck Collection.*

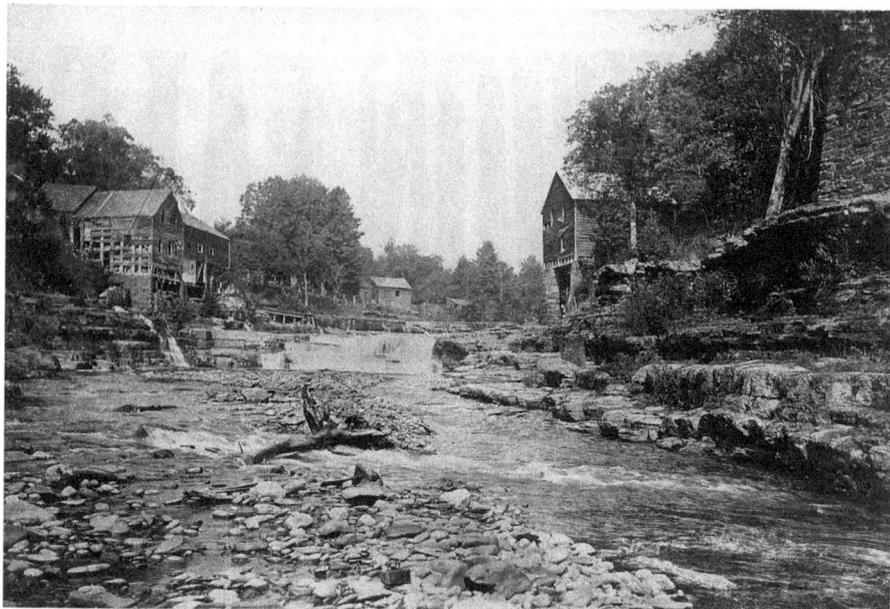

Bishop Falls on the Esopus Creek is shown in this photograph, which was taken about a quarter of a mile north of the Ashokan Dam. On either side of the photograph are gristmills. John I. Boice received $112,000 from the City of New York for the property and water power he lost from the falls. It represented the largest settlement paid by New York City in the construction of the Ashokan Reservoir system. *Courtesy of the Town of Olive Archives, John Watson's photograph album donated by Peggy Mahon.*

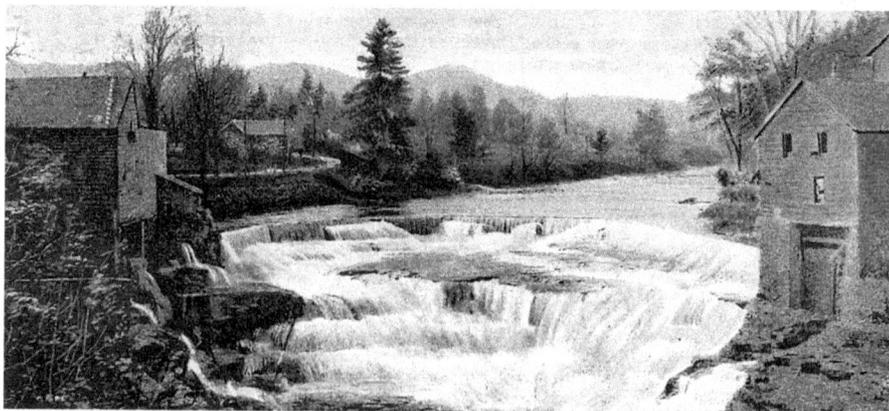

This postcard shows Bishop Falls before the reservoir was built. *Courtesy of Eleanor Arold.*

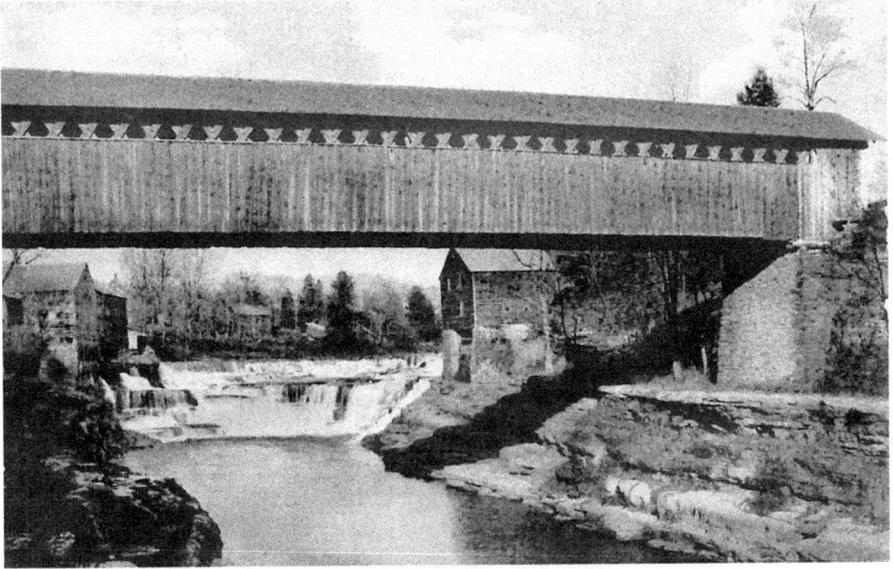

Below Bishop Falls stood the oldest wooden bridge in the Catskills. This bridge, along with the falls, gristmills and nearby homes, was destroyed due to its proximity to the main dam site. *Courtesy of Eleanor Arold.*

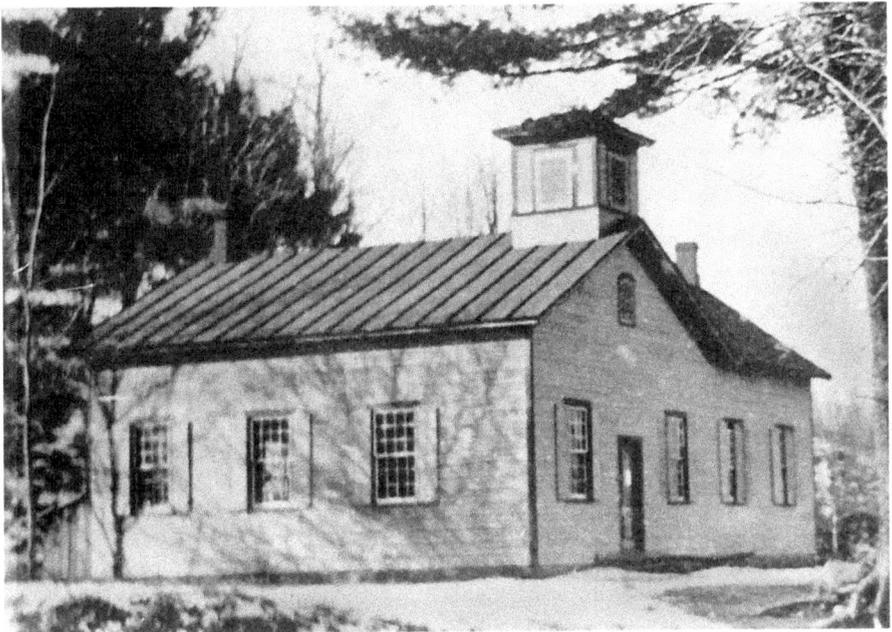

The Brookside School District #15 school site is now under the Ashokan Reservoir. *Courtesy of the Town of Olive Archives, Vera Sickler Collection.*

31

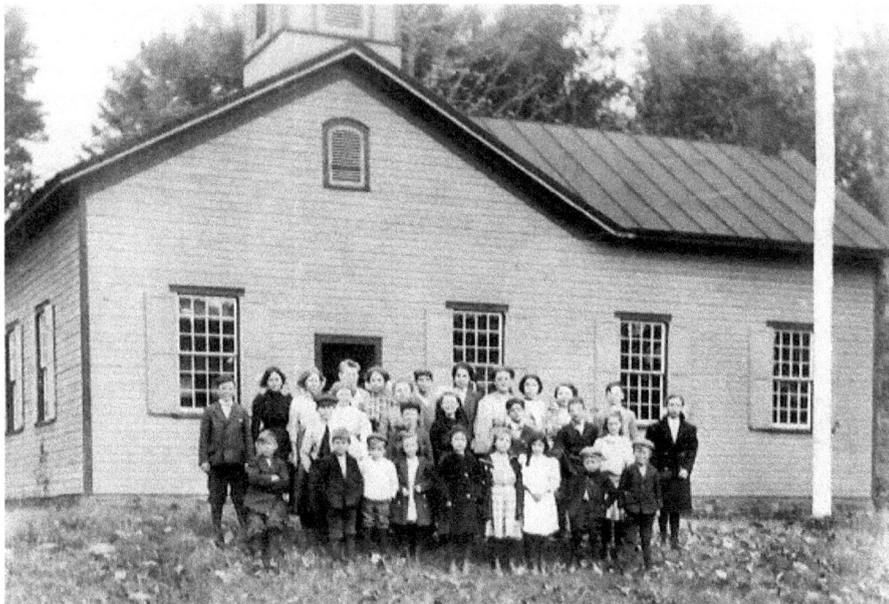

In 1910, a group of students poses in front of the Brookside School District #15 school. *Courtesy of the Town of Olive Archives, Vera Sickler Collection.*

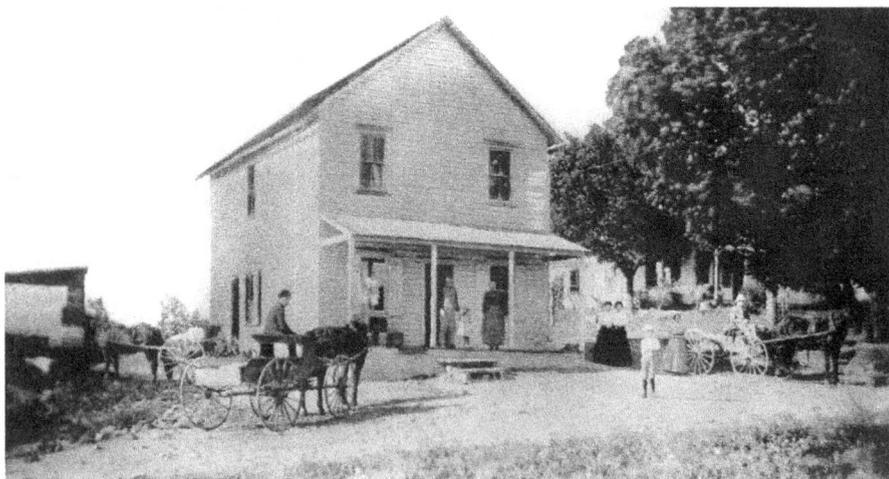

In 1900, T.S. Lennox purchased a store and house in Ashton for $600. This picture shows the store and big farmhouse on the hill to the right. In 1902, T.S. became the postmaster there. *Courtesy of Eleanor Arold.*

Ashokan Reservoir Towns

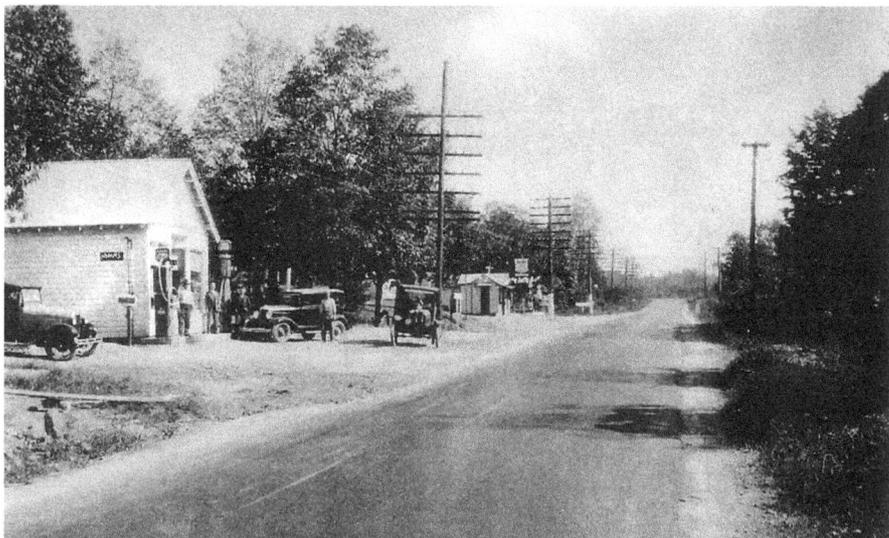

The Glenford store and post office, owned by T.S. Lennox, and a gas station were located on Main Street in Glenford, New York. The date of this postcard is unknown. *Courtesy of Eleanor Arold.*

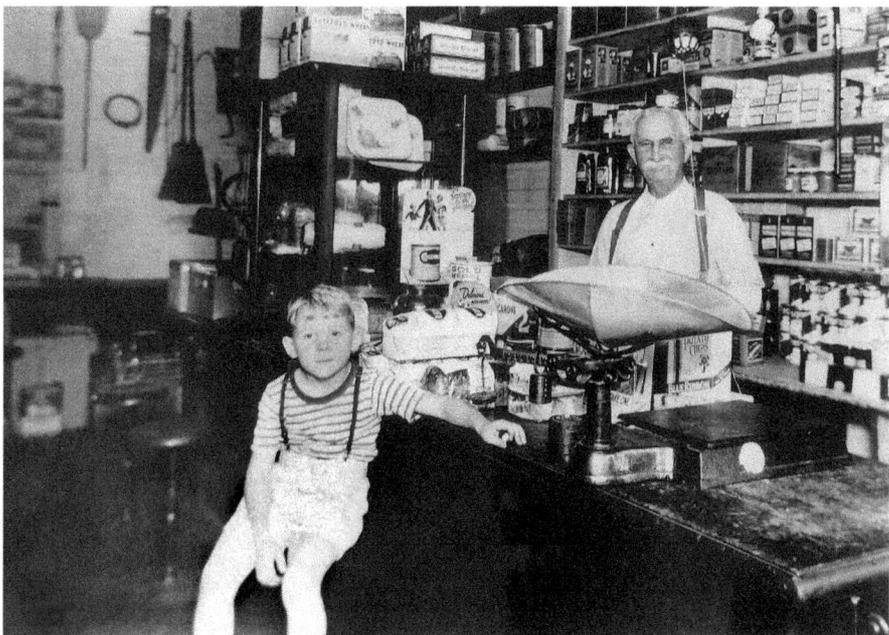

The interior of the Glenford store, with T.S. and young Harold Grumme, is pictured here. Eleanor Arold recalls spending many happy hours there playing tick-tack-toe and checkers with T.S., her grandfather. *Courtesy of the Town of Hurley Archives, Eleanor Arold Collection.*

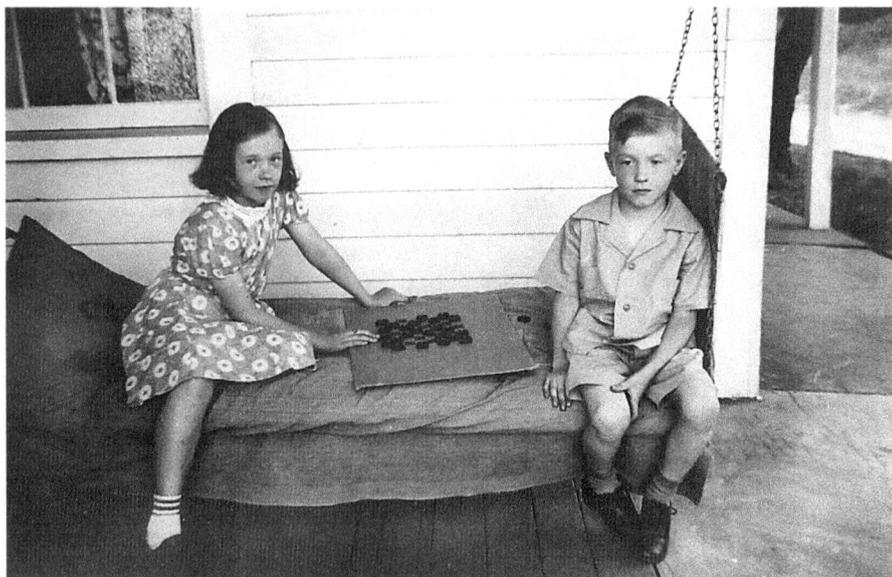

Eleanor Whiting Arold and her brother, Gene, are having a game of checkers on the porch swing outside their grandfather's house in Glenford. *Courtesy of Eleanor Arold.*

Eleanor Arold graciously invited this book's coauthors to her home to share her memories of the lost towns of the Ashokan. *Photograph by Wesley Gottlock.*

Ashokan Reservoir Towns

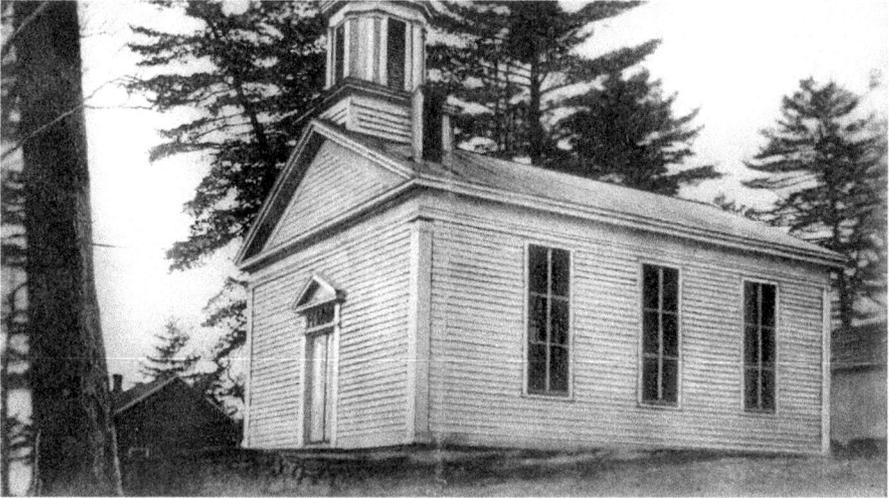

In 1911, New York City condemned church property in old Glenford and paid the church trustees $4,898 for the land and building. Part of the land was transferred to the Ulster and Delaware Railroad. One-fifth of the church building ended up on railroad property and four-fifths on city property. The trustees approached both the railroad and a city engineer about buying the church. They were told that they could have the building at no cost. John Crispell was hired to move the church rather than have it razed. When the chief engineer reported to the city that the church had been moved, the city sued the church trustees. In December 1914, the suit was settled. The jury awarded the city $45. The trustees paid $500 to their attorney. *Courtesy of the Town of Hurley Archives, Eleanor Arold Collection.*

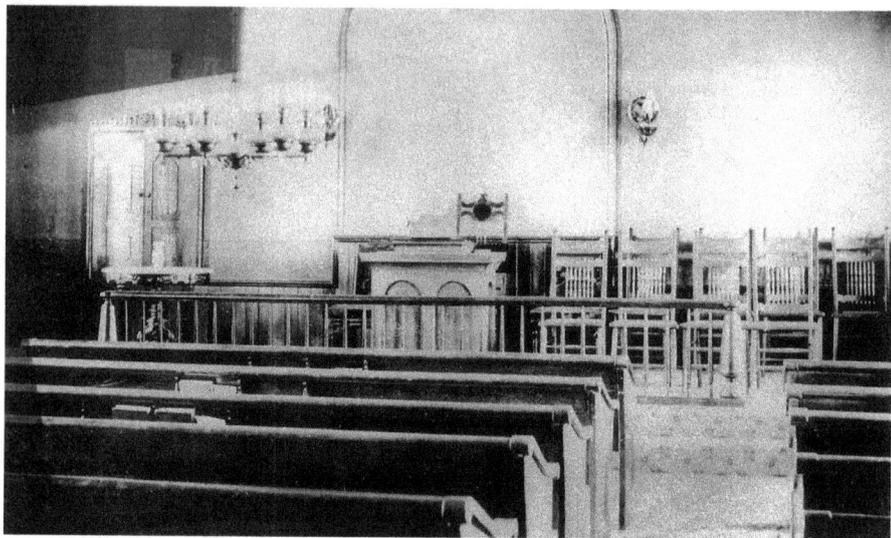

This photograph shows the interior of the old Glenford Church before it was moved. It was originally called the Greenwood Centenary Methodist Episcopal Church or the Beaverkill (original name of Glenford) Church. When it was moved outside the "Take Area," it was part of a three-church charge. Ashokan, Glenford and West Hurley all had one pastor. In recent years, both the West Hurley and Glenford churches were sold. The Ashokan church was remodeled and enlarged and is now called the Reservoir United Methodist Church. *Courtesy of the Town of Hurley Archives, Eleanor Arold Collection.*

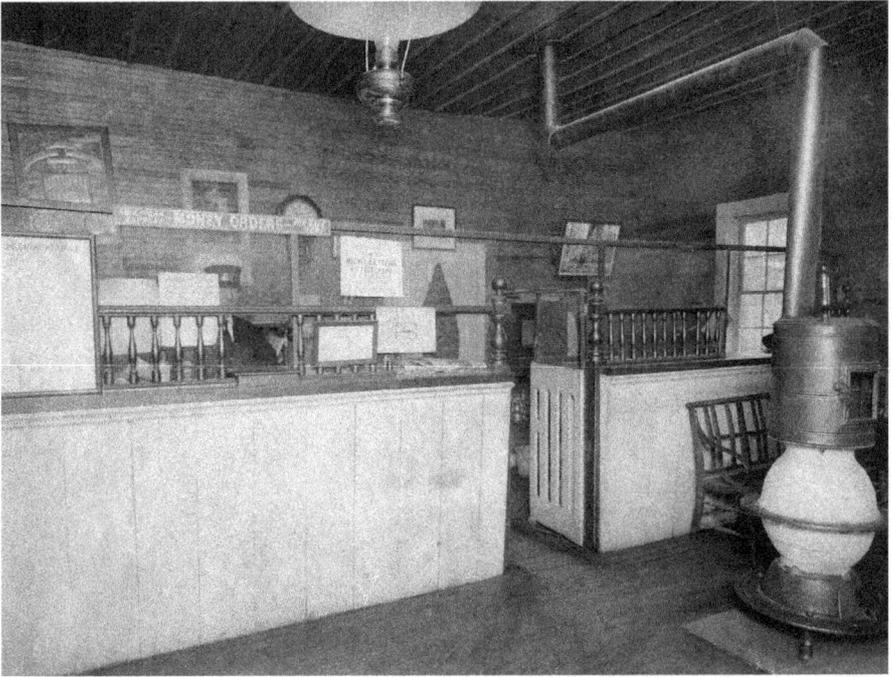

In addition to villages, the Ulster and Delaware Railroad needed to remove and relocate over eleven miles of track. These tracks originally ran in the valley that was to be flooded when the reservoir was completed. Along these tracks were six railroad stations: Boiceville, West Shokan, Brodhead's Bridge, Brown's Station, Olive Branch and West Hurley. The waiting room and ticket office of the station at Brodhead's Bridge can be seen in this photograph. *Courtesy of the Town of Olive Archives, Lois Langthorn Collection.*

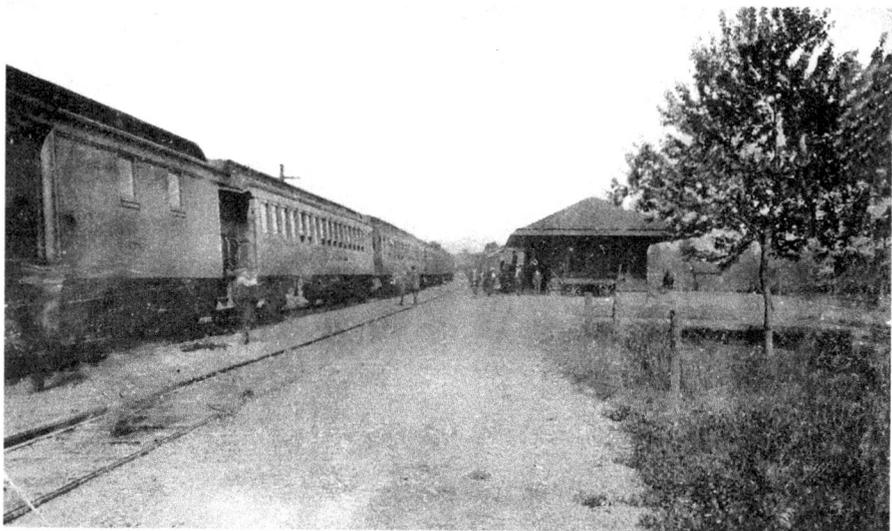

The exterior of Brown's Station is pictured in this postcard. *Courtesy of the Town of Olive Archives, Vera Sickler Collection.*

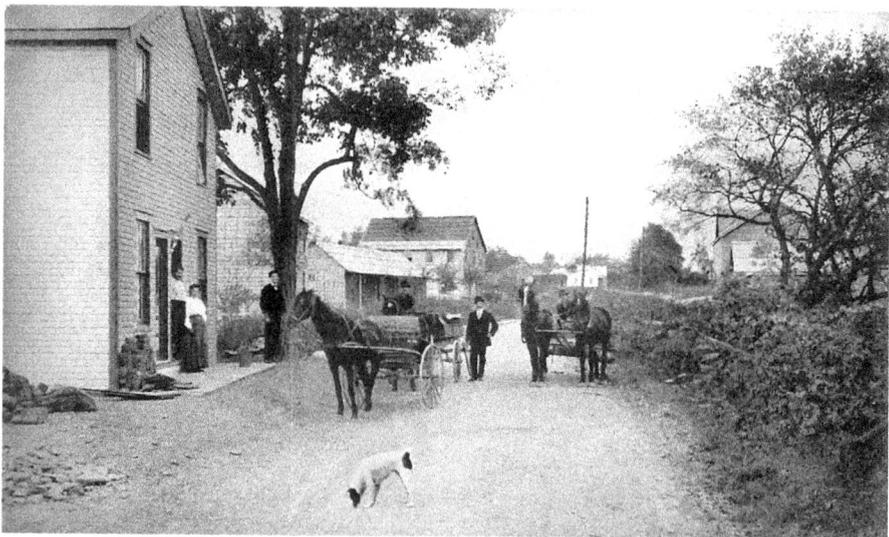

A typical street scene in Brown's Station is depicted in this postcard. Since the main dam built at Olive Bridge was close to Brown's Station, Winston and Company built its biggest work camp nearby. *Courtesy of Eleanor Arold.*

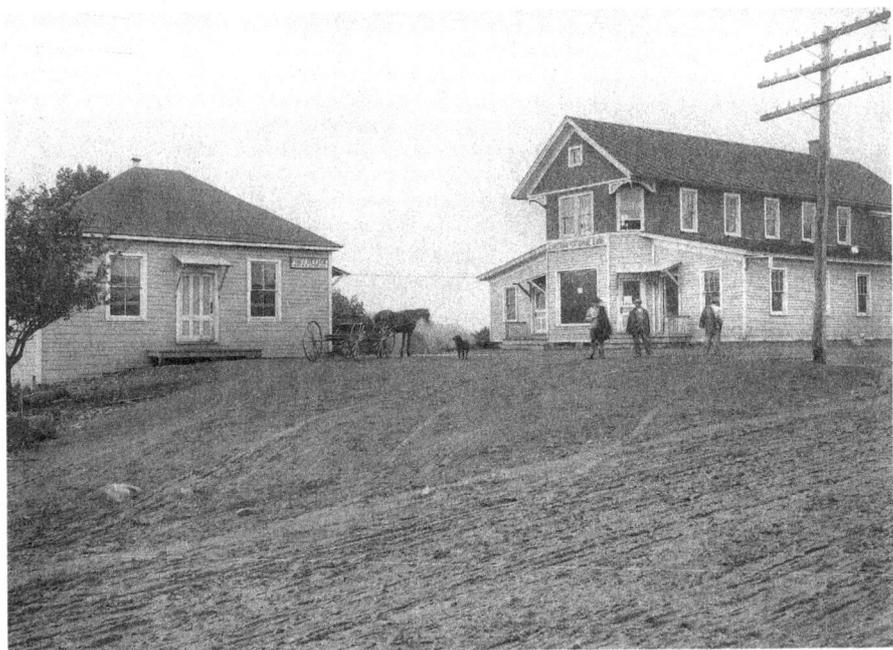

Brown's Station Post Office is pictured on the left side of this 1910 photograph. On the right is the Ashokan National Bank. *Courtesy of the Town of Olive Archives, Lois Langthorn Collection.*

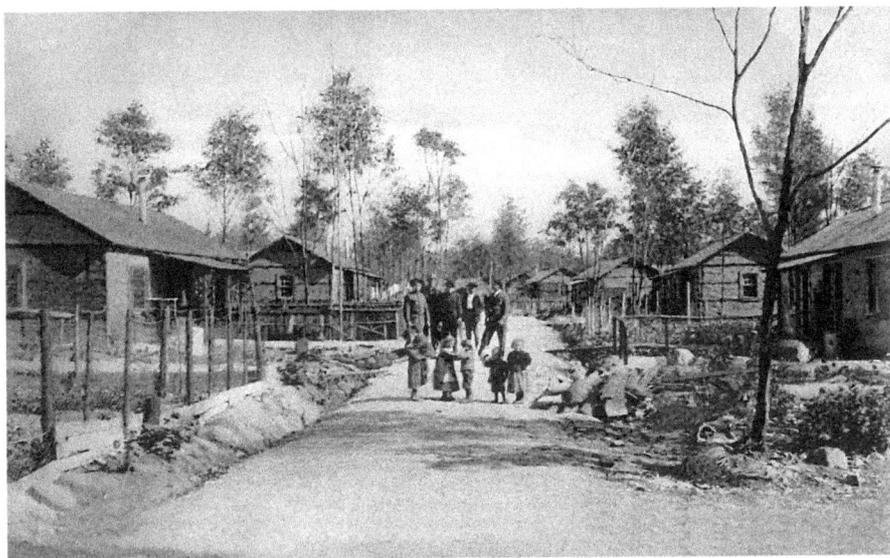

A street in Brown's Station is lined with quarters for the reservoir workers. *Courtesy of Eleanor Arold.*

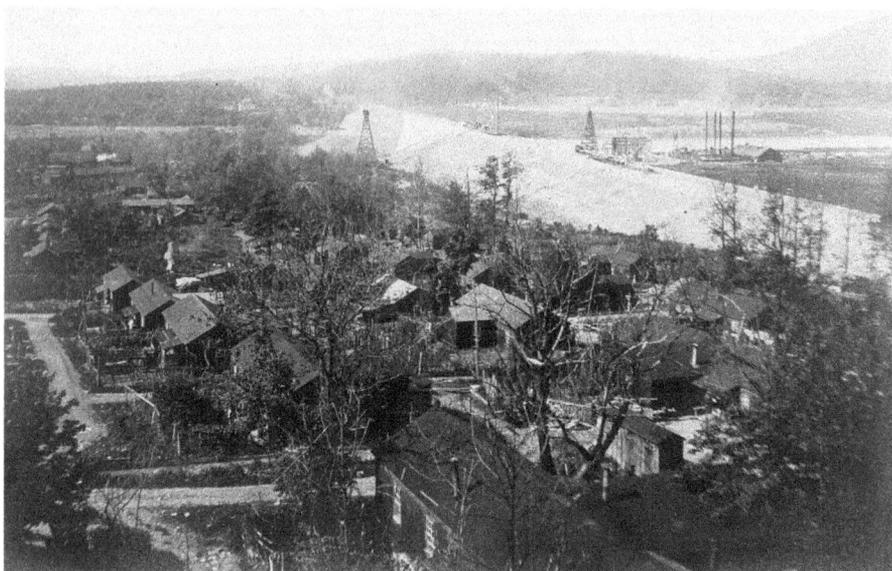

Ironically, this work camp on Winchell Hill near Brown's Station was the last place razed when the reservoir was completed. The camp could hold up to four thousand workers. The workers were mostly European immigrants, along with southern African Americans who handled the mule teams. The camp was largely segregated by race and nationality. It contained schools, a hospital, police and fire stations, churches, stores, a post office and a bank. A dormitory for single men had electricity and running water. There were also two hundred cottages for married men and their families. On the right, the dam begins to take shape. *Courtesy of the Town of Olive Archives, Loni Gale photograph.*

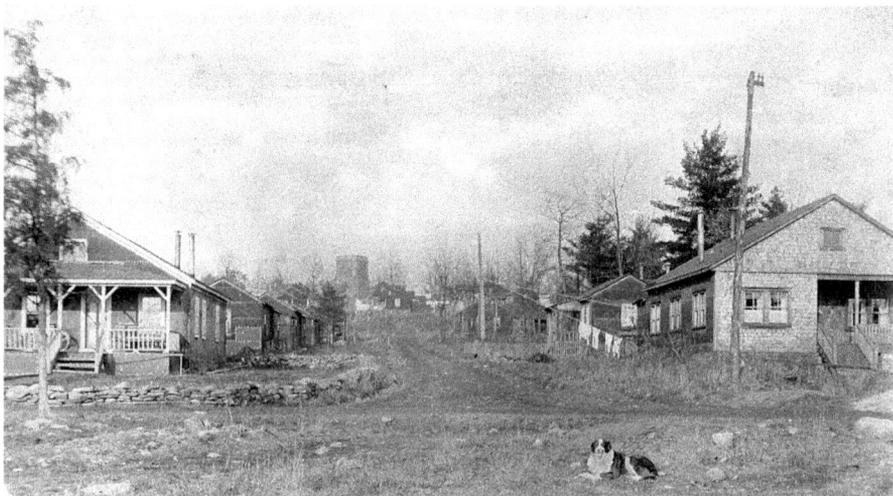

In the distance, the triangulation tower is visible. It was used to determine locations during the construction of the dam. *Courtesy of the Town of Olive Archives, Loni Gale photograph.*

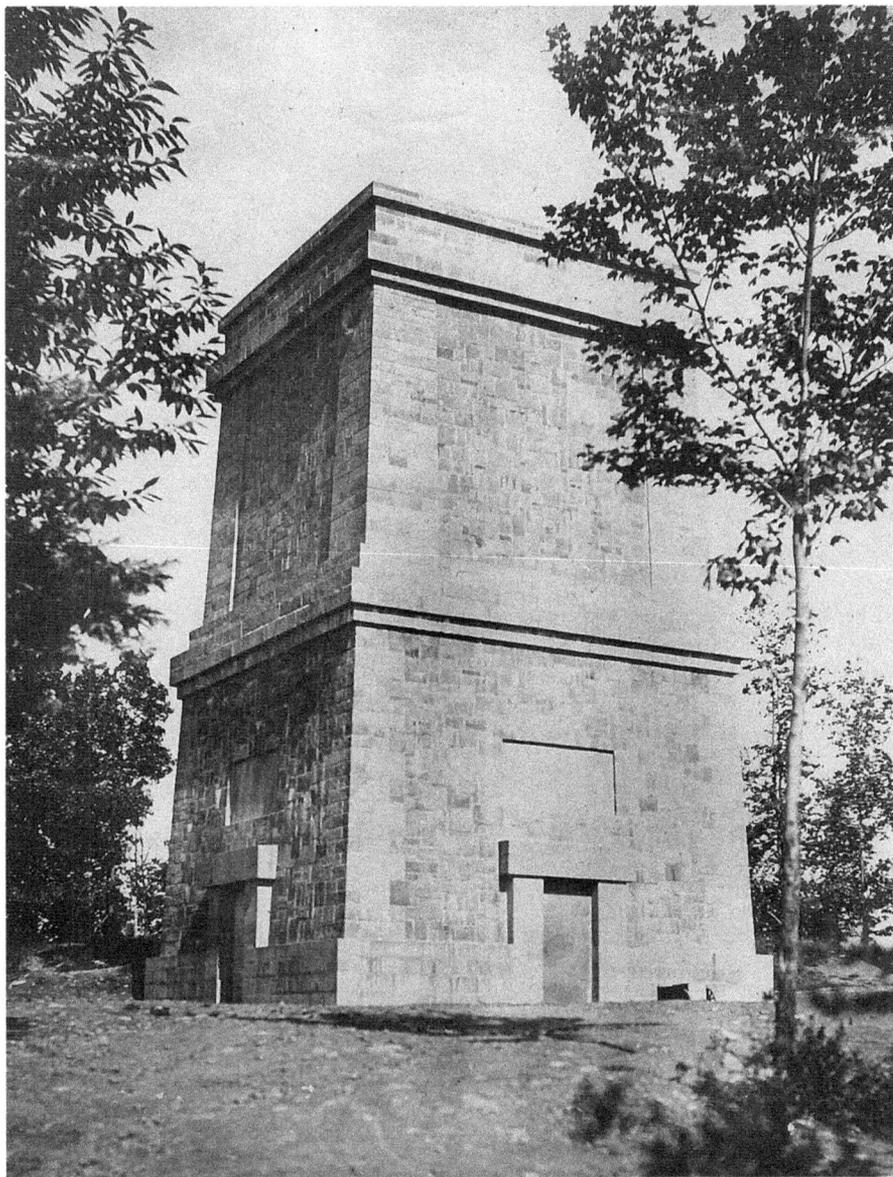

The triangulation tower was the first structure completed during the building of the Ashokan Dam. Engraved on the tower is the name George B. McClellan, who was the mayor of New York City when the reservoir project began. The name of J. Waldo Smith, engineer of the water supply, and a list of Board of Water Supply commissioners are also engraved on the tower. The tower remains as a commemorative monument to the project. *Courtesy of the Town of Olive Archives, John Watson's photograph album donated by Peggy Mahon.*

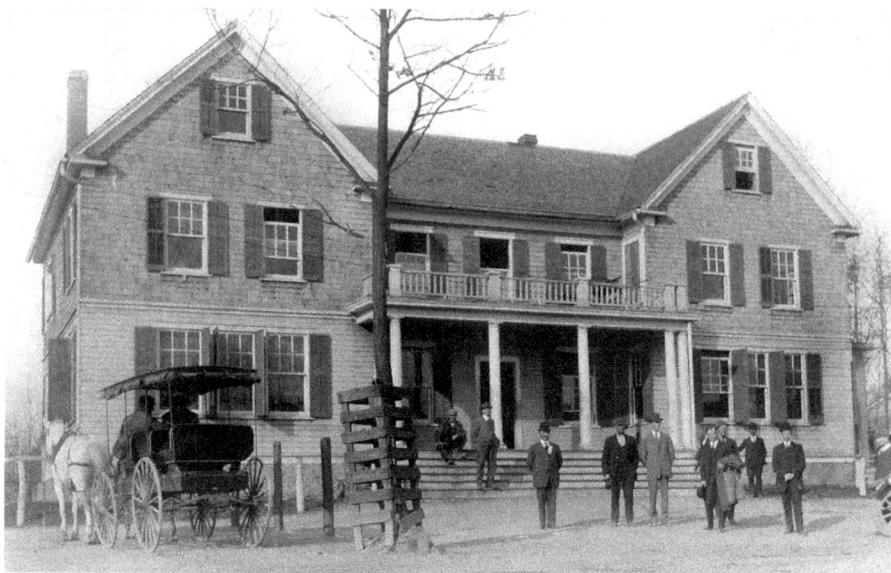

The single men's dormitory and the camp's main office are shown here. Workers earned from $1.20 to $3.00 a day depending on their skills. During construction, a man living in a single room paid $22.50 a month for room and board. If he shared a room, the cost was $20.00. *Courtesy of the Town of Olive Archives, Loni Gale photograph.*

The work camp included 152 cabins similar to the one in this photograph. They housed the workers and their families. Superintendent Joe Grady and his wife are pictured here. *Courtesy of the Town of Olive Archives, Robert Pleasants Collection.*

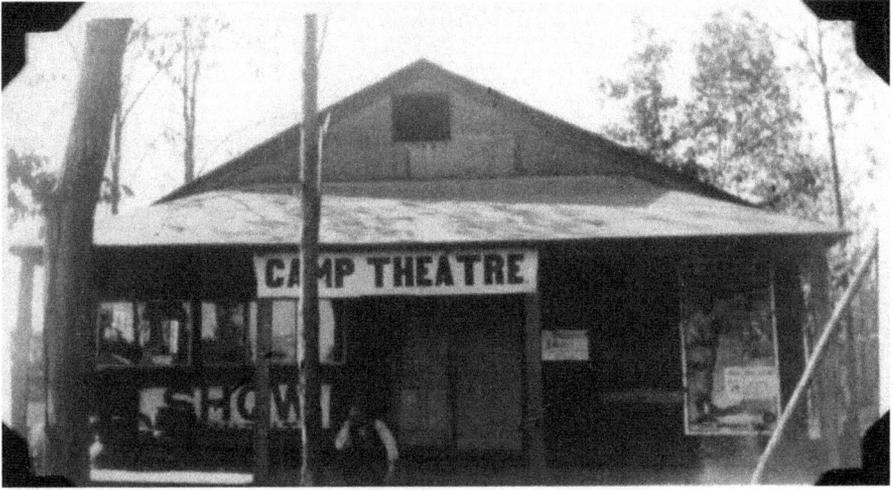

In addition to living quarters, the camp provided entertainment for the workers and their families at the camp theatre. *Courtesy of the Town of Olive Archives, Robert Pleasants Collection.*

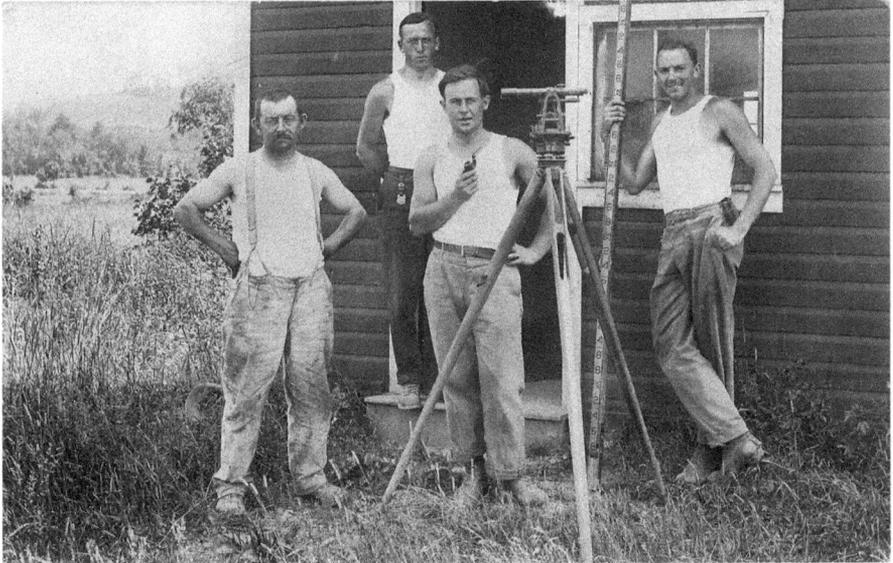

Surveyors for the reservoir are standing behind a transit, a tool for measuring angles. The man behind the transit is L.E. DuBois. *Courtesy of the Town of Olive Archives, Mark DuBois photograph.*

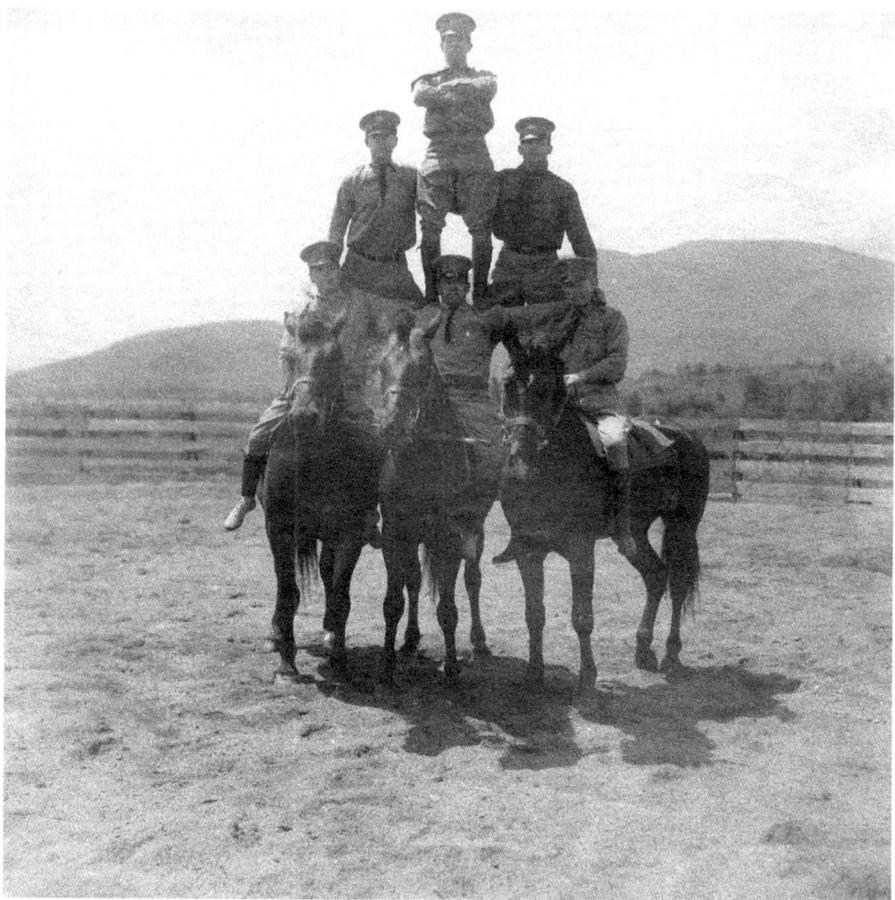

During early phases of construction, crimes committed at the dam construction sites rose dramatically. Assaults, burglaries, drunkenness and even murders were not uncommon. Local police from neighboring towns were overwhelmed. It was not until 1908 that the Board of Water Supply formed a trained and uniformed police force to cope with the problems. The force was organized into squads of thirteen men. In this photograph, dated 1910, a group of policemen show off their acrobatic abilities. A patrolman's salary was seventy-five dollars per month. *Courtesy of the Town of Olive Archives, Lois Langthorn Collection.*

A large group of surveyors pose near a transit. In 1909 alone, the Board of Water Supply employed up to 2,218 men for the project. *Courtesy of the Town of Olive Archives, Mark DuBois photograph.*

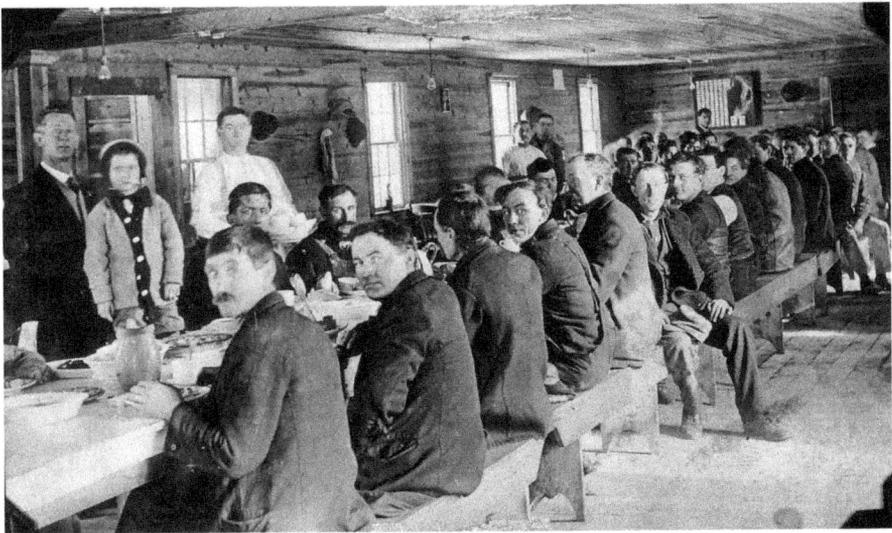

The workers are having a family-style meal at one of the camp's boardinghouses. Notice that the cabin has electric lights hanging from the ceiling. Local residents often came to see the camp because of its electricity, running water and paved streets. *Courtesy of the Town of Olive Archives, Robert Pleasants Collection.*

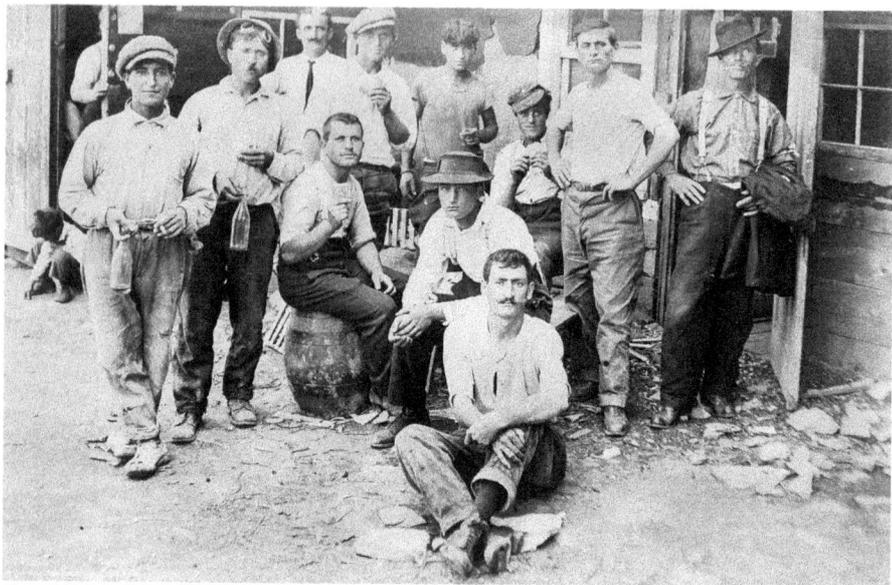

A group of workers enjoys a relaxing game of cards. *Courtesy of the Town of Olive Archives, Loni Gale photograph.*

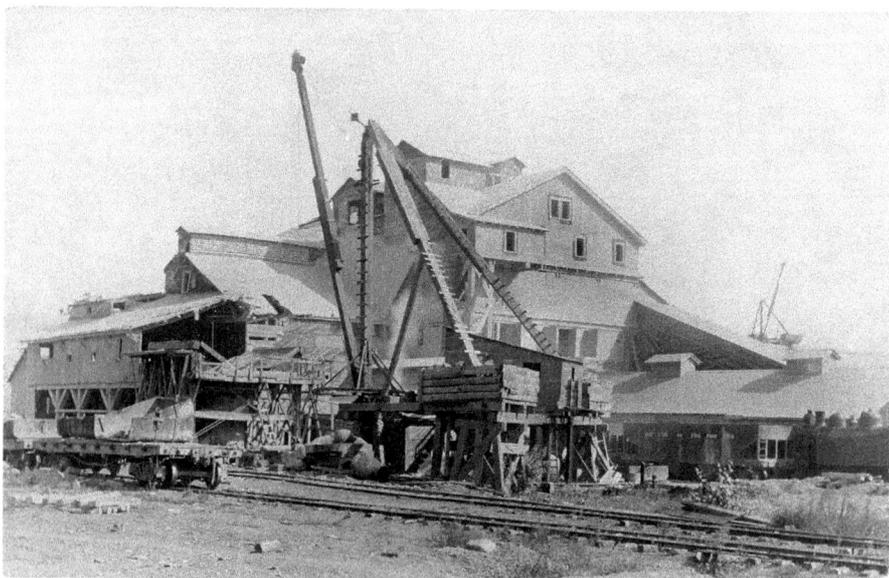

Winston and Company built a large crusher near the reservoir site. This enabled the company to have building materials nearby, saving time and money. *Courtesy of the Town of Olive Archives, Loni Gale photograph.*

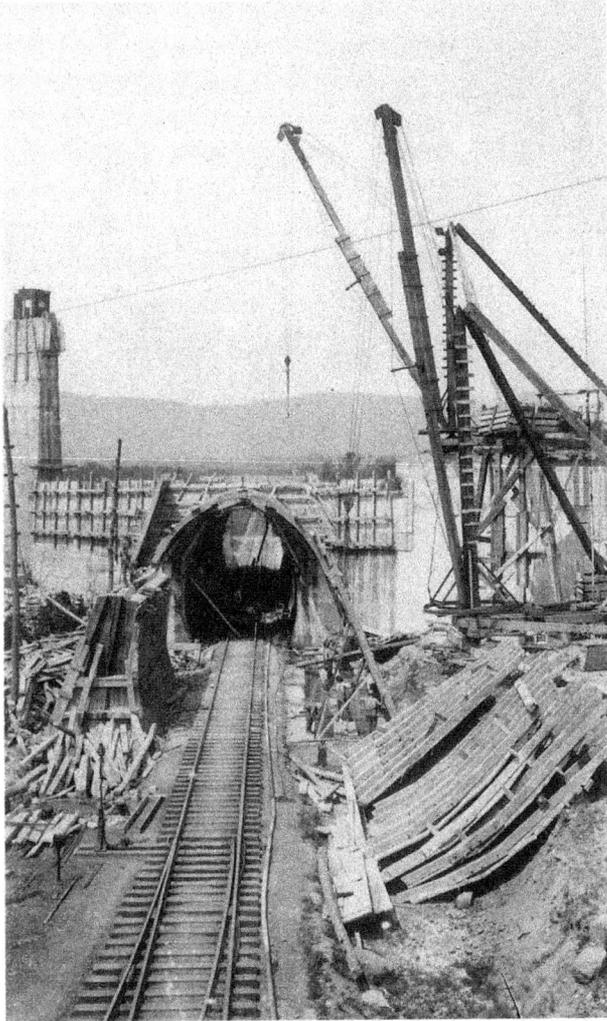

This tunnel built over the Ulster and Delaware Railroad tracks is part of the east dike of the reservoir. The tunnel allowed the railroad to continue running during construction. Eventually, this tunnel was filled with concrete and the railroad tracks were rerouted. *Courtesy of the Town of Olive Archives, Robert Pleasants Collection.*

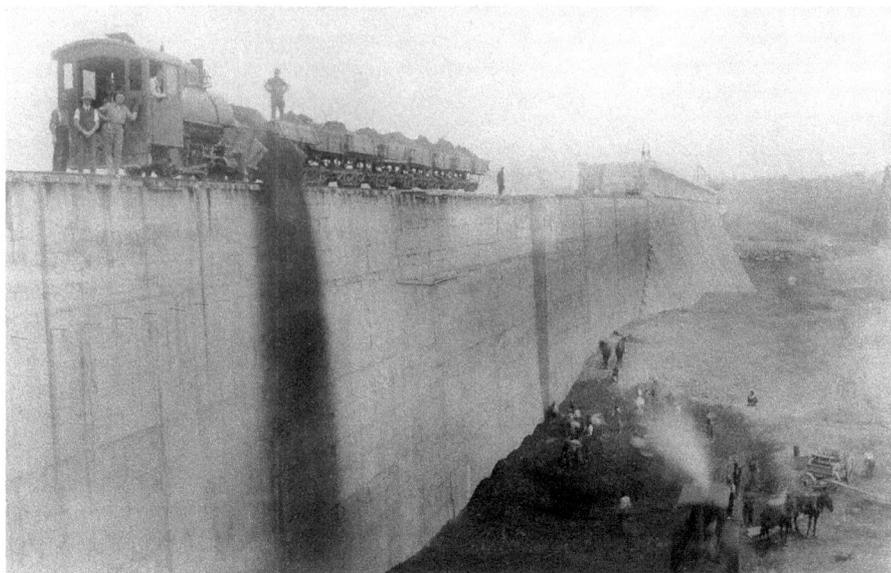

Workers used train cars to dump dirt needed to bury the reservoir's concrete walls. *Courtesy of the Town of Olive Archives, Loni Gale photograph.*

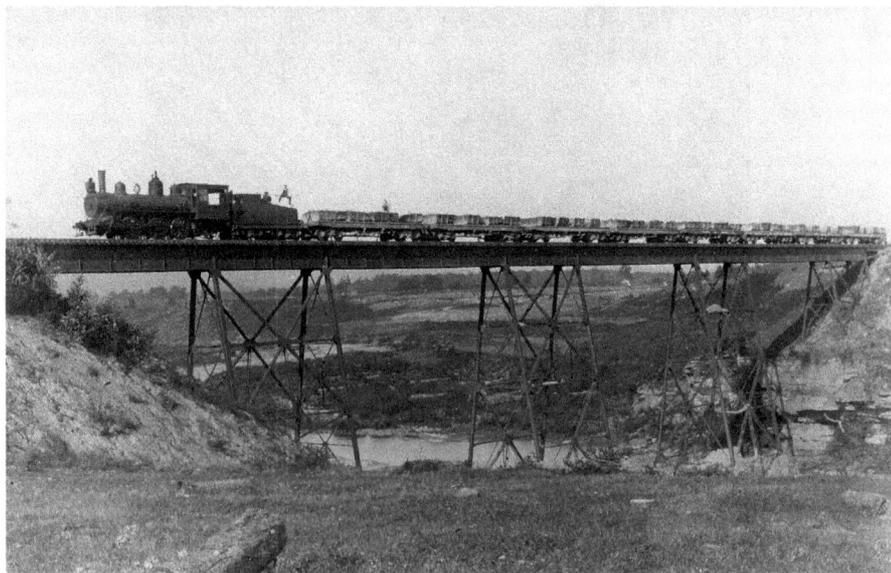

This railroad bridge is 93 feet high and 253 feet long. It was built over the Esopus Creek to allow for the transportation of goods and materials for the construction of the dam. On June 24, 1914, whistles sounded to announce the completion of the dam. *Courtesy of the Town of Olive Archives, Loni Gale photograph.*

Ashokan Reservoir Towns

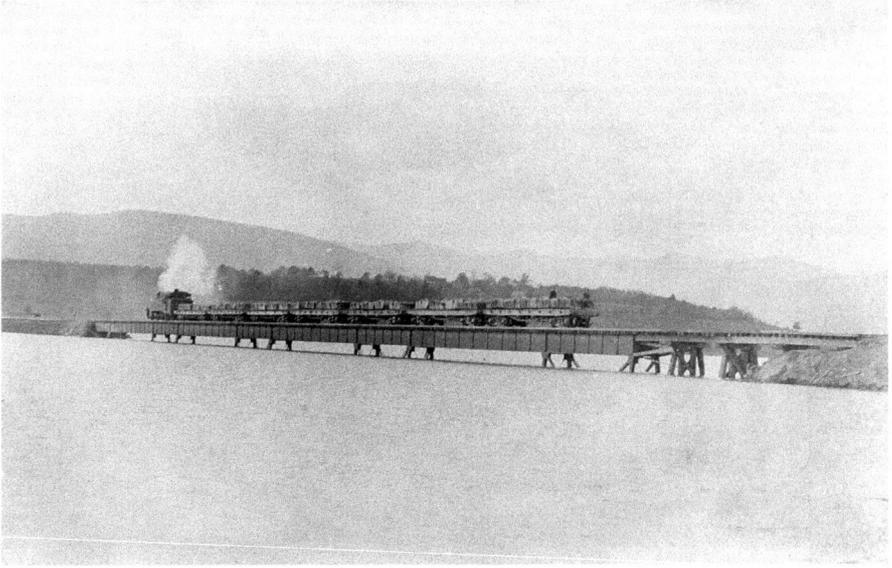

Water rises in the Ashokan Reservoir at the railroad bridge. The reservoir covers ten thousand acres. It is twelve miles long, up to three miles wide and has a maximum depth of 119 feet. *Courtesy of the Town of Olive Archives. Loni Gale photograph.*

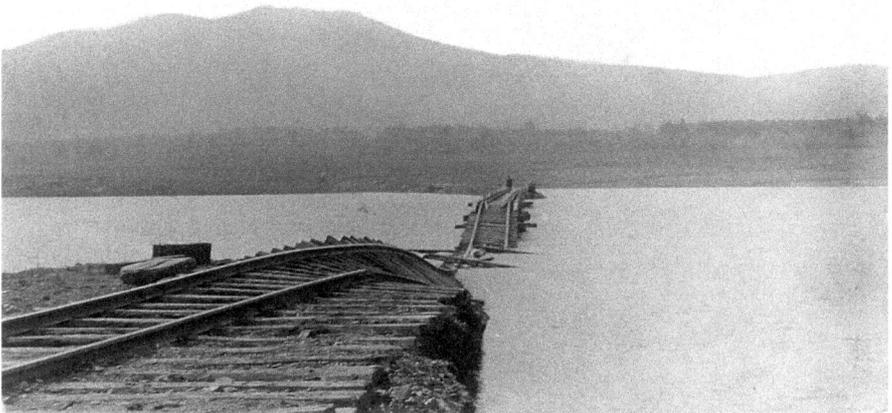

In this photograph, the reservoir rises to cover the tracks. Today these tracks are totally submerged beneath the deepest part of the reservoir. *Courtesy of the Town of Olive Archives, Loni Gale photograph.*

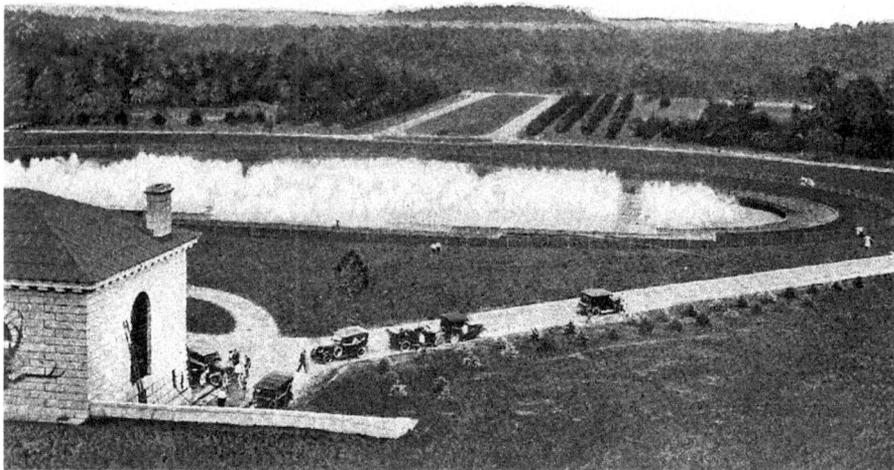

After the completion of the reservoir, Brown's Station was demolished, and in its place huge aerators were installed to oxygenate the water. This was supposed to ensure purification of the water. During hot summer days, local people would picnic near the aerators to enjoy the cooling mists. *Courtesy of Eleanor Arold.*

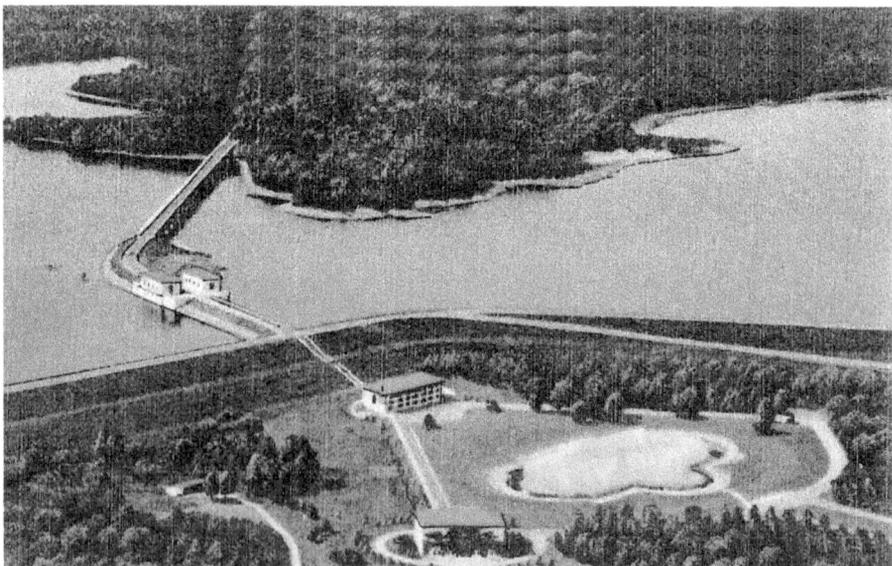

The completed reservoir, main dam and aerators are shown in this aerial postcard. Sadly, the lost Ashokan towns are now marked only by roadside signs. *Courtesy of Eleanor Arold.*

CHAPTER 2

ROSETON

Brick by Brick

I n the mid-nineteenth century, New York City entered an extended population boom. Concomitant construction of new buildings to meet housing and business needs led to a huge demand for raw materials. Quarries set up shop along the lower Palisades cliffs. Farther upriver, the banks' rich clay deposits enticed entrepreneurs to mass produce what would become a building staple. The Hudson Valley brick industry region quickly evolved into one of the world's largest.

In 1883, John C. Rose, wishing to expand his modest brick-making business in Haverstraw, New York, purchased property some twenty miles farther north along the Hudson's west bank, just north of Newburgh. In 1897, John Bailey Rose, at the age of twenty-two, succeeded his father as the company's president. Using innovative production and management techniques, the young Yale graduate soon propelled the Rose Brick Company into international prominence.

At its peak, the company employed close to one thousand people. A village was built around the brickyard. The hamlet of Roseton was formed. Among the structures built were houses for the culturally diverse workforce and its families, churches, stores, a school, a post office and an entertainment facility.

Another family played an instrumental part in Roseton's history. About 1875, Cuban-born Juan Jacinto Jova bought property, including the stately Armstrong mansion, near Danskammer Point, just a short walk upriver from the soon-to-be Rose complex. He intended for it to be used solely as a family retreat, but he eventually realized the value of the rich clay deposits on his property. Though he resisted the urge for years, he began extracting the clay in 1885. The Jova brickyards were underway. After his sudden death in 1893, Jova's four sons, known locally as the "Jova boys," continued the

successful business. Their brickyard added much to the beehive of activity at Roseton.

Today, a road marker with the name "Roseton" stands on the northbound side of Route 9W, just a few miles north of Newburgh. From there, it is a short drive down to the Hudson River. Along the way, the landscape is dominated by the sprawling Roseton and Danskammer generating stations and a Hess Oil Corporation terminal. Sadly, little remains of the Roseton that once provided generations with their livelihoods and a community way of life.

This passport was issued to John (Juan) Jova about the time that he first purchased property along the Hudson River. Note the written physical description of Jova, as passport photographs were not yet being used. At this point in time, it is very doubtful that he had any intention of entering into the brickmaking business.

Roseton

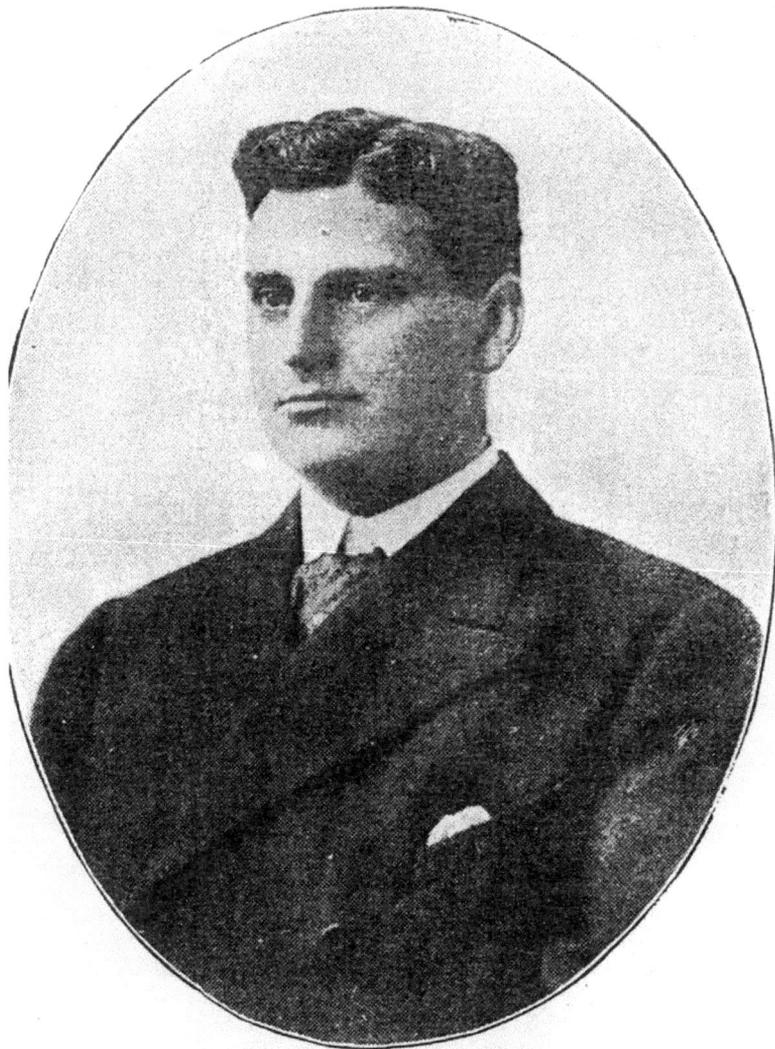

John Bailey Rose, pictured here, assumed the dominant role in the Rose family's brick-making business in 1897 upon the death of his father, John C. Rose, the company's founder. Under his leadership, the Rose Brick Company became the largest in the Hudson River Valley region and one of the largest in the world. The company's success around the turn of the twentieth century led to the creation of Roseton, an entire community built around the business and named after the Rose family. John B. Rose was born in 1875 in Haverstraw, site of the family's first brick-making venture. At the age of twelve, he began learning the brick business and became determined to make it his life's work. About the time of his graduation from Yale, Rose was prepared to assume leadership in the company business at Roseton. Among his many accomplishments, Rose served as a member of the Electoral College in 1904 and served two terms in the New York State Senate. He died on March 4, 1949, not long after the company manufactured its last brick at Roseton.

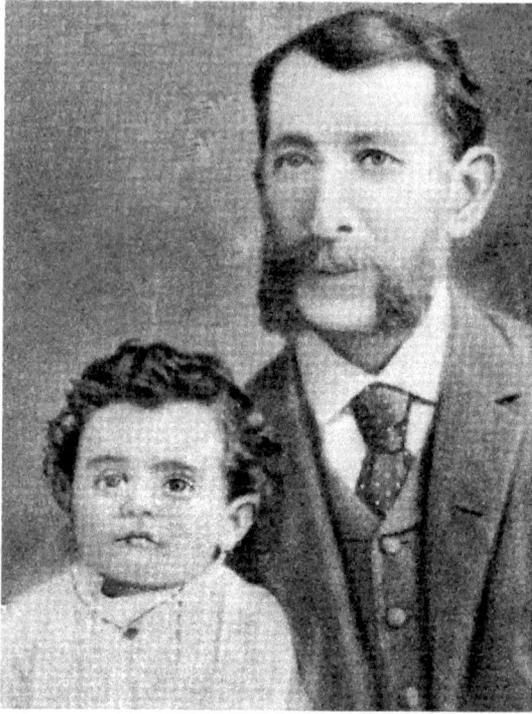

Juan (John) Jacinto Jova, pictured here with his son
Joseph, was born in Cuba in 1832. Though raised
in Cuba, he was educated in American schools. His
home country's sugar industry led Jova to New York
City, where he became a successful broker in that
commodity at Perry, Jova and Company. After his
purchase of a large parcel of the Armstrong estate
about 1875, almost ten years passed before he decided
to capitalize on its rich clay deposits. Coupled with his
property's proximity to the river and the West Shore
Railroad, Jova Brick Works, as it was later named, was
an immediate success. When Jova died suddenly in
1893, two of his sons, Edward and Henry, assumed
control. Eventually they would be joined by their
younger brothers, John and Joseph. The Jova complex
employed several hundred workers. The workforce
was composed largely of Hungarian immigrants who,
for the most part, lived and worked on the company's
property. The Jova family closed down operations at
Roseton in the spring of 1968 after a run of almost
eighty years. *Courtesy of the Historical Society of Newburgh
Bay and the Highlands.*

Roseton

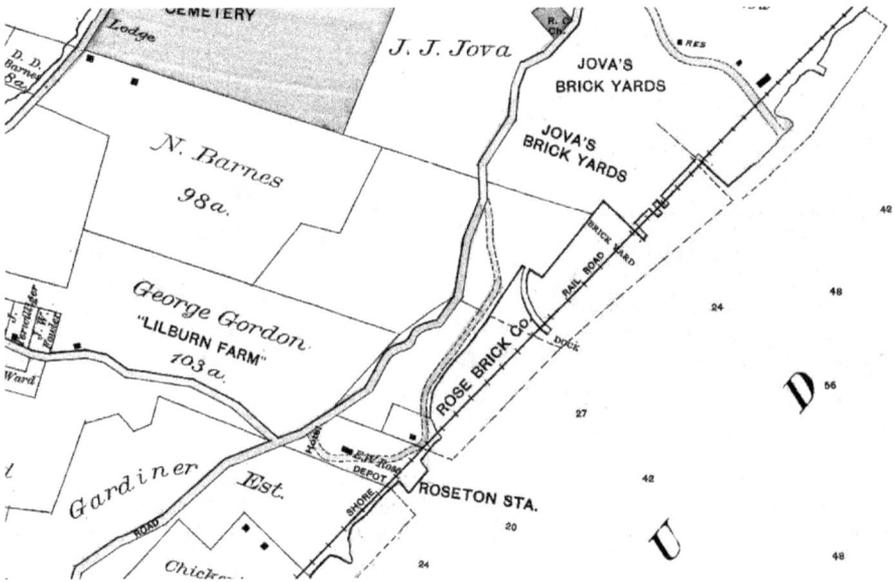

This map shows the location of the Rose and Jova brickyards, a few miles north of the city of Newburgh at Roseton, in 1891. Our Lady of Mercy Roman Catholic Church, sponsored by the Jovas in the same year, is indicated near the top of the map. Just east of the church stood Danskammer, the Jova mansion. The Hudson River can be seen along the right. *Courtesy of brickcollecting.com.*

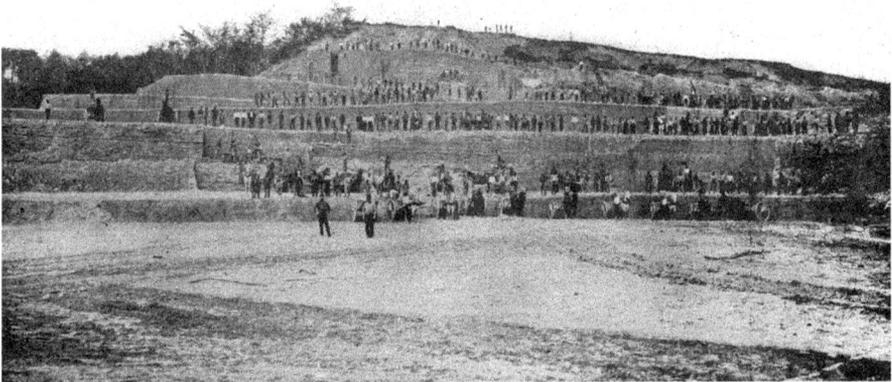

Workers pose on the rich blue clay banks at the Rose brickyard. The banks often reached two hundred feet in depth. Some of the sand and coarse chunks left after the sifting process were incorporated into paved walkways in Central Park in Manhattan and Prospect Park in Brooklyn. Some of the excess clay found its way into the pitching mounds and home plate areas of Yankee Stadium, Ebbets Field and the Polo Grounds. *Photograph by William Thompson.*

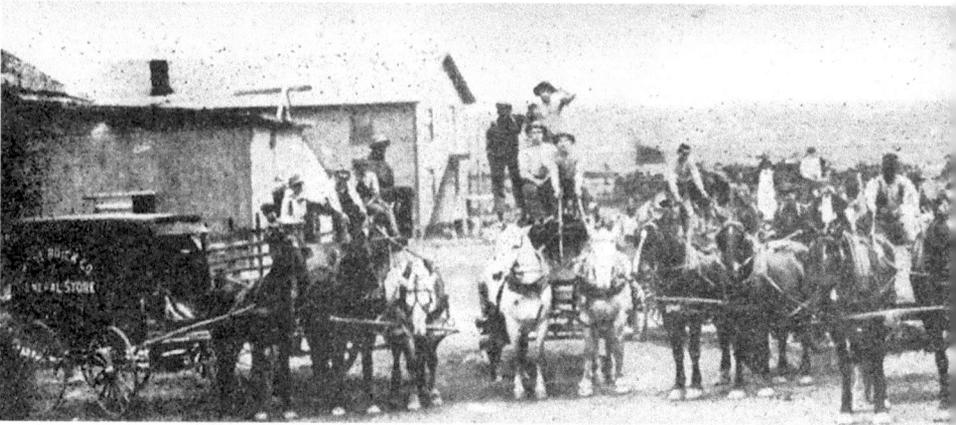

Workers from the Rose Brick Company start off on their long workday. A team of 150 horses moved material to and from the brick machines. About 1908, John B. Rose developed a three-mile railroad with fifty cars. Fully loaded, the system could carry 750 tons of material. He also added three electric steam shovels. These innovations replaced the horses and about one hundred workers. *Photograph by William Thompson.*

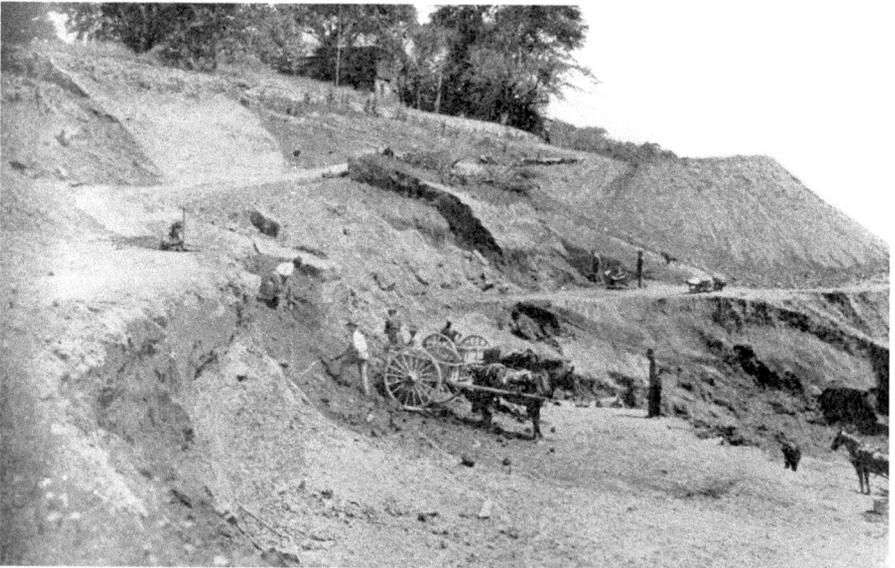

In this picture, human and animal muscle combine to open a clay bank near Danskammer Point in Roseton. It is unknown if this particular bank was owned by Jova Brick Works or the smaller Arrow Brick Works, which also plied its trade in Roseton. By 1910, the Rose Brick Company had expanded to twenty-six brick-making machines, by far the largest number in the entire Hudson Valley region. Jova Brick Works utilized fourteen machines, and Arrow Brick Works operated with six. *Photograph by William Thompson.*

Roseton

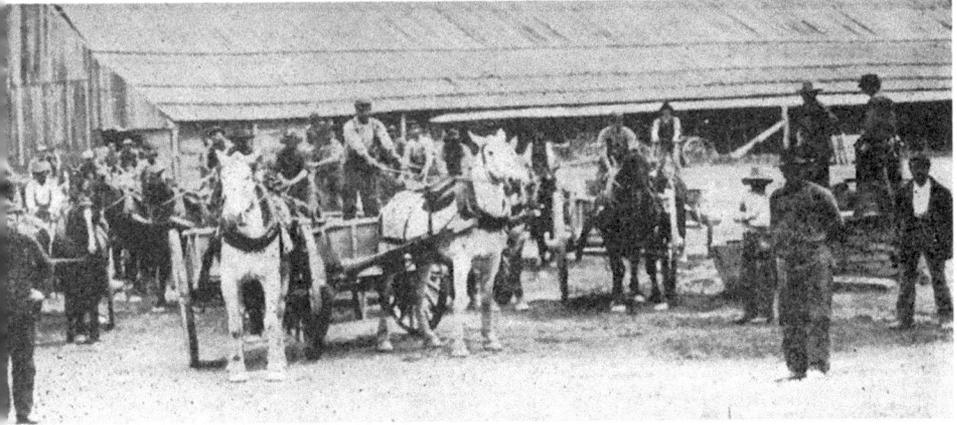

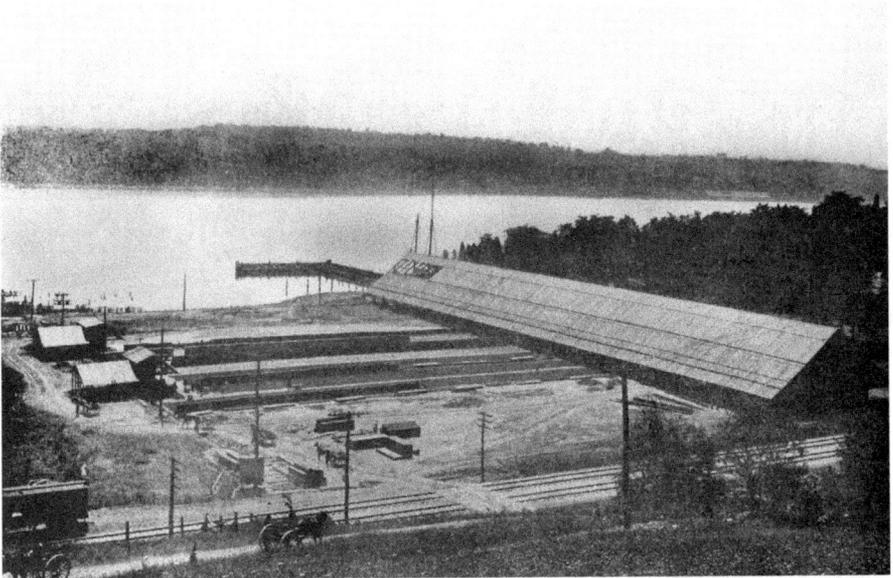

This circa 1905 photograph shows the construction of the yard and dock nearing completion at Arrow Brick Works. The company was operated by David Maitland Armstrong. The discovery of Native American artifacts at the excavation site near Danskammer Point let to the company's name. The West Shore Railroad tracks can be seen in the foreground. *Photograph by William Thompson.*

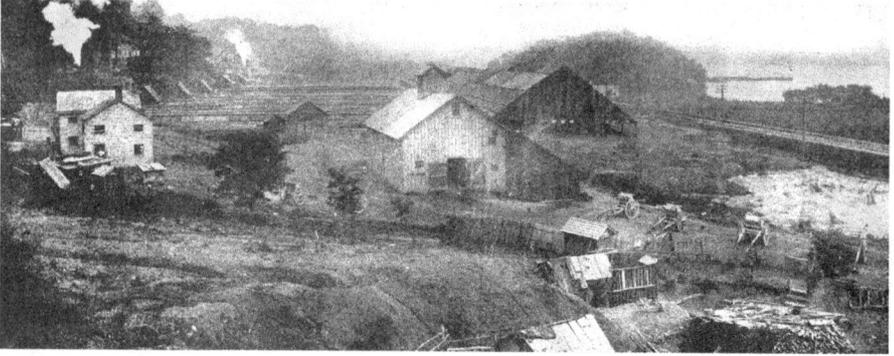

Part of the north yard at Jova Brick Works is shown here. The "Jova boys" modernized their equipment continuously to stay ahead of their competition. The Great Depression brought about many plant closures along the Hudson Valley, but in response to the times, the Jovas installed two huge oil-fired tunnel kilns capable of producing 50 million bricks a year. Fuel rationing during World War II caused further harm to the Hudson Valley manufacturers, but the Jovas received special dispensation from the War Production Board to operate at half capacity to provide brick for the war effort. In the 1950s, the Jova yard was among the first to install jet dryers and to manufacture bricks in custom hues. *Photograph by William Thompson.*

Pictured is an advertisement for the Rose Brick Company. Note the reference to the New York City address at West Fifty-second Street. Rose maintained offices there when the John B. Rose Commission House was established in 1902. It became the largest brick brokerage house in the world. To help resolve industry issues related to production and pricing, the brokerage consolidated over fifty brick-manufacturing firms. Their combined output brought over a half billion bricks, utilizing 130 barges, to the New York City market annually. *Courtesy of brickcollecting.com.*

Roseton

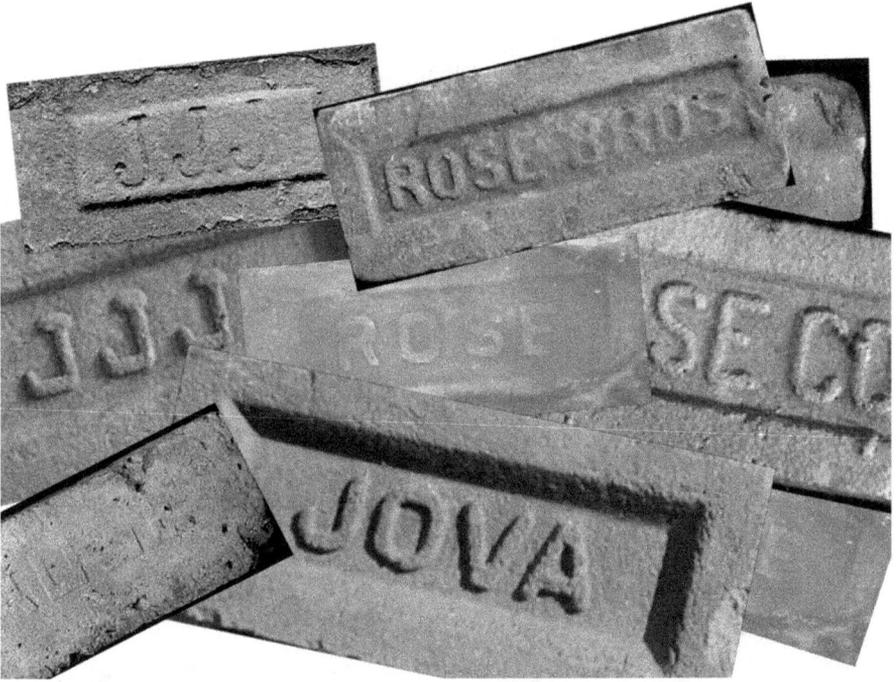

The bricks manufactured in Roseton were incorporated into hundreds of building projects during New York City's enormous population growth between 1880 and 1920. Rose and Jova bricks helped to shape the early skyline of Manhattan. Rose bricks were utilized in the construction of the customhouse at the Battery, the New York Stock Exchange, the Empire State Building and the Waldorf Astoria, among many others. The Singer Tower, a forty-one-story architectural marvel built with Rose bricks in Manhattan, laid claim to being the tallest building in the world between 1908 and 1909. Upon its completion in 1908, John B. Rose presented the "last" brick, made of solid silver, to its owners. Jova bricks found their way into the main branch of the New York Public Library on Forty-second Street, as well as the customhouse. The "JJJ" initials were recognized far and wide. Not limited to New York City, Roseton-fired bricks could also be found in many local projects, including Balmville's Powelton Club and several structures in Newburgh's Historic District that were designed by renowned Hudson River School architects, including Frederick Clarke Withers and Calvert Vaux. *Photograph by Wesley Gottlock.*

Heifer Tom	Lodger	W	M	27	Germany	10	al	Gardner	W
Rose John B	Head	W	M	40	U S		Cit	Manufacturer Brick	Emp
" Maude B	Wife	W	F	39	"		Cit		x
" " John B	Son	W	M	18	"		Cit	Student - College	x
Trevillion Geo H	Boarder	W	M	48	"		Cit	Time Keeper Brick yd	W
Mooney Anna	Maid	W	F	24	"		Cit	Maid House	W
Conway Edward	Butler	B	M	25	"		Cit	Butler	W
" Lillian	Cook	B	F	28	"		Cit	Cook	W
Martin Chas E	Chauffeur	W	M	34	"		Cit	Chauffeur	W
Jova Marie	Head	W	F	67	France	64	Cit	No Occupation	x
" Hortense	Daughter	W	F	37	U S		Cit	" "	x
" John J	Son	W	M	33	"		Cit	Contractor	Emp
" Joseph	"	W	M	29	"		Cit	Superintendent Brick	W
" Angela	Daughter	W	F	26	"		Cit	No Occupation	x
Maguar Elizabeth	Cook	W	F	18	Hungary	1	al	Cook	W
Bennett James	Head	W	M	27	U S		Cit	Chauffeur	W
" Julia J	Wife	W	F	31	"		Cit	Housework	x
Hotaling Edward	Head	W	M	33	"		Cit	Engineer Brick yard	W
" Violet	Wife	W	F	29	"		Cit	Housework	x
" Katherine	Daughter	W	F	6	"		Cit		x
" Louise	Daughter	W	F	4	"		Cit		x
Hotaling Alonga	Head	W	M	62	"		Cit	Superintendent Brick yard	x
" Georgia	Wife	W	F	51	"		Cit	Housework	x
Welsh William J	Head	W	M	24	"		Cit	Bookkeeper Contractor	W
" Margaret	Wife	W	F	22	"		Cit	Housework	x
Young William	Head	W	M	18	"		Cit		
" Vera									

There were about 1,350 Roseton residents in 1915 according to the New York State Census. The overwhelming majority were brickyard workers. This partial page from that census lists both the Rose and Jova families, along with their respective household helpers. *New York State Census, 1915.*

Shaffer Mary Ann	Head	W	F	76	Germany		43	Cit	Housework	x
Shaffer Edward	Son	W	M	38	U S			Cit	Ass't Foreman Brick yd	n
Namick Stephen	Head	W	M	36	Hungary		14	al	Salmer Brick yard	n
Namick Mary	Wfe	W	F	26	Hungary		17	al	Housework	x
Namick Lizzie	Daughter	W	F	8	U S			Cit	School	x
Namick Mary	Daughter	W	F	6	U S			Cit	School	x
Namick Theresa	Daughter	W	F	5	U S			Cit		x
Namick Annie	Daughter	W	F	3	U S			Cit		x
Namick John	Son	W	M	7/12	U S			Cit		v
Szamang John	Head	W	M	53	Hungary		20	al	Salmer Brick yard	n
Szamang Mary	Wfe	W	F	51	Hungary		17	al	Housework	x
Szamang James	Son	W	M	15	U S			Cit	School	x
Agurkis Anthony	Head	W	M	50	Russian Poland		28	al	Salmer Brick yard	n
Agurkis Eva	Wfe	W	F	49	Russian Poland		28	al	midwife	n
Agurkis Nichols	Son	W	M	23	U S			Cit	Steam Shovel Operator	n
Agurkis Mary	Daughter	W	F	17	U S			Cit	Housework	x
Agurkis Joseph	Son	W	M	10	U S			Cit	School	x
Shea Elizabeth	Head	W	F	41	Canada		23	Cit	Housework	x
Shea Edith	Daughter	W	F	20	U S			Cit	Cashier Grocery Store	n
Shea William	Son	W	M	18	U S			Cit	Salesman Grocery Store	n
Shea Donald	Son	W	M	14	U S			Cit	School	x
Shea Leona	Daughter	W	F	10	U S			Cit	School	x
Shea Rose	Daughter	W	F	4	U S			Cit		x
Manning Charles	Head	W	M	40	U S			Cit	Electrician	n
Manning Sadie	Wfe	W	F	40	U S			Cit	Housework	x
West Thomas	Unlimited	W	M	49	Ireland		Un	Cit	Salmer Brick yard	n
Han John	Lodger	W	M	42	Austria		8	al	Salmer Brick yard	n
Cassell John	Head	W	M	32	Hungary		8	al	Salmer Brick Yard	n
Cassell Barbara	Wfe	W	F	30	Hungary		8	al	Housework	x
Cassell Helen	Daughter	W	F	3	U S			Cit		x

This partial census page illustrates, in part, the cultural diversity of the hamlet around that time. In addition to numerous first-generation European families, many African Americans from Virginia and other southern states were employed by the brick companies. They were housed in separate quarters. *New York State Census, 1915.*

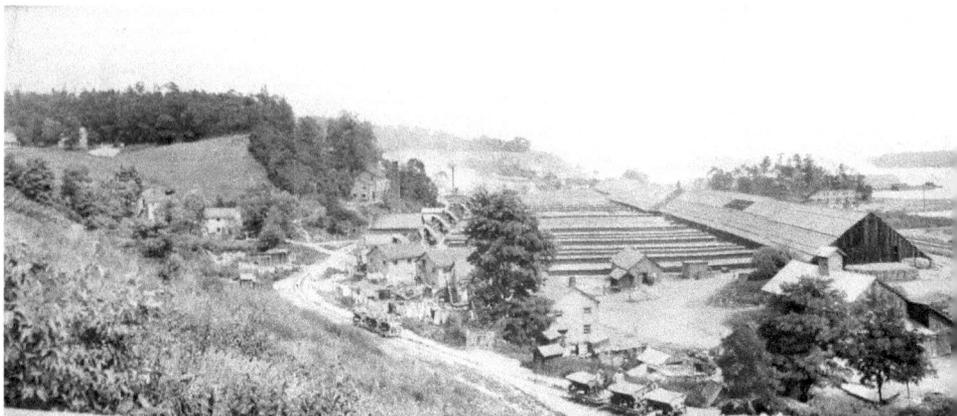

This overview shows part of the Roseton complex near its peak production period. Some of the company-built housing may be seen along the outskirts of the production area. Note the wash being hung to dry and the outdoor lavatories. The light rail had already been installed, but the use of horses and carts was still evident. The Jova yard used coal to fire its bricks. The Rose Company, on the other hand, preferred wood-burning kilns. The bulk of Rose's wood supply was sent upriver from the property of industrialist Edward H. Harriman. *Courtesy of the Cutrone family.*

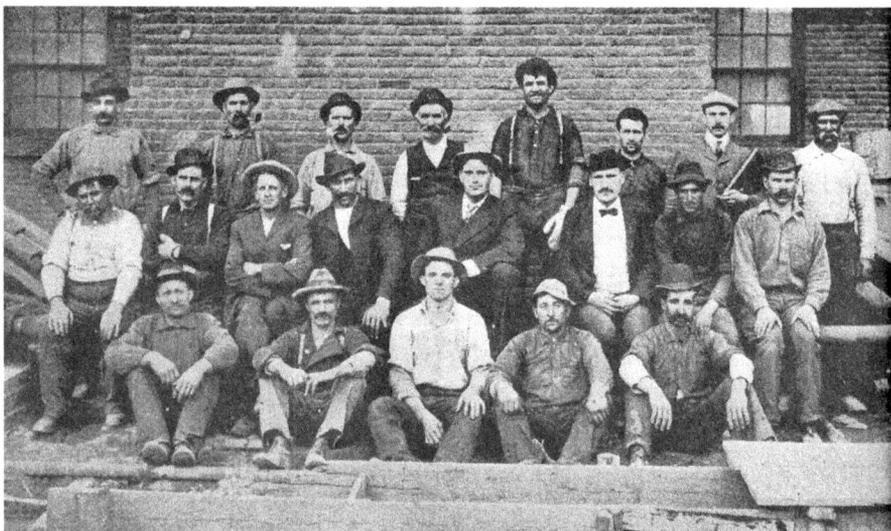

Pictured here is the executive staff of the Rose Brick Company. John B. Rose, the company's president and general manager, is seated in the middle row, fourth from the right. The brickyard's superintendent, Joseph Mocko, is seated at the far left of the bottom row. *Photograph by William Thompson.*

Roseton

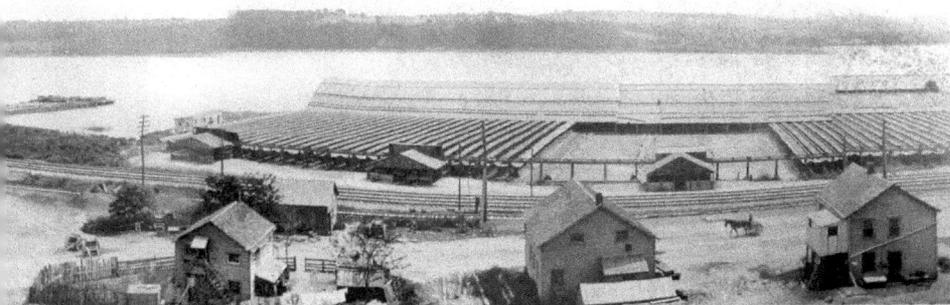

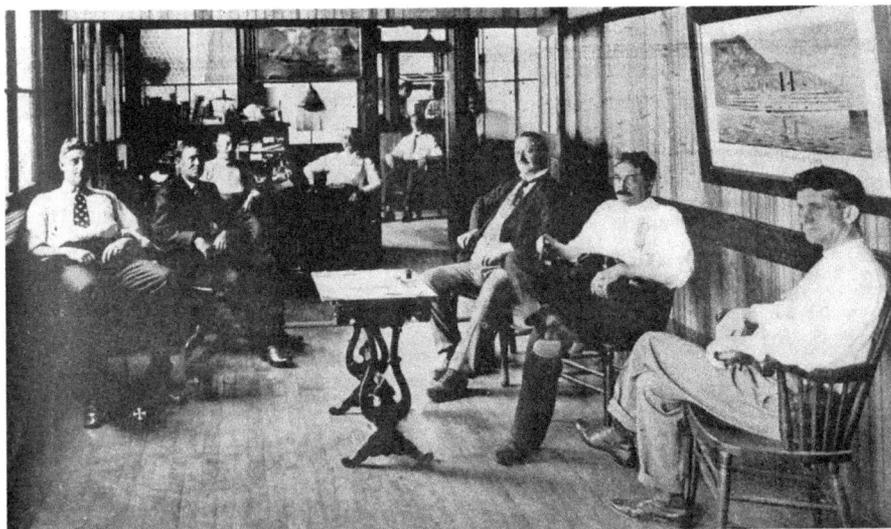

Officers of the brick brokerage firm meet at Rose's office. John B. Rose is seated at the far left. *Photograph by William Thompson.*

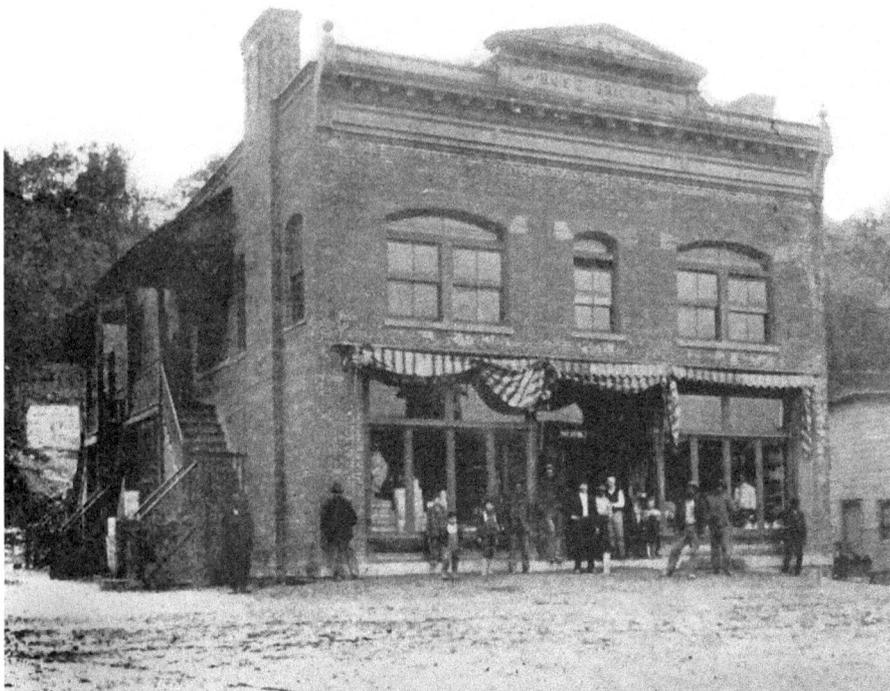

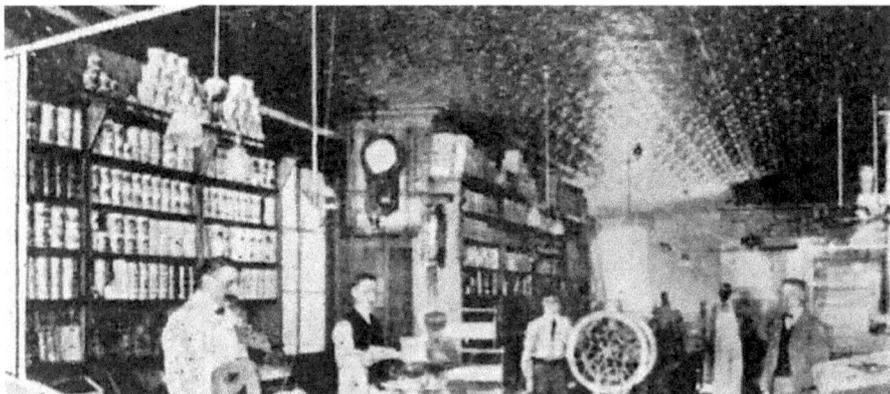

Both the Rose and Jova brickyards had general stores. The Rose Brick Company store, pictured, met the workers' needs for food items, tobacco products, soda water and various sundries. Completed in 1903, it also included a post office. An adjacent icehouse was an added convenience. John B. Rose let it be known that his prices were generally lower than establishments in nearby downtown Newburgh. The Jova family was quite fond of imported Maillard chocolates and kept their store stocked with the specialty item. Both stores extended credit to their workers. Purchases would be deducted from earnings. Because of the industry's seasonal nature, many workers were granted credit over the winter months. Some traveled downriver to Rockland Lake, where they obtained off-season employment in the ice industry. *Photographs by William Thompson.*

Roseton

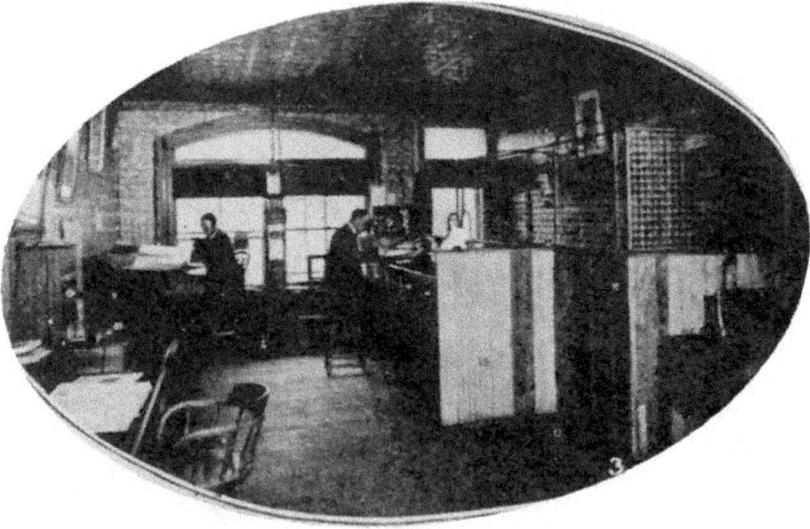

The Rose Company's general office was located on the store's second floor. The bookkeepers, timekeeper and paymaster worked there. John B. Rose's private office was located there as well. *Photograph by William Thompson.*

Roseton's school was built in 1905. It served several generations of students, most of whom were children of the brickyards' workers. The two-story structure of about two thousand square feet contained four classrooms. After graduating, most students moved to schools located in the city of Newburgh. After the school closed its doors to students in the mid-1960s, the school was used for storage by the Marlboro School District. Later, Central Hudson Gas and Electric bought the school and its property and planned to convert the building to a warehouse. That decision was reversed, and the building was razed in the 1970s. *Photograph by William Thompson.*

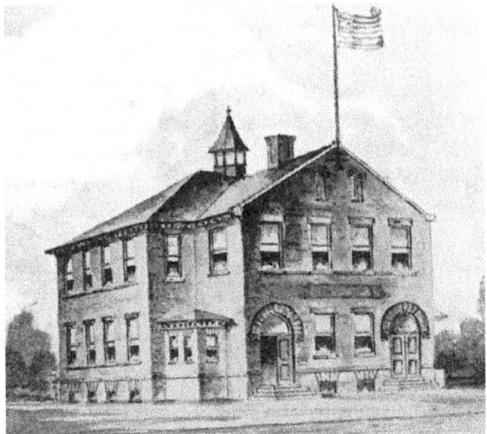

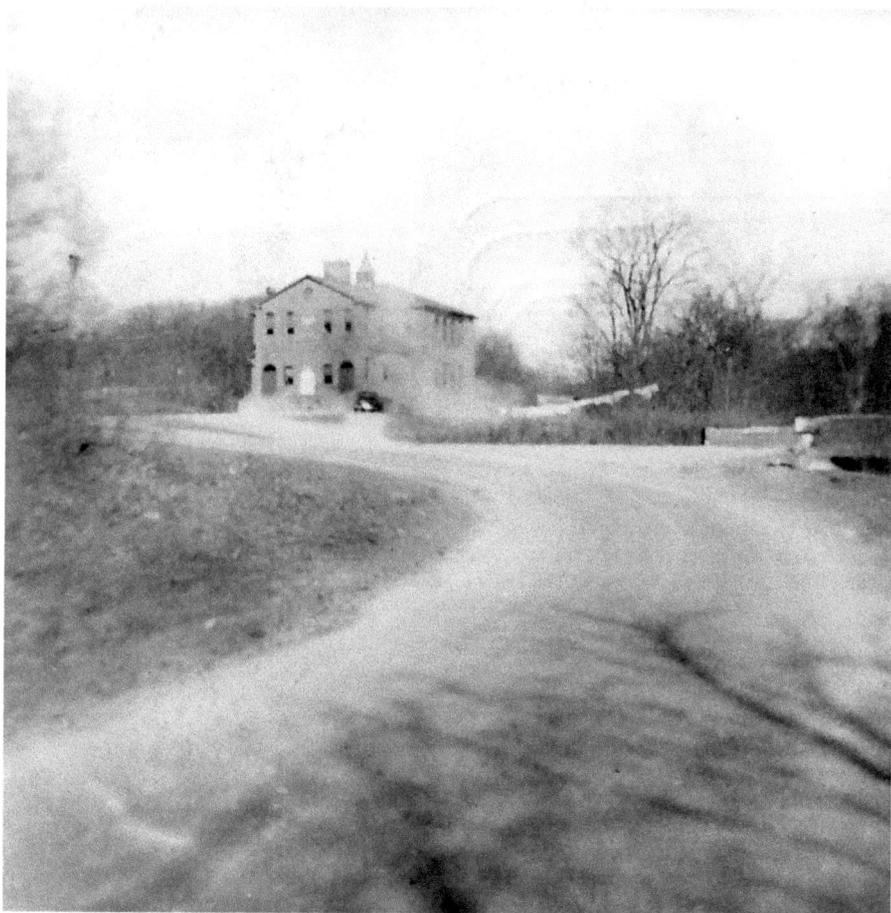

Local residents conjured up names for certain features of the hamlet. The road leading to Roseton's school was dubbed "Soap Hill." It was so named due to its slippery nature in times of ice and snow. The bridge to the right led to a thickly wooded section referred to as "the Jungle." This photograph was taken circa 1947. *Courtesy of William Lamey.*

Roseton

Attendance record in school district no. _5_ town of _Newburgh_ county of _Orange_

Follow exactly "Directions For Keeping This Register" on inside front cover.

PUPIL'S NO.	GRADE	Names of pupils Boys / Name of teacher	Age	Date of birth Month	Day	Year	Mon	Tue	Wed	Thu	Fri	TOTAL	Mon	Tue	Wed	Thu	Fri	TOTAL	Mon	Tue	Wed	Thu	Fri	TOTAL	Mon	Tue	Wed	Thu	Fri	TOTAL	Mon	Tue	Wed	Thu	
		Ryan, Margaret (teacher)									4							5						5											
1	1A	Gekakis, Gus	7	7	10	25	E				4							5						5						5				4	
2	1B	Horaz, Ernest	7	6	4	25	E				4		6				5						5						5						
3	1B	Horaz, James	5	16	30	26	E				4		6				5						5						5						
✓4	1B	Horaz, John	10	8	4	22	E	6			4						5		6				5												
5	1B	Lamey, William	5	5	5	27	E				4							5						5						5					
6	1A	Leechow, Lawrence	8	10	1	24	E				4							5						5						5					
7	1B	Meehan, Joseph	5	3	23	27	E				4							5						5						5					
8	1B	Meehan, Warren	6	12	28	25	E				4							5						5		6			4						
9	1A	Sabo, John	6	4	30	26	E				4						5	Left						2nd					an						
10	1A	Shaugnessy, Francis	8	8	20	24						E						5						5						5					
11	1B	Smith, Alfred	7	10	24	25	E				4						5						5						5						
✓12	1A	Smith, Clifford	10	12	24	22	E				4						5						5						5						
13	1A	Smith, Ernest	9	1	14	24	E				4						5						5						5						
14	1A	Szelie, Arthur	5	4	1	26	E				4						5						5						5						
15	1A	Tomlins, Eugene	8	2	28	24	E				4						5						5						5						
16	1A	Toch, Joseph	8	8	5	24	E				4						5						5						5						
17	1A	Nassii, John	7	4	6	25	E				4						5						5						5						
																		0						0						0		30	8		
																														1					
		TOTALS										64							85						80						79				

149 229 308

Margaret Ryan taught grades 1A and 1B at the Roseton school. This is the attendance roster for one of these classes for the 1932–33 school year. She earned $110 per month for her services. The school was part of the Town of Newburgh's school system. *Courtesy of the Marlboro Free Library.*

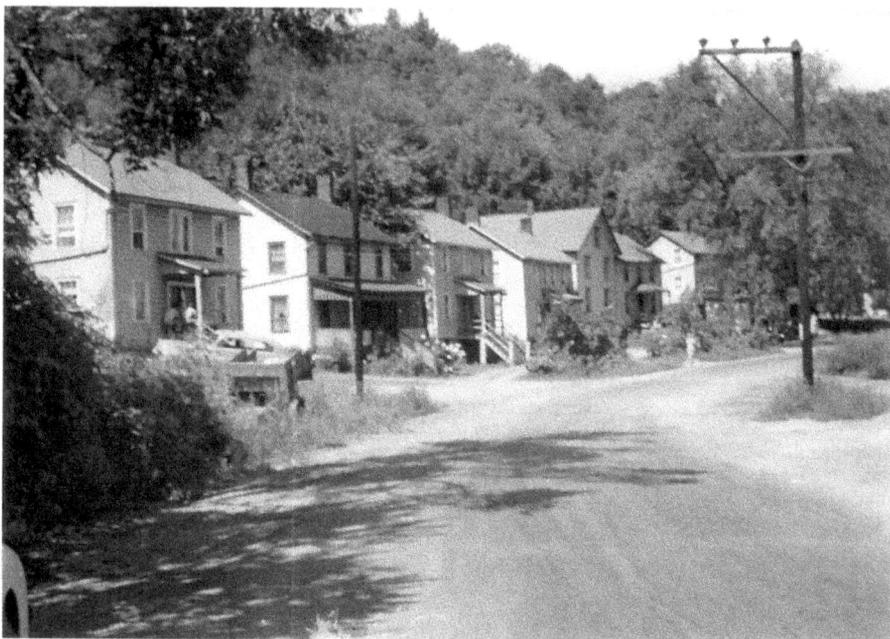

The "hollow" was a group of company-owned homes, along with some individually owned properties. It is unknown how this nickname came about. None of these houses stands today. *Courtesy of William Lamey.*

Roseton

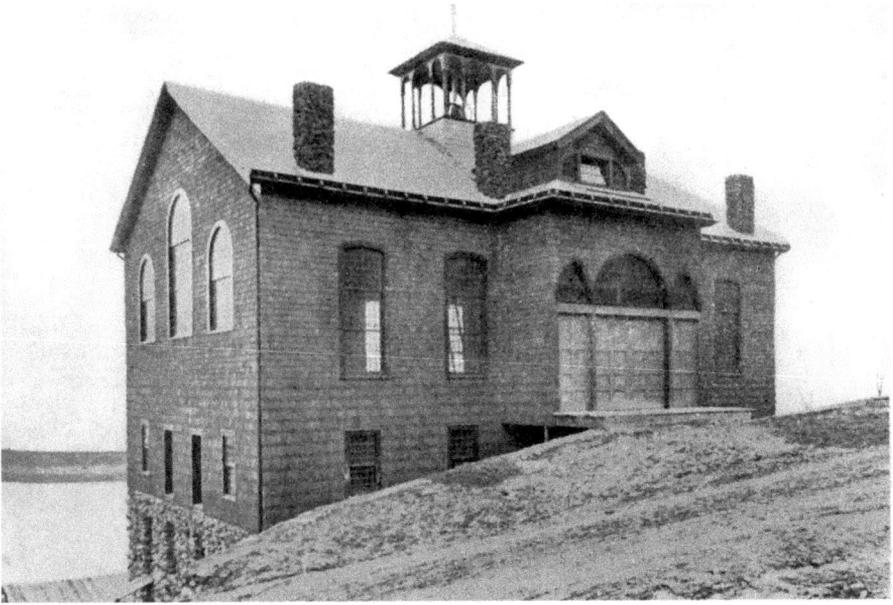

In a progressive move for the times, Roseton Hall was constructed by the Roses to provide a recreational and social outlet for the families of its workforce. The building contained a reading area, a performance stage, a billiards room, meeting rooms and areas where workers could relax by playing cards. The Hungarian Baptist Church held weekly services in the hall. Apartments were located on the lowest level. *Photograph by William Thompson.*

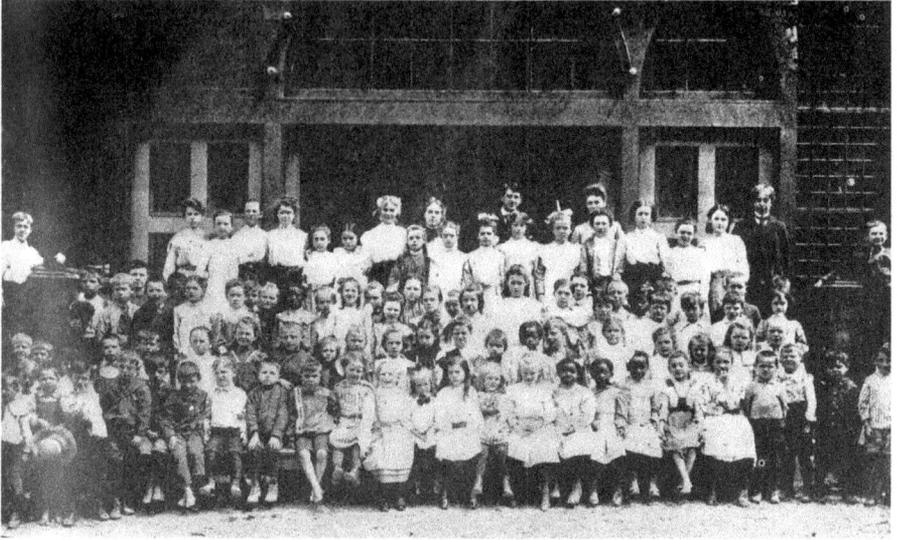

A group of Roseton children pose in front of Roseton Hall in this undated photograph. The school's population was diverse, coming primarily from families of Hungarian, Italian, Irish, German, African American, Polish and Greek backgrounds. *Photograph by William Thompson.*

This photograph shows the stage inside Roseton Hall. Many plays and performances were held there over the years. Outdoor activities, including a uniformed baseball team, were provided by the Roseton Athletic Club. Fairs and an annual Christmas celebration added to the hamlet's social life. *Photograph by William Thompson.*

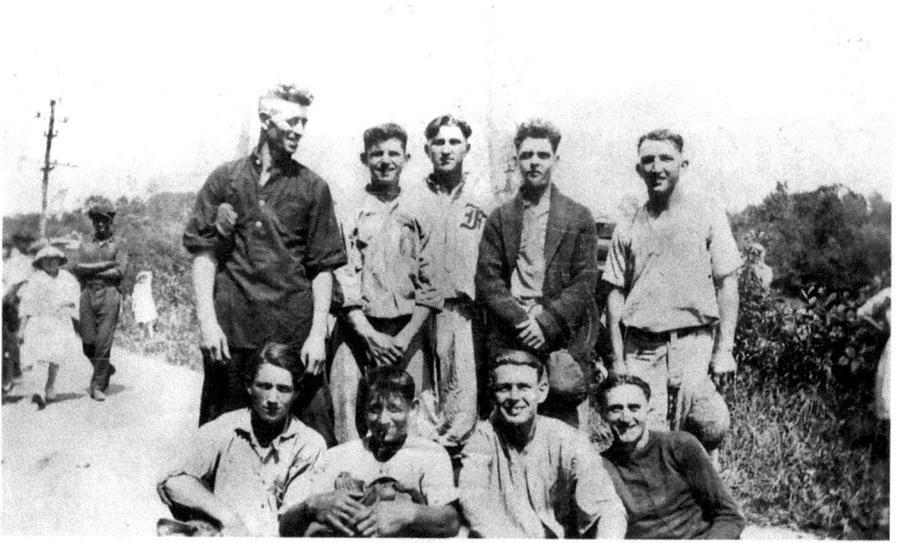

This circa 1930 photograph shows a nine-member Roseton baseball team. The teams played many of their games in Newburgh. *From left to right, top row*: unidentified, unidentified, Andrew Sabo (who was killed in action during World War II), William Lamey (a Rose Brick Company pallet rack man) and James Sheehan. *Bottom row*: unidentified, Alec Gomboy, James Sheehan (cousin of the James Sheehan in the top row) and Spike Conyea. *Courtesy of William Lamey.*

Roseton

This house along River Road was occupied by the Rose Brick Company's assistant superintendent and store manager for a time. Later, the Roses' household workers occupied the building. The building looks much the same today as it did during the company's heyday. The brickyard's laborers did not fare as well, but the boardinghouses built by the company were relatively airy and bright. Interestingly, most of the buildings were of a rose hue. *Photograph by William Thompson.*

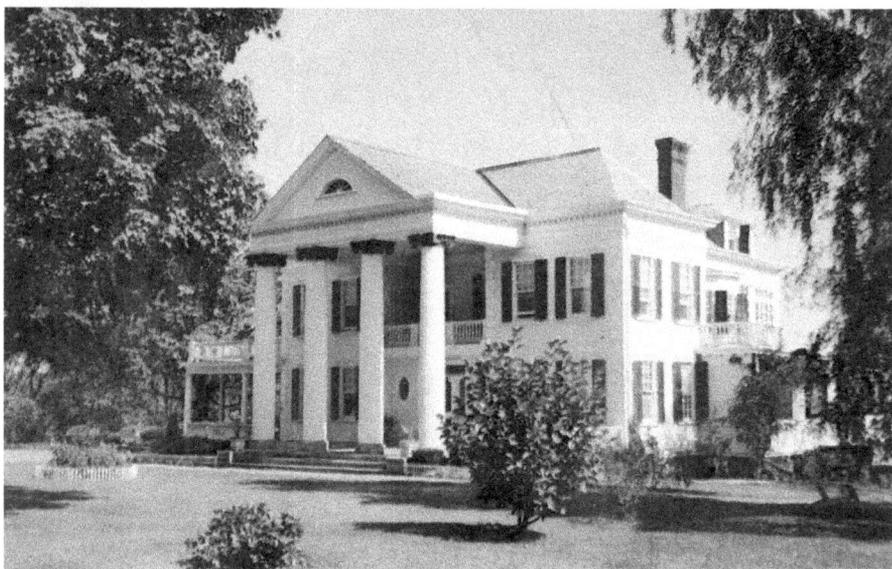

The house in the top picture was referred to as "the Homestead." It was the residence of John B. Rose and his family. The rear porch, on the right, overlooked the Hudson River. A major renovation took place some years after this photograph was taken. As seen in the bottom postcard, the transformation resulted in a two-story Greek revival structure with four stately Ionic columns adorning the front entrance. In 1950, shortly after Rose's death, a local restaurateur named Angelo Sasso bought it. Angelo, along with his wife, Carole, opened the Beau Rivage, an establishment of fine dining. The restaurant was popular and had a long run, but about seven years after the Sassos retired, it burned to the ground on New Year's Eve 1982. *Top photograph by William Thompson. Bottom postcard courtesy of Carla Decker.*

Roseton

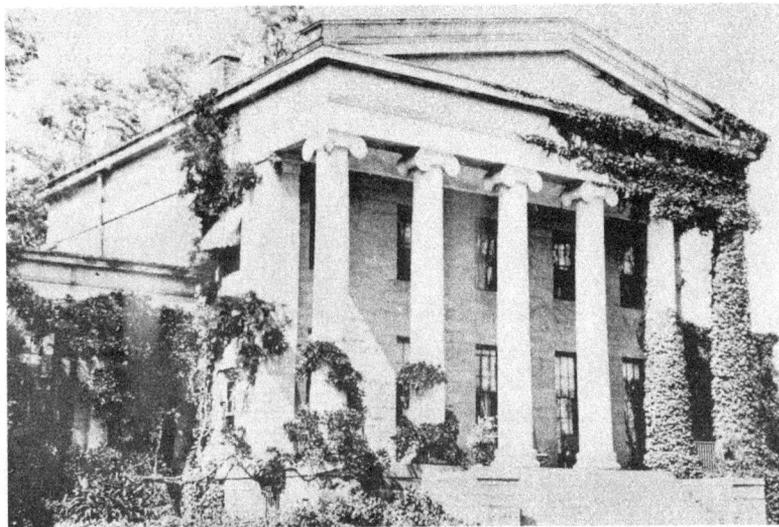

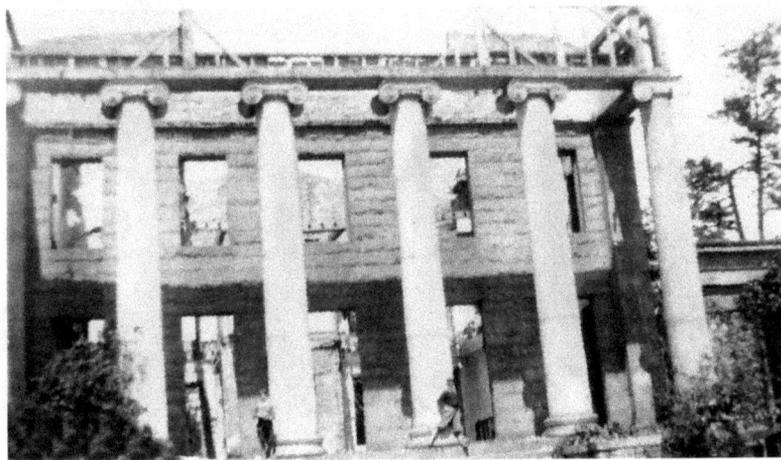

In the late 1820s, work began on a building that would be a familiar sight along the Hudson River's west bank for almost one hundred years. The mansion at Danskammer was completed about 1834 at a cost of $70,000. Edward Armstrong, son of William Armstrong, built his dream home on an elevation near Danskammer Point. Gray granite from nearby Breakneck Mountain and white granite from Quincy, Massachusetts, for its six stately twenty-four-foot columns were shipped to the site. The interior was fitted with black walnut. This idyllic home, with its grand view of the river, became a social hub. Edward's son, David Maitland Armstrong, an artist who specialized in fine stained glass, would go on to chronicle his most interesting life at the farmhouse, or "little Danskammer," near the larger mansion. About 1875, the mansion was bought by Juan J. Jova and his wife, Marie, who fell in love with the area's beauty. Juan Jova's interest in brick making, however, eventually led to the mansion's demise. As the clay pits encroached on the home, the decision was made to dismantle it. The bottom picture, circa 1932, shows the mansion in a state of ruin. Fortunately, many of the mansion's building features were preserved and sent to new owners. Five of its beautiful columns are now part of the Storm King Art Center in Mountainville. *Bottom photograph courtesy of William Lamey.*

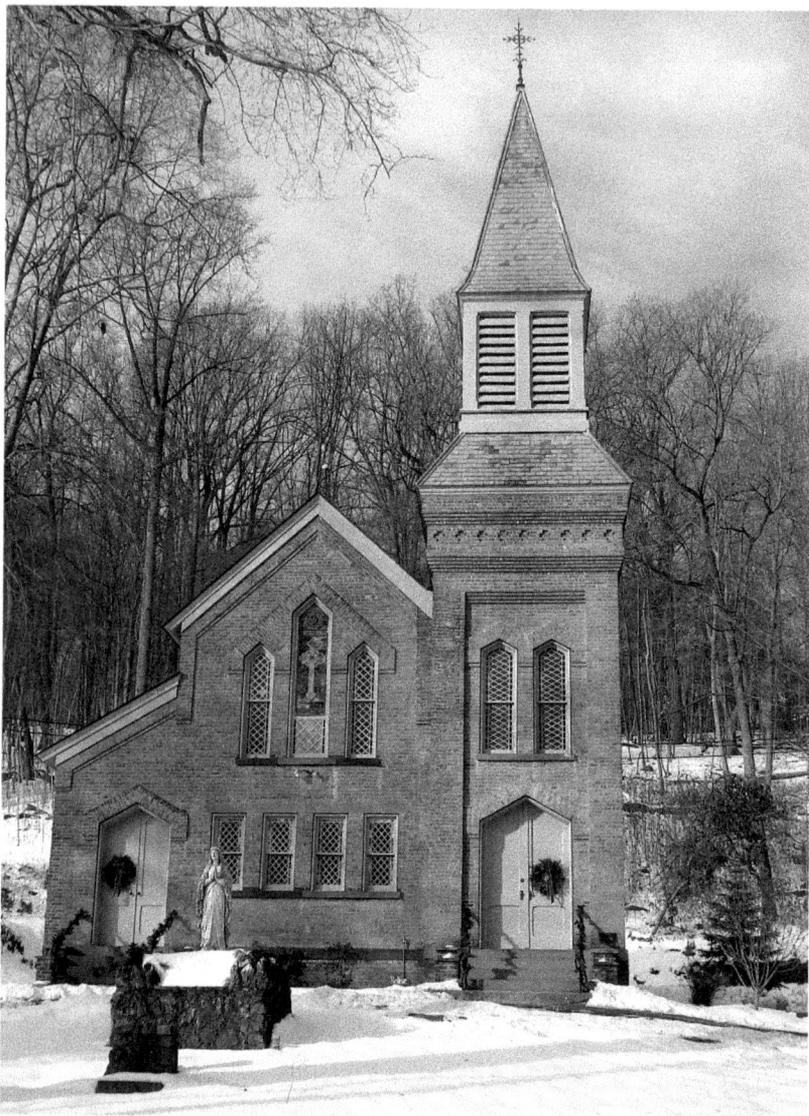

The decline of Roseton, along with the rest of the Hudson River brick industry, was a gradual one. External events such as the national industrial recession starting in 1907, World War I, the Depression and eventually World War II brought about many plant closures. Demand lessened as New York City converted to construction using steel and cement. Homes using wood frames were favored over brick in the outer boroughs. Southern clay found its way into the northern market. Coupled with labor strife and legal entanglements, the Hudson River brick industry slowly faded. Though time has clouded memories of Roseton, one constant stands out. In this recent photograph, Our Lady of Mercy Roman Catholic Church, erected in 1891 still stands. The church was sponsored by the Jova family. The company's bricks were used in its construction. Today, many of the parishioners at its well-attended services are descendants of former Roseton brickyard employees. *Photograph by Wesley Gottlock.*

CHAPTER 3

ROCKLAND LAKE

From Town to Park

In 1835, John J. Felter, John G. Perry and Edward Felter cut a sloop load of ice from the lake and sold it in New York City for a profit. The next year, along with seventeen other men, they formed an ice company called Barmore, Felter and Company (BFC). Each man put up $100 in capital. They used the $2,000 in capital to build a small dock and icehouse at the landing. The icehouse had a capacity of two to three hundred tons of ice. They also leased two cellars in the city to store the ice. The lake was originally called Quaspeck Pond. The ice company renamed the lake and surrounding area Rockland Lake.

Competition became fierce over control of the ice at the lake. Eventually, only BFC remained at Rockland Lake after the other companies moved north to Rondout Creek. By 1853, three companies controlled the Hudson River ice business: John A. Ascough and Company, A. Barmore and Company and the Ulster County Ice Company. They consolidated to form the Knickerbocker Ice Company in 1855.

At Rockland Lake, the booming ice business spurred a need for other local businesses. It soon became a thriving town with a post office, a school, butcher shops, saloons, candy stores, boathouses, a firehouse, two churches and a roadside stand.

Along with the ice industry, quarries also operated at Hook Mountain, just east of the current Rockland Lake State Park. In 1872, John Mansfeld built a stone crusher at the landing. His quarry alone produced seventy-five to ninety boatloads of crushed stone annually and employed between twenty-five and sixty-five men at any one time. These two industries provided year-round employment to the people who lived in Rockland Lake.

These industries began to wane in the early twentieth century. The development of refrigeration put an end to the ice industry in the 1920s.

The quarries suffered due to growing concern about the defacement of the Palisades along the Hudson River.

In the 1950s, John D. Rockefeller became interested in the natural lake, which was already a tourist destination. He felt that it would be a wonderful addition to the Palisades Interstate Park. He raised $1 million in private donations, and the Palisades Interstate Park Commission purchased the land in 1958. Today, the 1,079 acres that compose Rockland Lake State Park include two swimming pools, two golf courses, boat rentals, a nature center, tennis courts, hiking trails and walking trails.

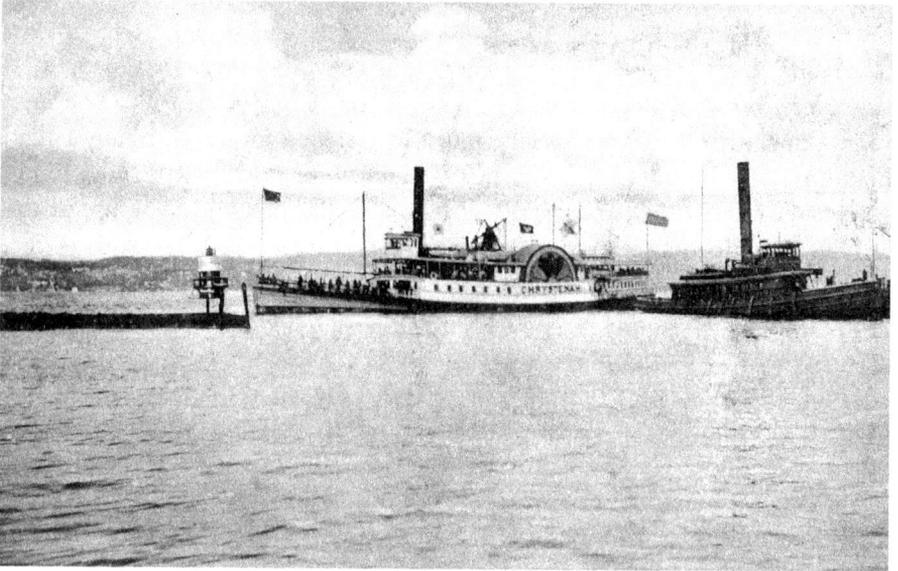

The Steamboat *Chrystenah* was built in Nyack, New York, in 1866. It was one of the many steamboats, ferries and day liners that brought visitors to Rockland Lake and Nyack Beach. Directly in front of the boat is the Rockland Lake Lighthouse. *Courtesy of the New City Library.*

Rockland Lake

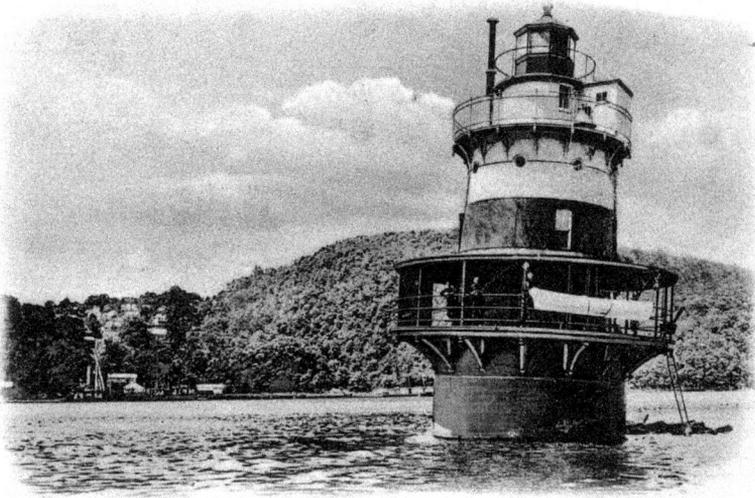

Established in 1894, the lighthouse at Rockland Lake remained in service until 1923. The lighthouse started to lean in the 1890s. Eventually, one side became nine inches lower than the other. Local residents referred to it as the leaning tower of Rockland. In 1923, a skeleton tower replaced it. *Courtesy of Robert Knight.*

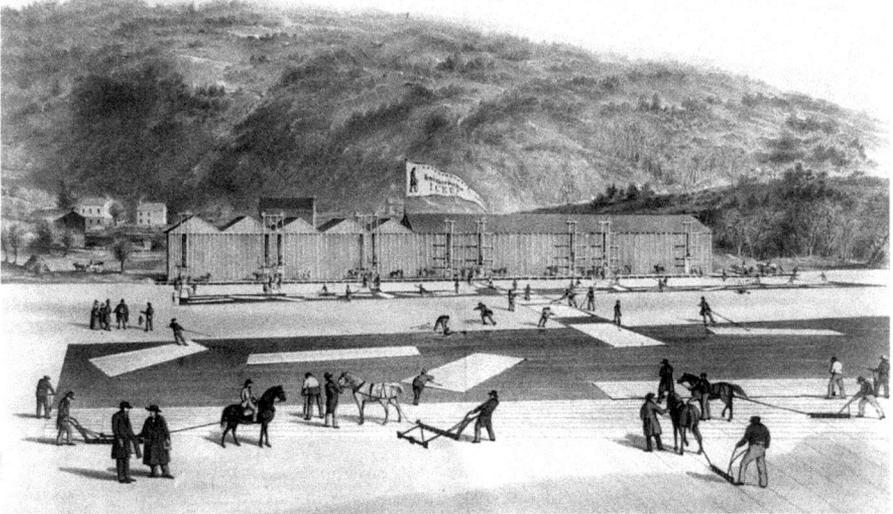

The Knickerbocker Ice Company published this lithograph on March 27, 1846. It depicts the process of ice making. The ice is first cut into large blocks called floats. These blocks are then floated to the icehouse, where they are stored. *Courtesy of the Library of Congress, LC-USZ62-2544.*

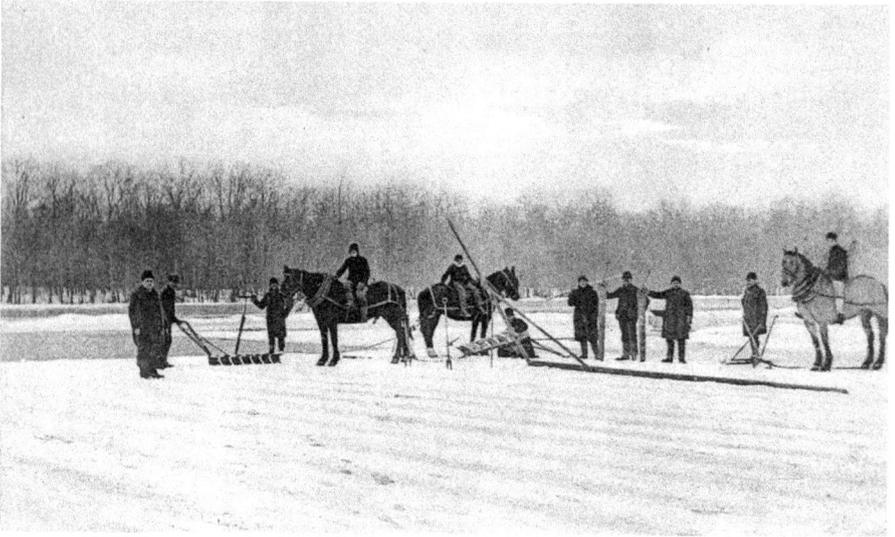

Ice harvesters are shown in this postcard cutting ice blocks. *Courtesy of Robert Knight.*

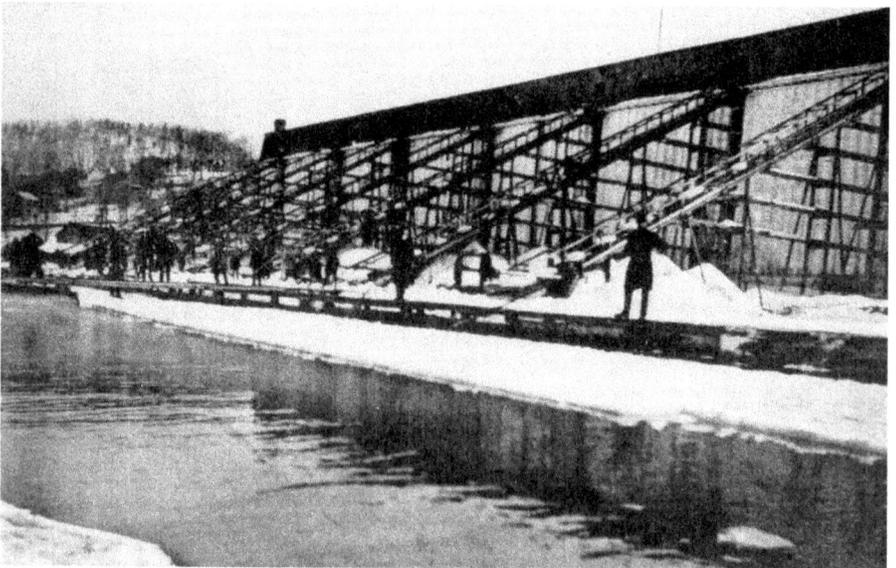

This building is one of three icehouses once located at Rockland Lake. The houses had the capacity to store 100,000 tons of ice. The tracks extending to the top of the building were elevators used to bring the ice up and into the icehouse. The channel in the lake, from which the ice was cut, is clearly visible. *Courtesy of the New City Library.*

Rockland Lake

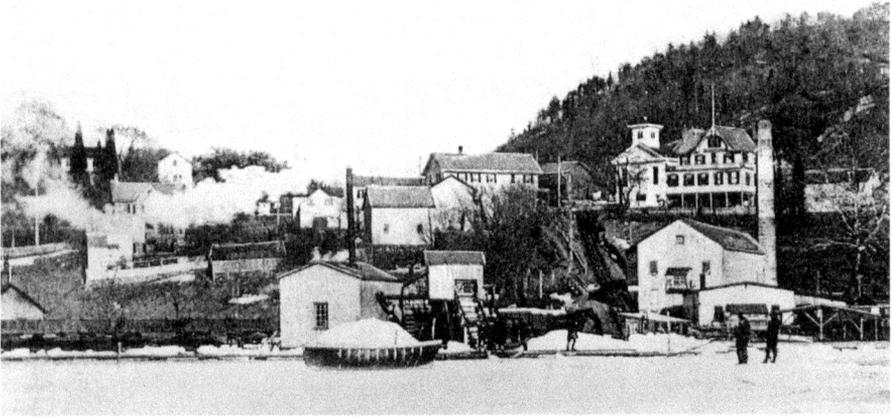

These men are dragging a boatload of ice along the lake. On the hillside behind the two men you can see the tracks of the railroad that transported the ice from the lake to the river. The steam-driven rail cars passed under Main Street at the top of the hill. Horses would pull the cars across the flat, where the cars would be attached to a cable and lowered to the river by gravity. The Continental Hotel can be seen in the upper right side of the photograph. *Courtesy of Robert Knight.*

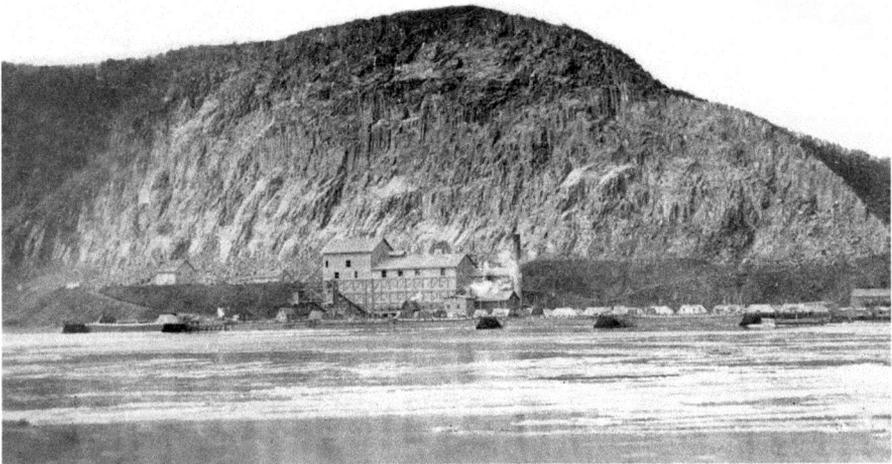

The Foss and Conklin quarry is shown in this 1916 postcard. In 1915, it owned the largest jaw crusher manufactured by Traylor Engineering and Manufacturing Company. The crusher weighed 520,000 pounds and required fourteen railroad cars to move it from the factory to the quarry. *Courtesy of Robert Knight.*

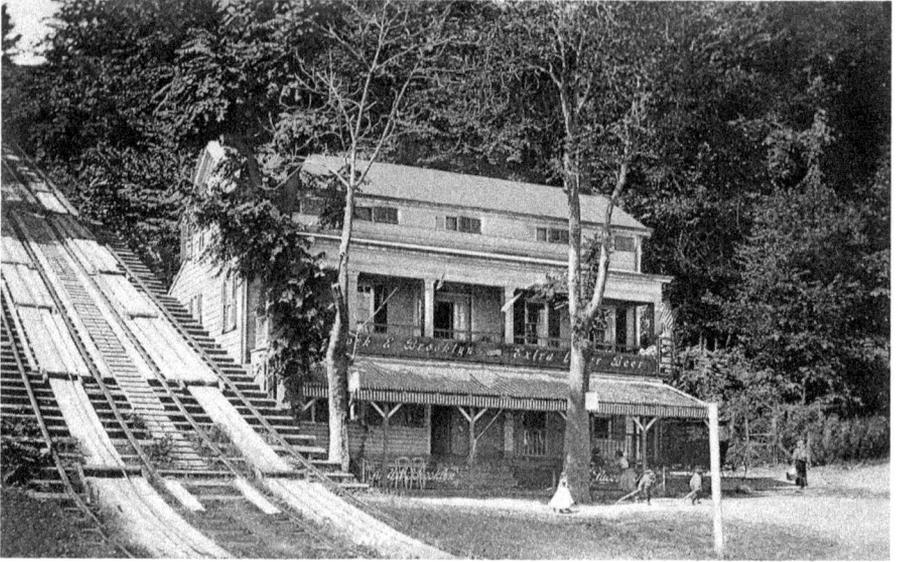

The River Hotel was one of many places where visitors could stay while at Rockland Lake. Its location at the base of Hook Mountain near the steamboat dock made it an ideal location. The tracks along the left edge of the photograph were used to bring ice down the mountain for shipment to New York City and other places. *Courtesy of Robert Knight.*

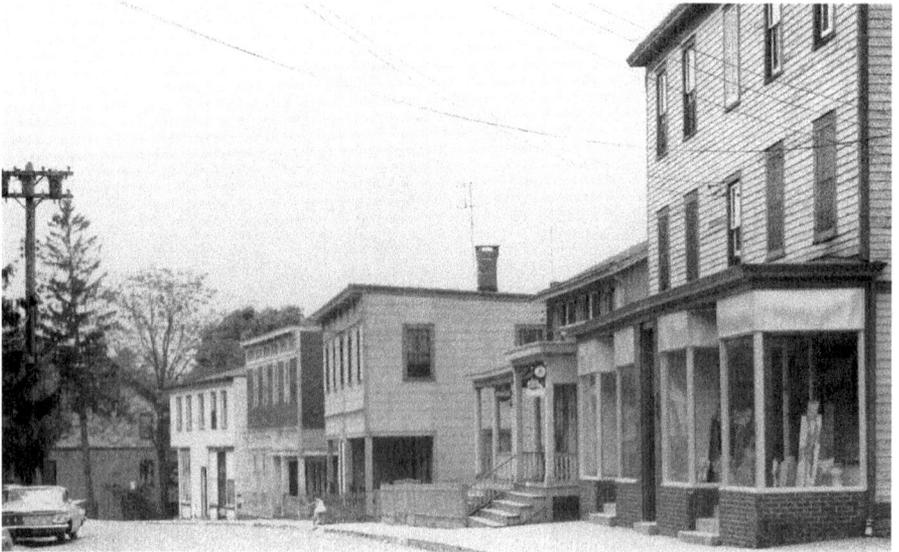

Rockland Lake's Main Street is shown in this postcard. The steep hill was nicknamed "Store Hill" by the local residents because of all the stores located there. This street was once part of Old Route 9W. A girl can be seen riding her tricycle along the sidewalk. *Courtesy of the New City Library.*

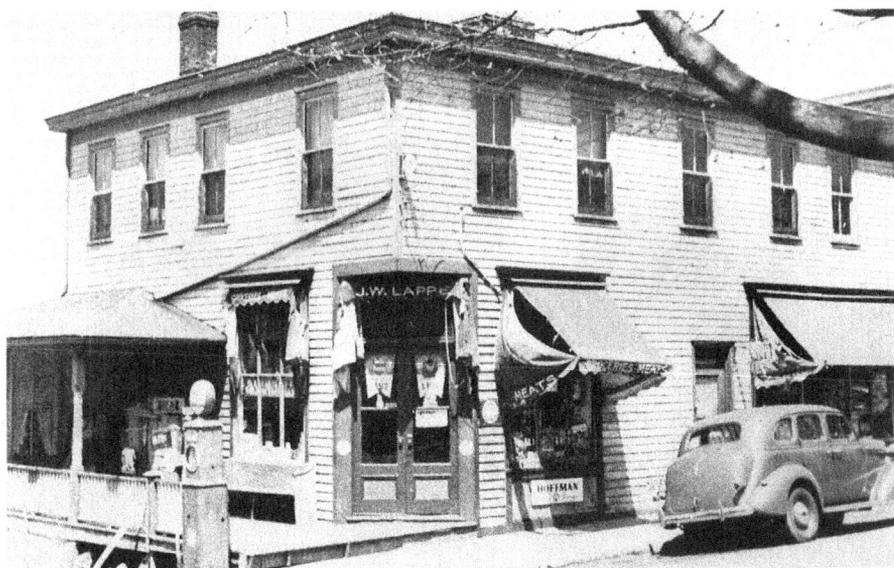

L.W. Lappe's butcher and grocery shop was located on Main Street. Ice harvesting in the winter and quarrying in the warmer weather created year-round employment. These industries helped to create a stable town of three thousand residents. *Courtesy of Robert Knight.*

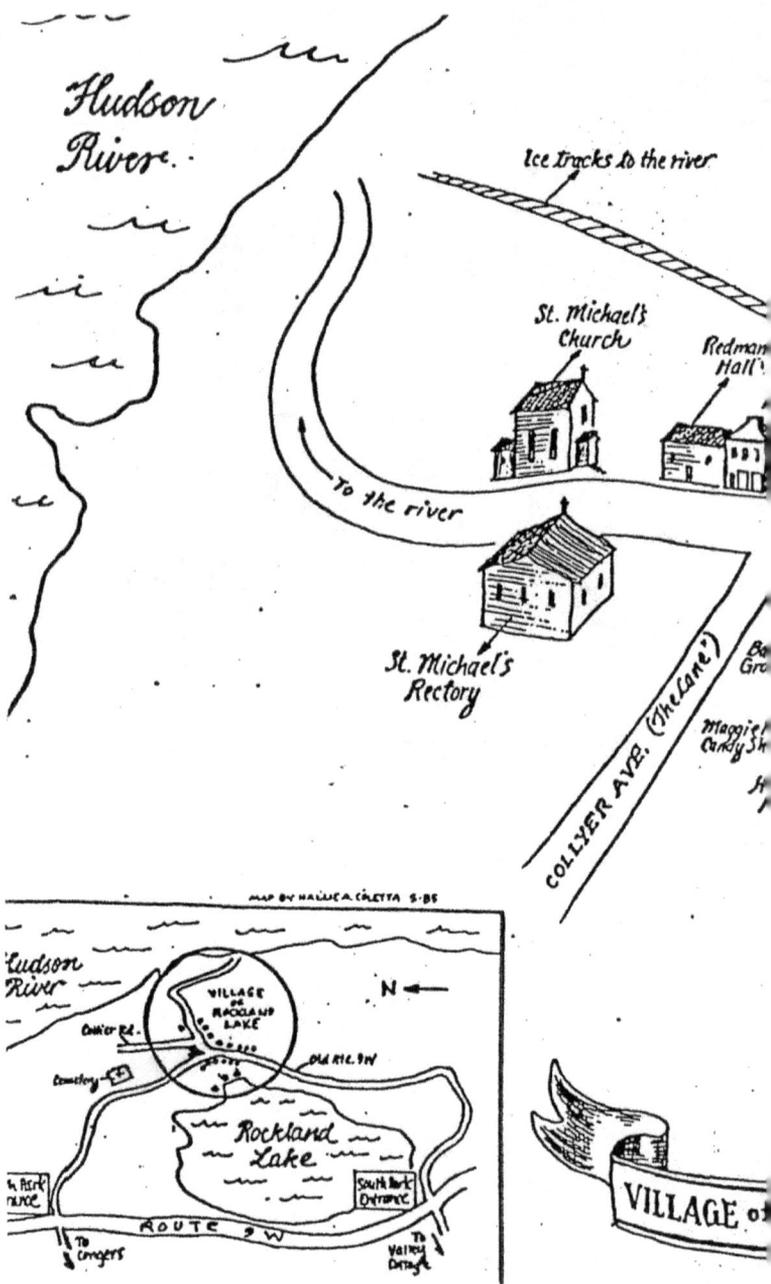

This map shows the locations of the businesses in Rockland Lake. The main street of the town continues past the Lane, now called Collyer Avenue, and ends at the Hudson River. The asterisks on the map denote the buildings that remained after the Palisades Interstate Park Commission purchased the land in 1958. *Courtesy of Rockland Lake.*

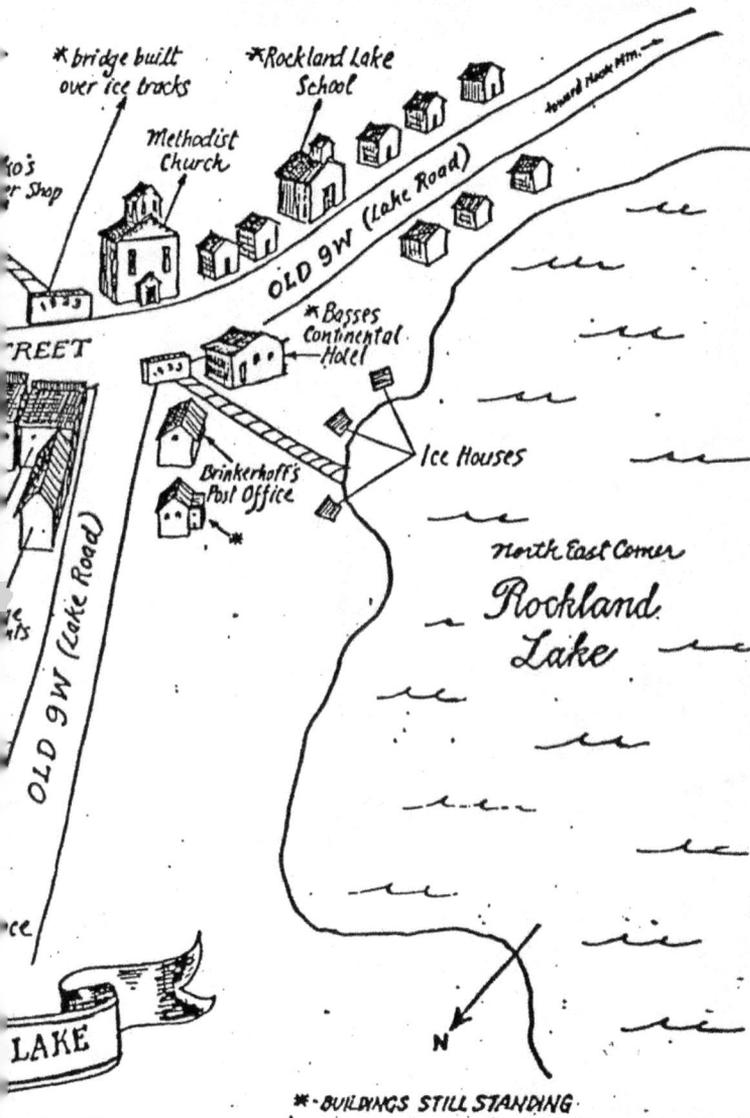

* bridge built
over ice tracks

* Rockland Lake
School

Methodist
Church

*o's
r Shop

toward Hook Mtn.

OLD 9W (Lake Road)

*REET

* Basses
Continental
Hotel

Brinkerhoff's
Post Office

Ice Houses

North East Corner

Rockland
Lake

OLD 9W (Lake Road)

ce

LAKE

N

* - BUILDINGS STILL STANDING

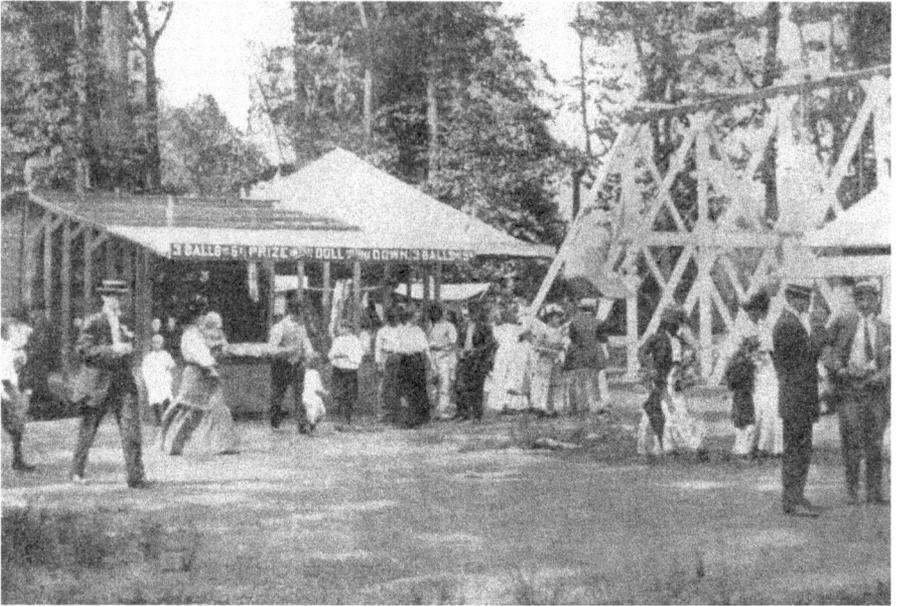

Summer visitors at the lake had a choice of myriad activities. Old Bill Thompson's Baby Game, shown on this postcard, was one of them. In addition to this game, Old Bill's also had a striker and rides. The card is labeled "Picnic Grounds and Games Rockland Lake Park, N.Y." *Courtesy of Robert Knight.*

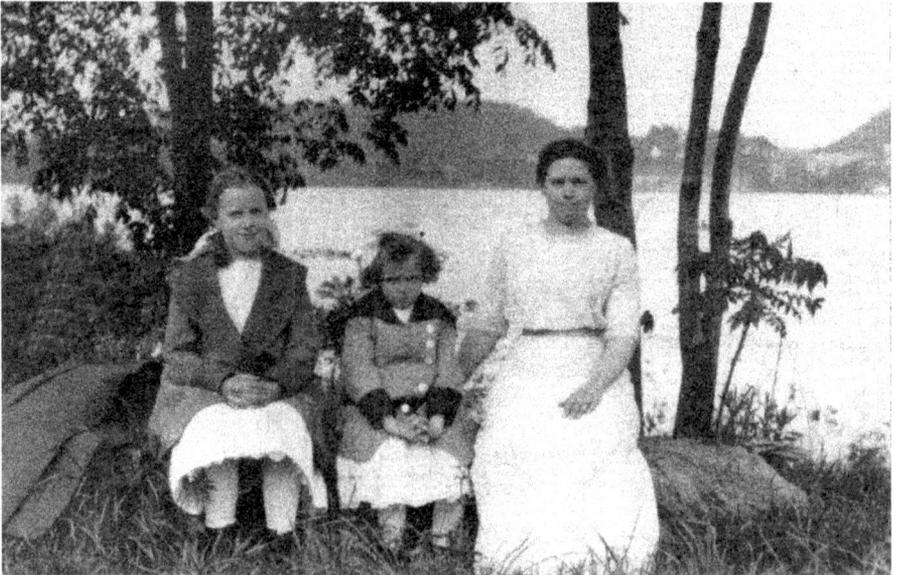

Three visitors to the lake pose for this photograph on the lake's western shore. Judging by the clothes this family is wearing, this photograph was taken around the turn of the century. An icehouse can be seen across the lake. *Courtesy of Robert Knight.*

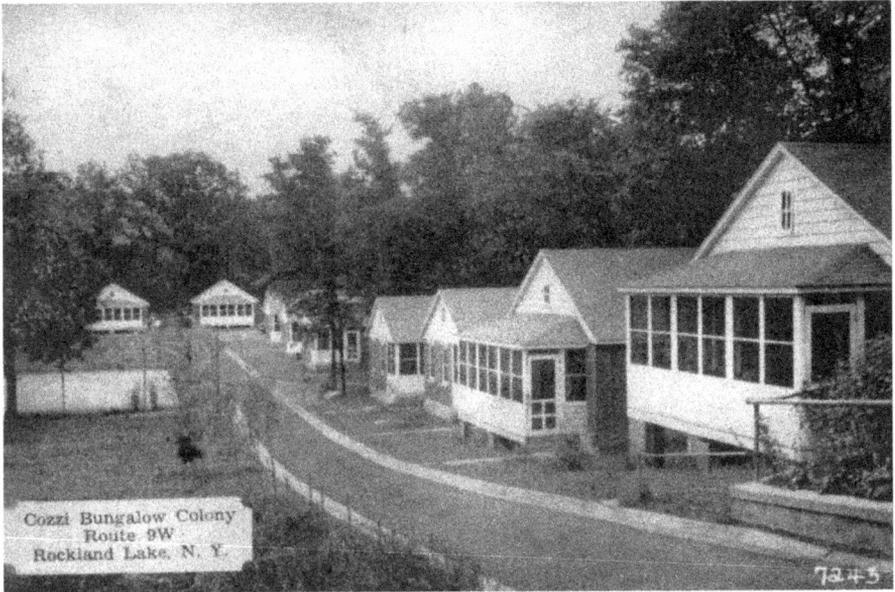

Cozzi's Bungalow Colony, Rockland Lake Lodge, Lake Grove Hotel, the Margard and Ha-Ya Camp are some of the places where visitors stayed during their vacations at Rockland Lake. *Courtesy of Robert Knight.*

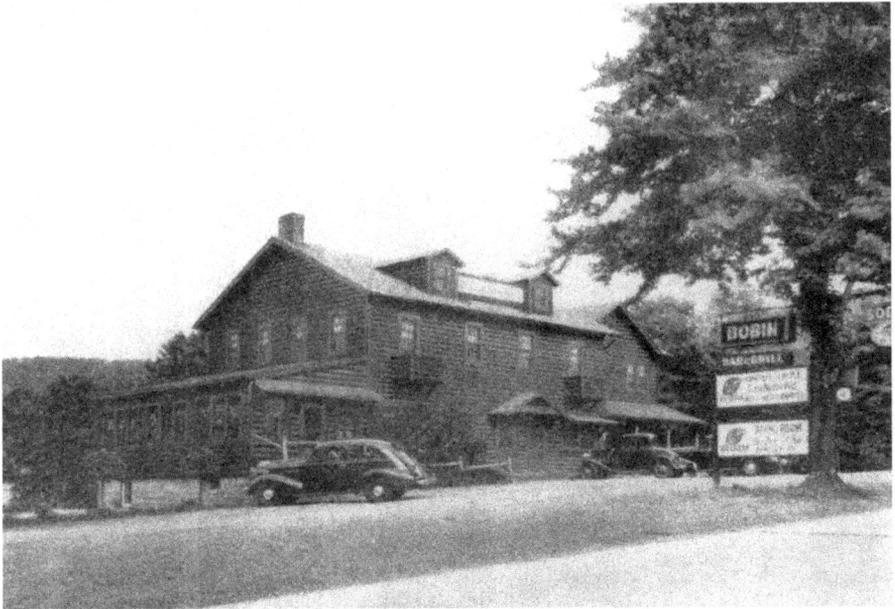

The Bobin Inn was a combination hotel, restaurant and bar and grill. Visitors to the lake often danced their nights away at the Bobin. *Courtesy of Robert Knight.*

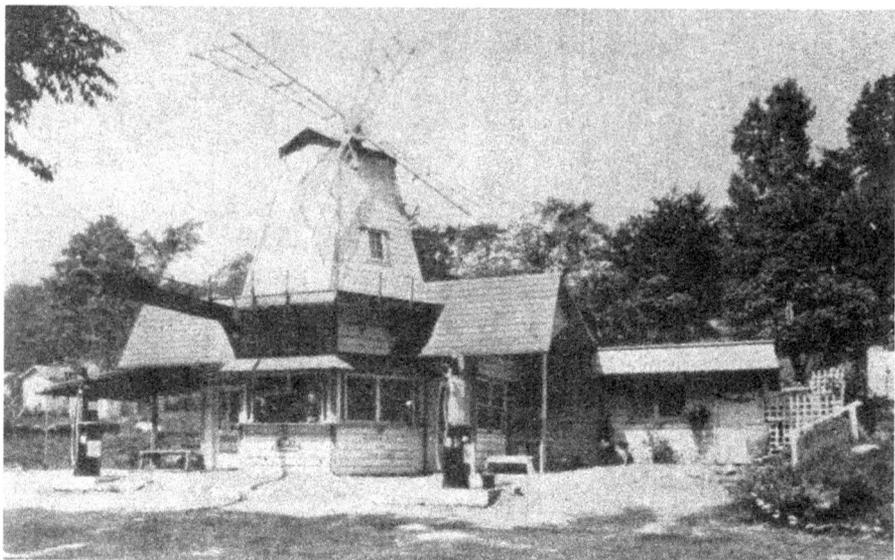

The Wind Mill, located on Route 9W, was one of the many roadside stands and restaurants near Rockland Lake. In addition to food, this stand also sold gasoline to the traveling public. *Courtesy of Robert Knight.*

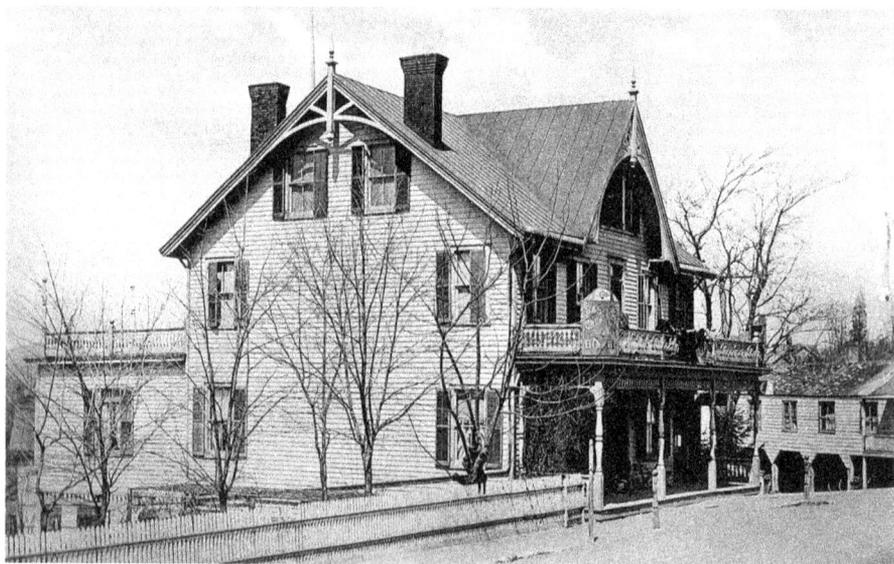

The side of the Continental Hotel is shown here in this undated postcard. Basses Continental Hotel, the Hudson River Hotel and Hine's and Cozzi's bungalow colonies all catered to summer guests. Visitors would fish or swim in the lake, go to the amusement park along the Hudson River and dine or dance at the Bobin Inn, Blue Urn or Quaspeck Casino in the evenings. *Courtesy of the New City Library.*

Rockland Lake

The Knickerbocker Fire Engine Company was established on May 25, 1861. William Hoffman was the first foreman. J.L. Conklin was the assistant foreman. The firehouse is still functioning. *Courtesy of the New City Library.*

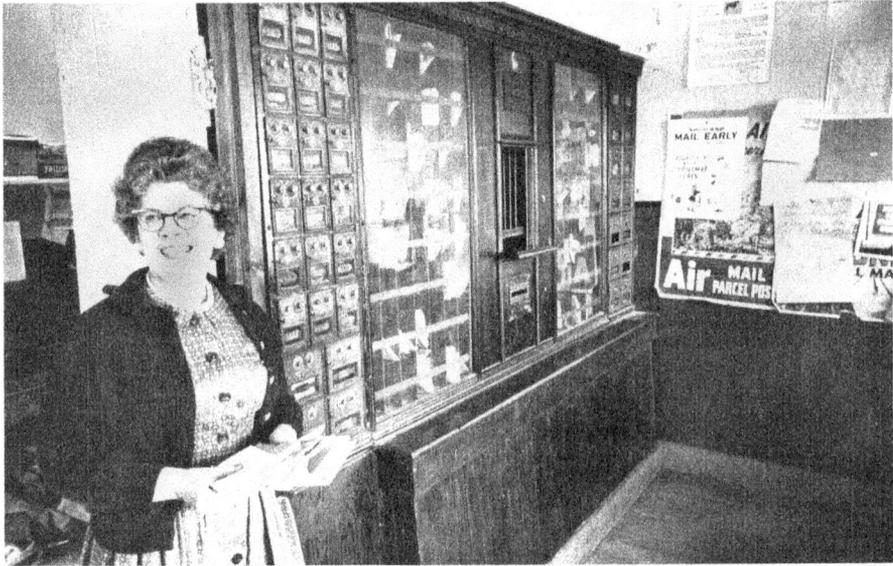

In 1942, the first post office was established in Rockland Lake with Thomas J. Wilcox as its postmaster. In later years, Florence Brinkerhoff, shown here, was the postmistress. *Courtesy of the New City Library.*

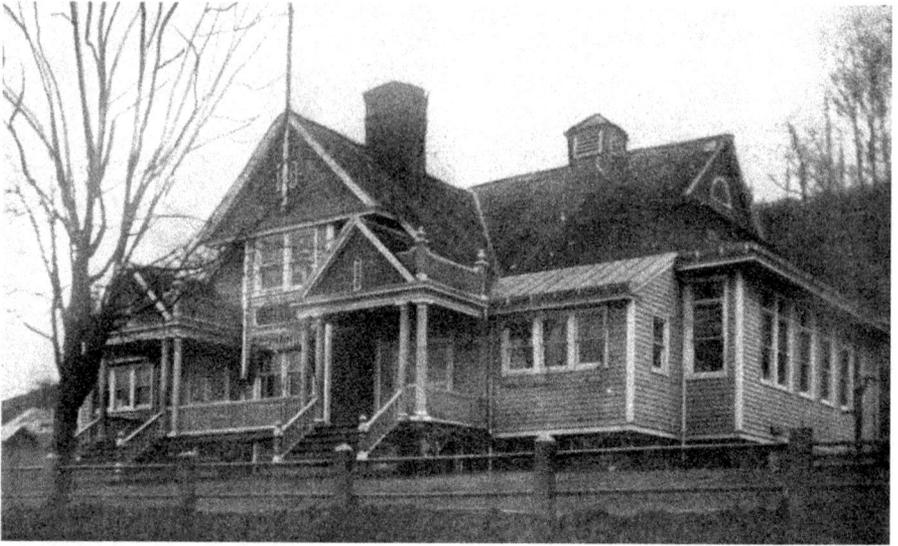

The original public school built in Rockland Lake is shown in this photograph. *Courtesy of the New City Library.*

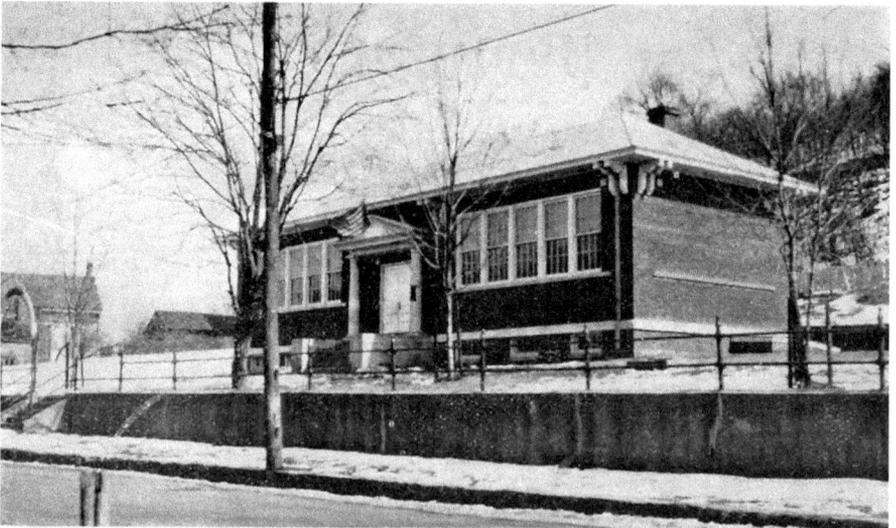

The new public school building at Rockland Lake is shown in this undated postcard. This school was attended by the town's children. Today, this building is used by Camp Venture Academy to provide care and training for people with developmental disabilities. Today, Rockland Lake is part of the Palisades Interstate Park. Only a few buildings survive to remind people of the once-thriving community. *Courtesy of the New City Library.*

CAMP SHANKS

Last Stop U.S.A.

In the summer of 1942, Orangeburg farmers, like generations before them, worked the soil while tending their corn, tomato and cabbage patches. Other homeowners enjoyed living in the serenity of this beautiful Hudson Valley region, which was close enough to New York City to make a daily commute relatively painless. However, this bucolic setting would soon come to an abrupt halt. A good portion of Orangeburg and smaller slices of adjacent Tappan and Blauvelt would soon go through a series of rapid transformations that few could have imagined. The world was at war.

On the evening of September 25, 1942, several hundred property owners, many of them farming families, were summoned to Orangeburg School. They were informed that their properties were being purchased by the United States Army under the War Powers Act. It was a prime location for transporting troops overseas. Its proximity to the Hudson River and the existence of rail lines made it vitally strategic. It was a short walk from the trains and a four-mile journey from the ships that docked in Piermont.

The owners had two weeks to vacate their land. Almost immediately, a force of 17,000 workers began constructing Camp Shanks, a facility capable of housing 46,875 troops as they were processed before being deployed to England, North Africa and the European Theatre of Operations. In a span of eight months, the United States Army converted roughly 2,020 acres into a self-sustaining city with its own infrastructure. Included in this total were 675 acres of property and facilities leased from New York State. A ferry slip was built along the pier in Piermont. The United States Army constructed over two thousand buildings on the site. These structures provided office space, housing, necessary infrastructure and entertainment, in addition to medical services and daily living needs, for the troops. A staff of over 6,000 people, both military and civilian, was needed to maintain the camp. Camp Shanks officially opened on January 4, 1943.

Camp Shanks deployed over 1.3 million troops throughout World War II, including the great majority of the troops that invaded Normandy. As the war wound down, returning troops, including the wounded, were received at Camp Shanks before they were redeployed to await discharge or reassignment. By the war's end, over 3 million troops departed from or returned to Camp Shanks. In addition, 290,000 German and Italian prisoners of war were processed at the camp.

The end of Camp Shanks came almost as abruptly as it had begun. Soon after the last returning GIs had their steak dinners at a mess hall and the last prisoners of war had been repatriated, the government once again moved swiftly. In May 1946, the War Department declared that Camp Shanks would become a housing project for returning GIs and their families. In September of that year, the first families moved into barracks that were subdivided into apartments. Shanks Village was born.

The hallowed grounds of Camp Shanks provided the setting for the last days spent on American soil by thousands of fallen American heroes. It is only fitting that it was often referred to as "Last Stop, U.S.A."

Camp Shanks

Construction at Camp Shanks began on September 21, 1942. In November 1942, actress Helen Hayes, from nearby Nyack, visited the construction site during its early stages. Seated with her in the front seat is Major Drew Eberson, who was in charge of construction. *Courtesy of the Orangetown Historic Museum and Archives, Scott Webber Collection.*

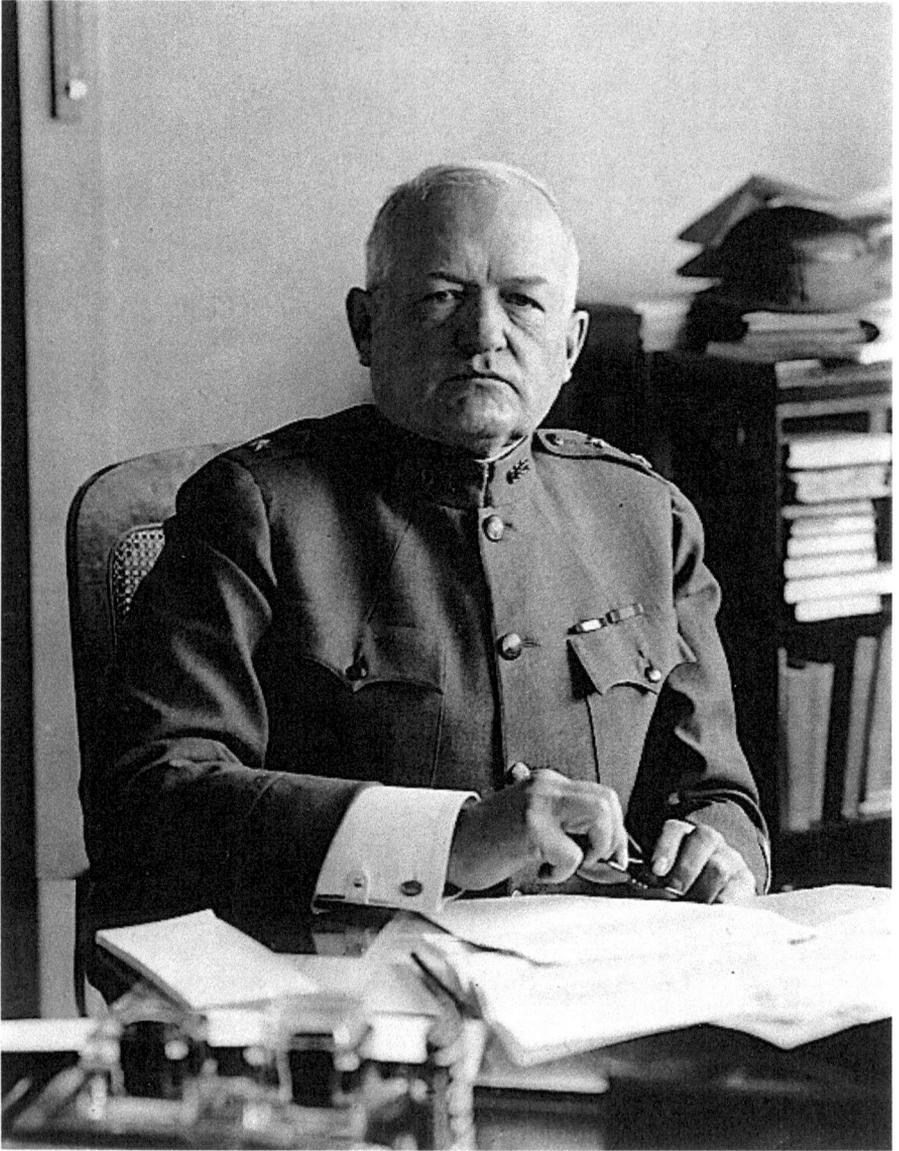

This page and next: Camp Shanks derived its name from Major General David Carey Shanks (1861–1940). Shanks attended Roanoke College and graduated from the United States Military Academy at West Point. He was instrumental in moving 1.7 million troops to Europe during World War I while serving as commander at the Port of Embarkation at Hoboken. He authored two books based on his experiences. Among his many honors, Shanks received the Distinguished Service Medal from President Woodrow Wilson. *Left picture courtesy of the Orangetown Historic Museum and Archives. Right picture courtesy of the Historical Image Collection (t12-019), Digital Library and Archives, University Libraries, Virginia Polytechnic Institute and State University.*

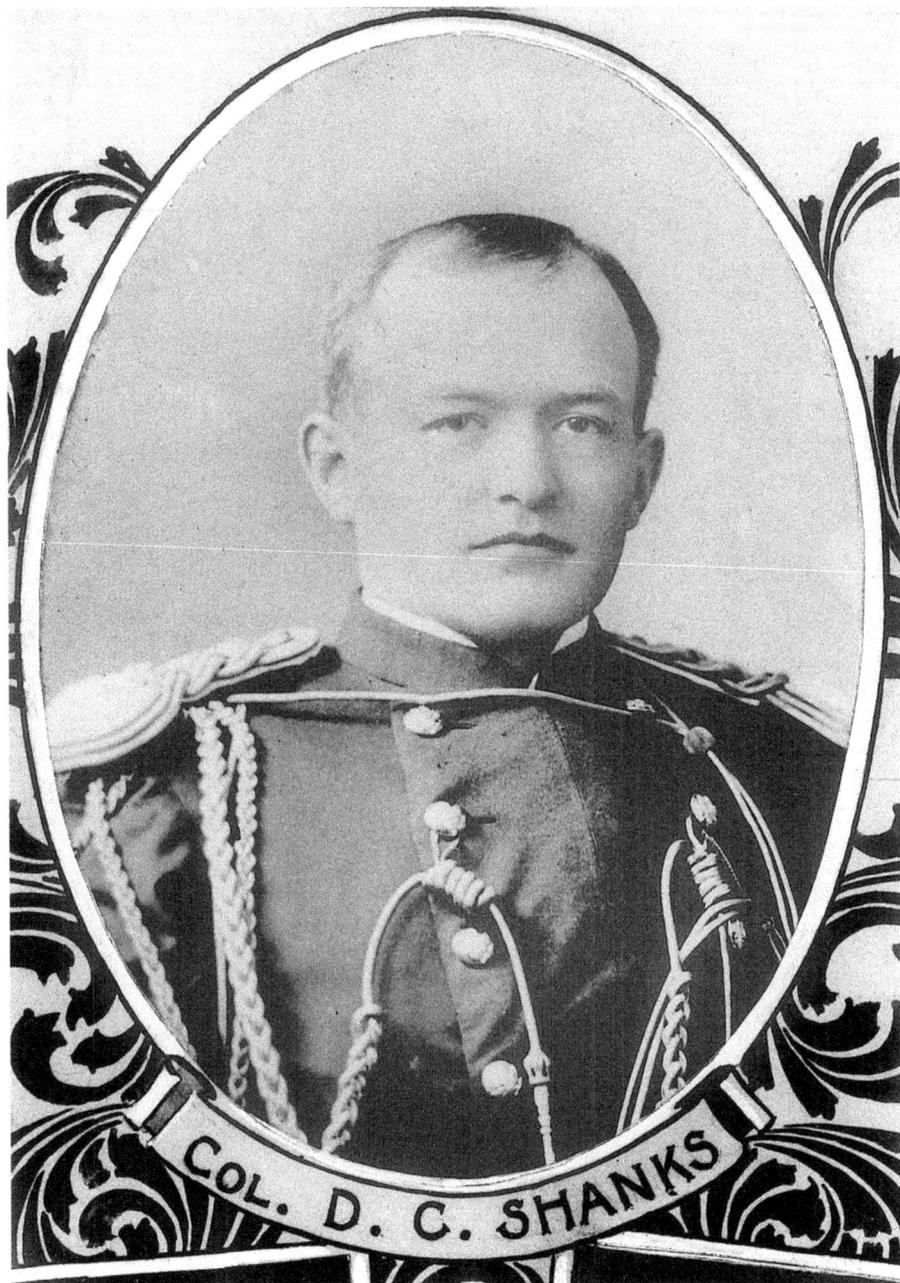

Col. D. C. SHANKS

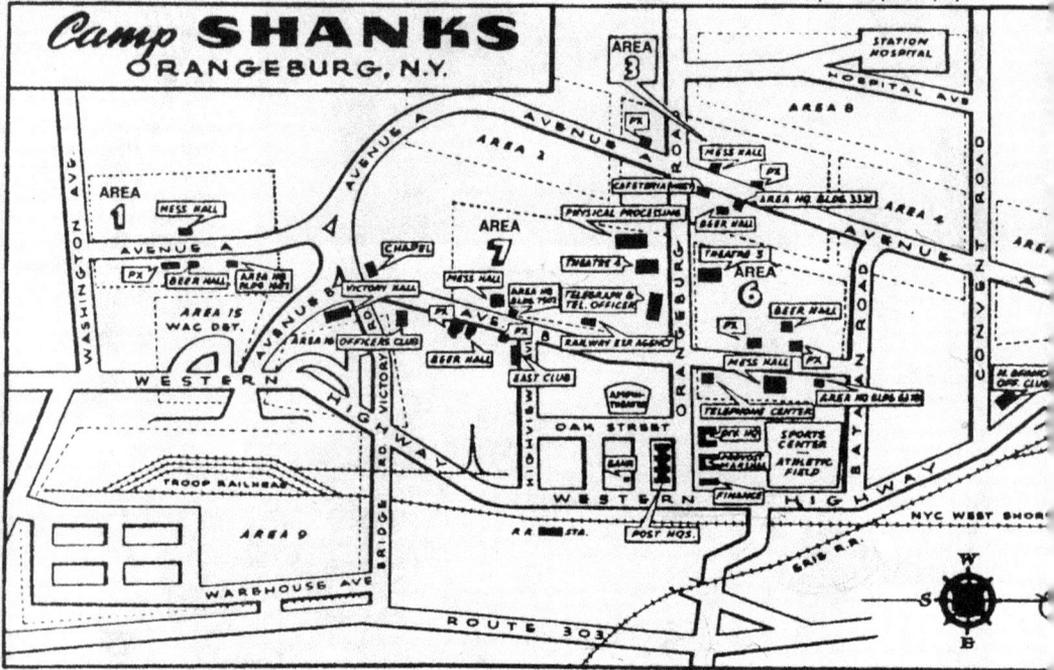

Camp Shanks, in essence, was a city capable of housing nearly fifty thousand troops spread over 2,020 acres. The government leased 675 of those acres from New York State to take advantage of the existing hospital and its surrounding facilities. Displaced were farms, vacant land and over one hundred homes. More than five thousand enlisted troops and fifteen hundred civilians, on average, were needed to keep the camp functioning. Its amenities included six theatres, post offices, a Western Union office, service clubs, athletic fields, an amphitheatre, beer halls, a cannery and a bakery. *Courtesy of the United States Military Academy Library, Special Collections Division.*

Camp Shanks

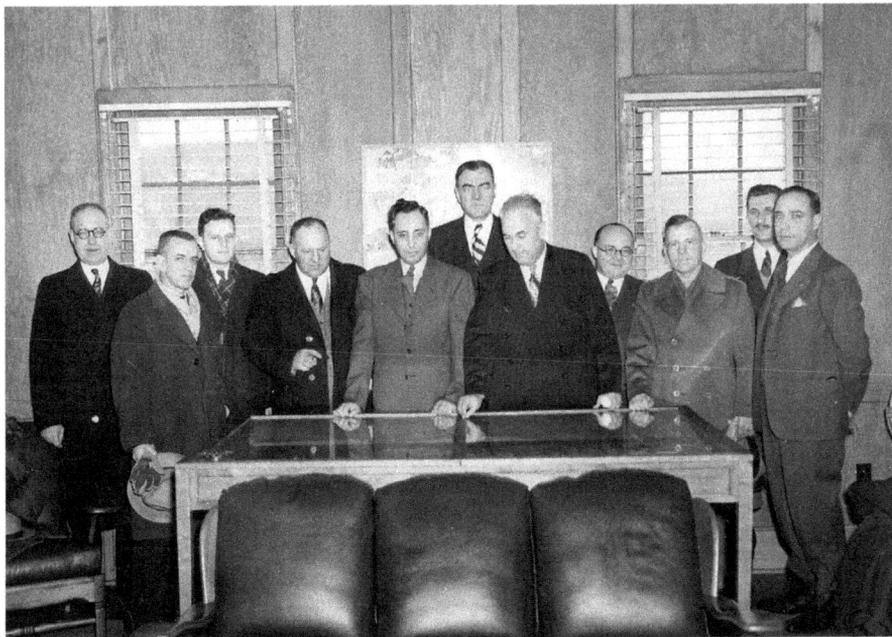

A group of officials from both the public and private sectors pose around a model of Camp Shanks. Colonel Kenna G. Eastham, third from the right, was the camp's commanding officer. He died suddenly of a heart attack at Camp Shanks on April 20, 1944. *Courtesy of the Orangetown Historic Museum and Archives. Photograph by the U.S. Army Signal Corps.*

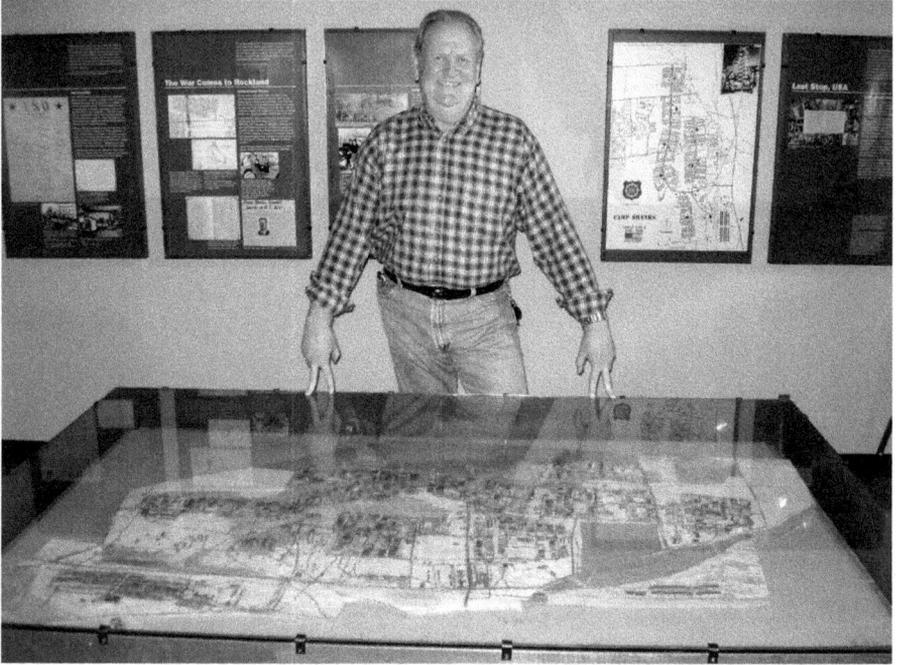

This recent photograph shows the same model as it is presently exhibited in the Camp Shanks Museum. In 1946, a workman saved the model from demolition, hoping to use some of its plywood for his own purposes. In 1994, it was found in a garage, intact, and it was donated to the museum. Jerry Donnellan poses behind the model. *Photograph by Wesley Gottlock.*

Camp Shanks

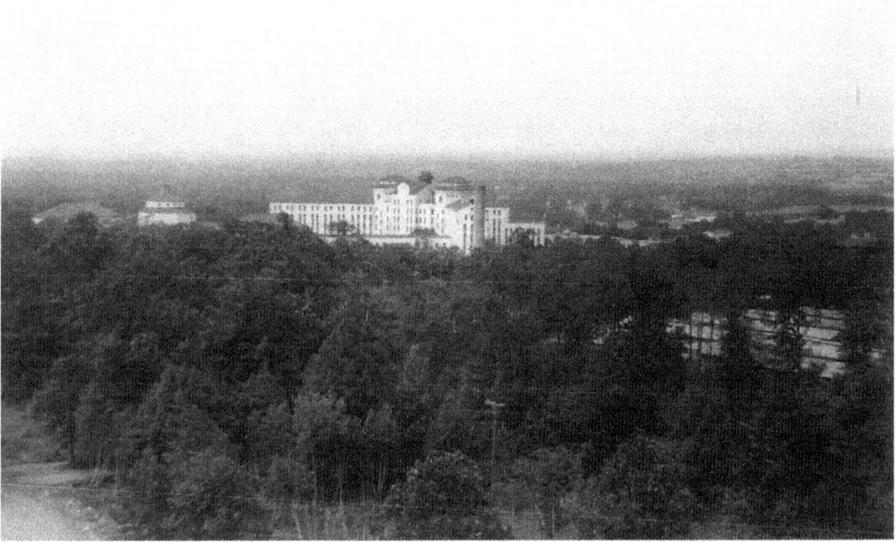

Three buildings at Rockland State Hospital were utilized by the government to provide medical services for the camp's population. Returning wounded troops were treated there as well. *Courtesy of the Orangetown Historic Museum and Archives. Photograph by the U.S. Army Signal Corps.*

The post chapel on the corner of Victory and Avenue B in Camp Shanks was an interdenominational church. In addition, it was used as a synagogue. Later, it was used by Shanks Village residents. It was destroyed by fire in 1951 after Camp Shanks had become Shanks Village. *Courtesy of the Orangetown Historic Museum and Archives. Photograph by the U.S. Army Signal Corps.*

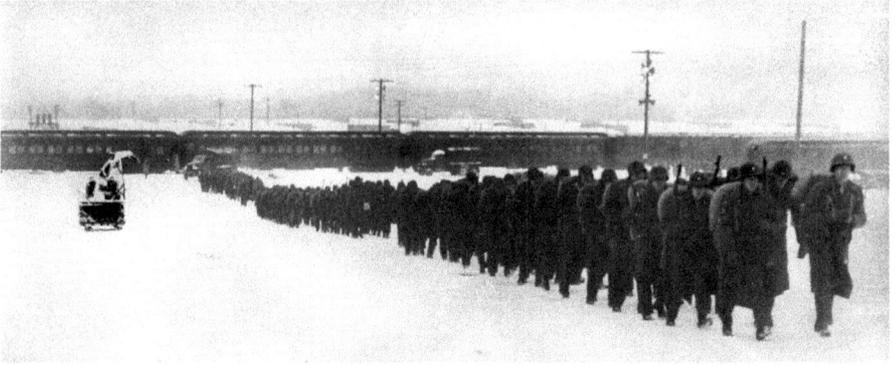

Troops arrive at Camp Shanks by train on this frigid day. After being assigned a barracks, a soldier would typically spend seven to twelve days at the camp for processing before being deployed. However, some spent as little time as two days. During this time, uniforms were issued, medical checks were made, financial papers were put in order, drills were conducted and information about life aboard ship was disseminated. Equipment was issued and tested, including gas masks, which each GI had to test in the camp's gas chamber. *Courtesy of the Orangetown Historic Museum and Archives. Photograph by the U.S. Army Signal Corps.*

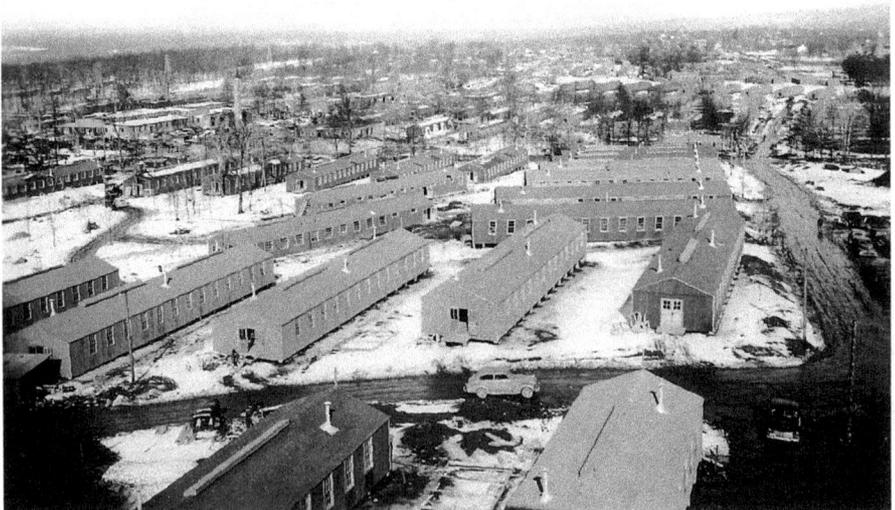

This photograph shows Area 3, a portion of Camp Shanks that was nearing completion in the spring of 1943. In total, there were eight designated areas throughout the camp. Though the entire project was completed in only eight months, reports of inefficiency, theft, corruption and social misdeeds among its huge workforce were rampant. The camp officially opened on January 4, 1943. *Courtesy of the Orangetown Historic Museum and Archives. Photograph by the U.S. Army Signal Corps.*

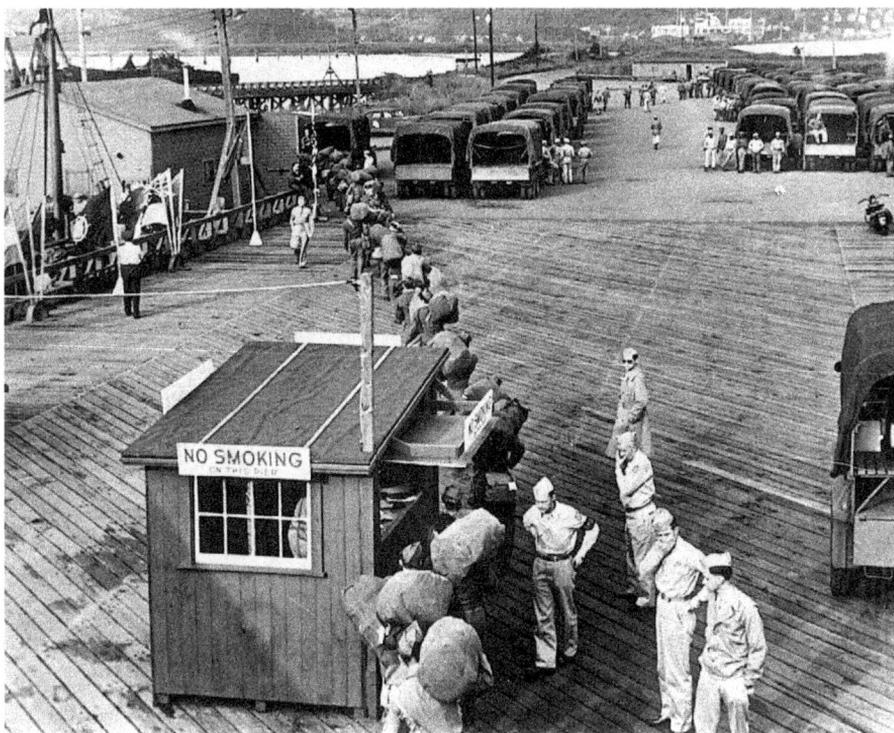

These troops arrived by ship along the Hudson River and are waiting to be shuttled by truck from Piermont to Camp Shanks, about a four-mile journey. *Courtesy of the Nyack Public Library. Photograph by the U.S. Army.*

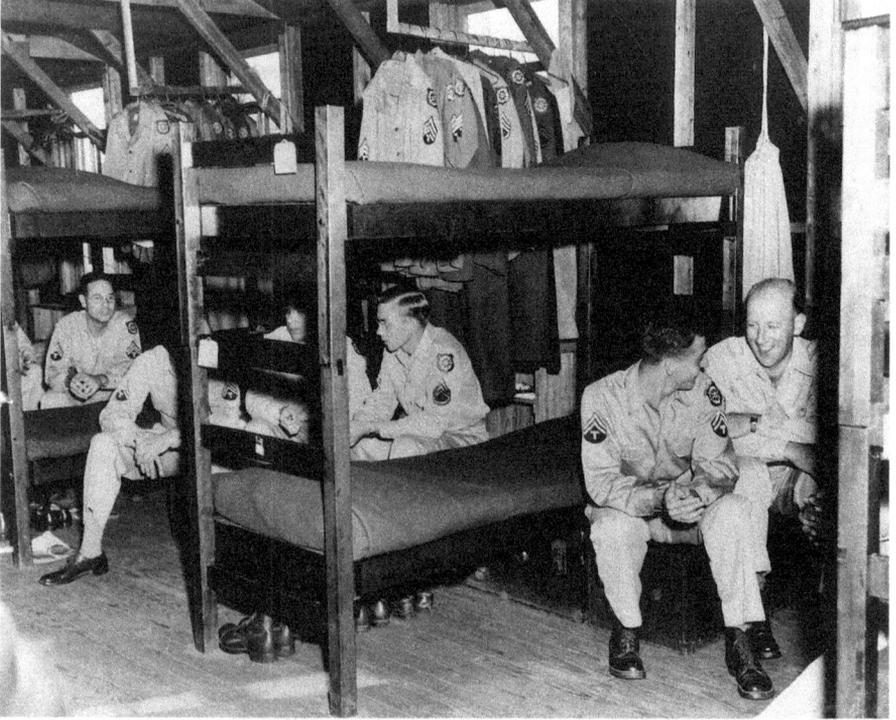

This photograph shows the interior of a typical barracks at Camp Shanks. The more than two thousand barracks could house up to almost forty-seven thousand troops at a time, in addition to permanent personnel. Each barracks measured twenty by one hundred feet. Heat was provided by three coal-burning potbellied stoves. African American soldiers were housed in separate facilities. *Courtesy of the Orangetown Historic Museum and Archives. Photograph by the U.S. Army Signal Corps.*

Camp Shanks

In May 1942, Congress passed a law creating the Women's Army Auxiliary Corps (WAAC) to work with the United States Army during World War II. Initially, the WAAC served to support the war effort by offering the skills, knowledge and special training that women could provide. The WAAC became part of the regular army and was renamed the Women's Army Corps (WAC) in 1943. Camp Shanks had a separate area for the four hundred WACs assigned to it. The section was posted with a sign warning that the area was for WACs and official business only. The women worked in many areas of the camp, including communications, the motor pool and the ordnance division. Leah Huber, left, and Erma Sargent McVicker pose at a WAC barracks. *Courtesy of the Orangetown Historic Museum and Archives. Photograph by Dorathea H. Daily.*

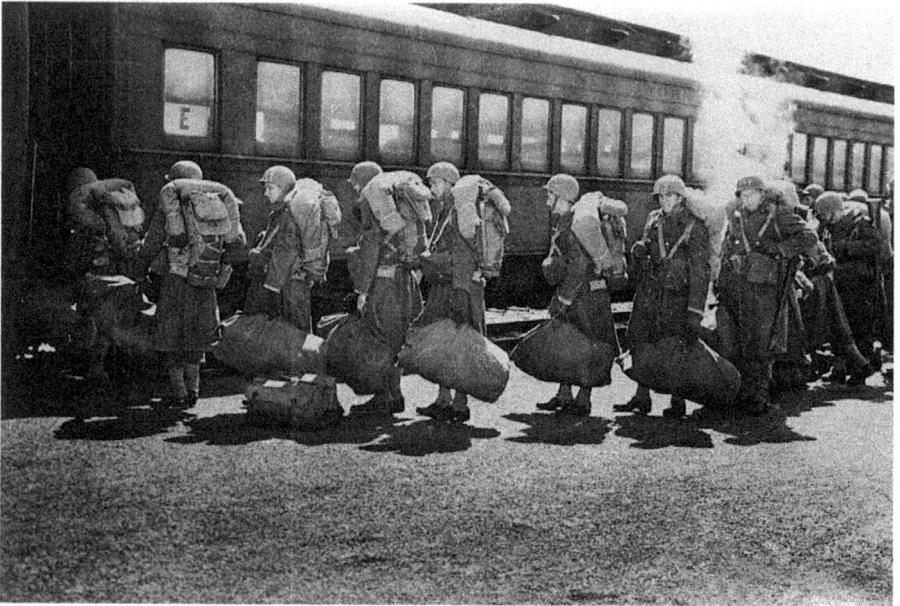

Troops carrying full gear board the train at the Orangeburg station for their trip downriver to New York Harbor, where they will embark for their transatlantic journey. The train station was a busy place with troops arriving and leaving twenty-four hours a day. *Courtesy of the Orangetown Historic Museum and Archives. Photograph by the U.S. Army Signal Corps.*

Camp Shanks

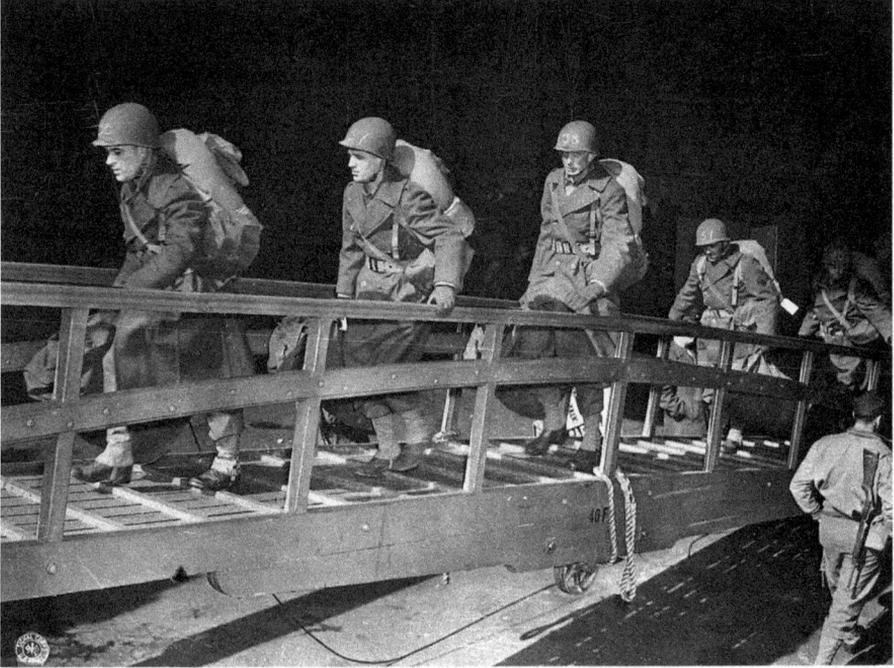

These GIs are departing Camp Shanks and will board ships for a direct cruise overseas. Even luxury liners, including the *Queen Elizabeth* and the *Queen Mary*, were used to transport both WACs and GIs. In addition to being splendidly outfitted, the large liners were speedy and safe. They could easily outpace enemy submarines, hence they needed no escort. *Courtesy of the Orangetown Historic Museum and Archives. Photograph by the U.S. Army Signal Corps.*

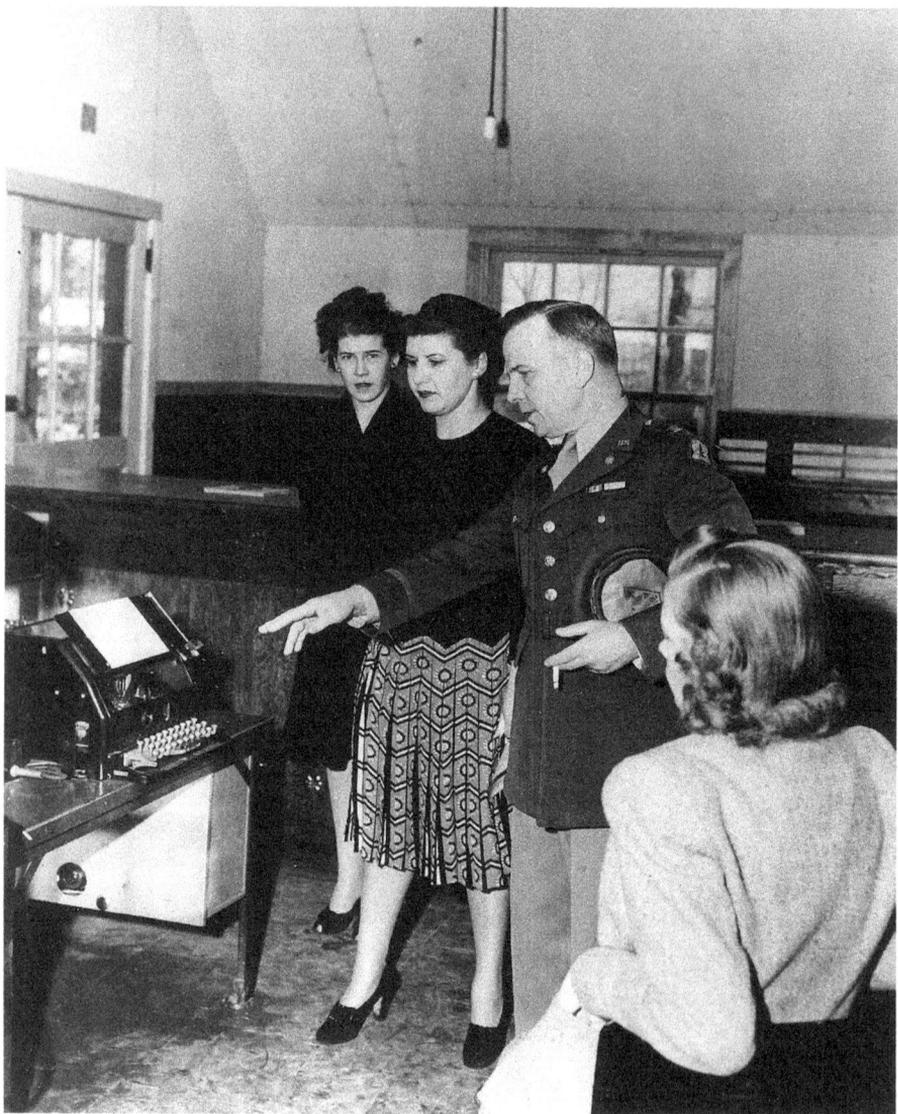

Base commander Colonel Kenna G. Eastham inspects the camp's switchboard operations on its opening day in January 1943. *Courtesy of the Orangetown Historic Museum and Archives. Photograph by the U.S. Army Signal Corps.*

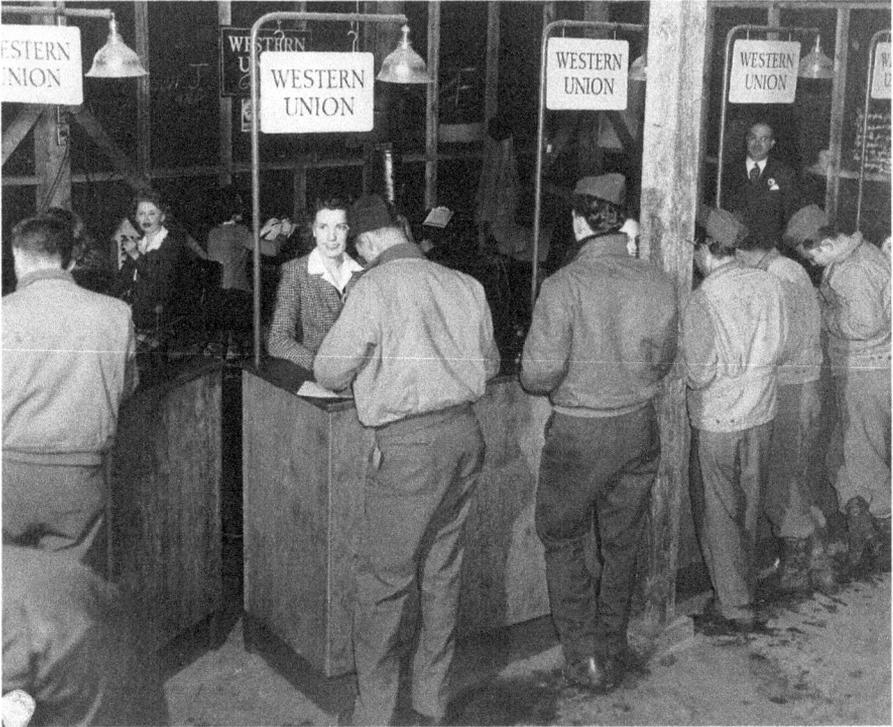

Among the many services available to the servicemen stationed at Camp Shanks was access to this Western Union office. The office was located on Orangeburg Road and operated twenty-four hours a day. This photograph was taken in 1945. *Courtesy of the Orangetown Historic Museum and Archives. Photograph by the U.S. Army Signal Corps.*

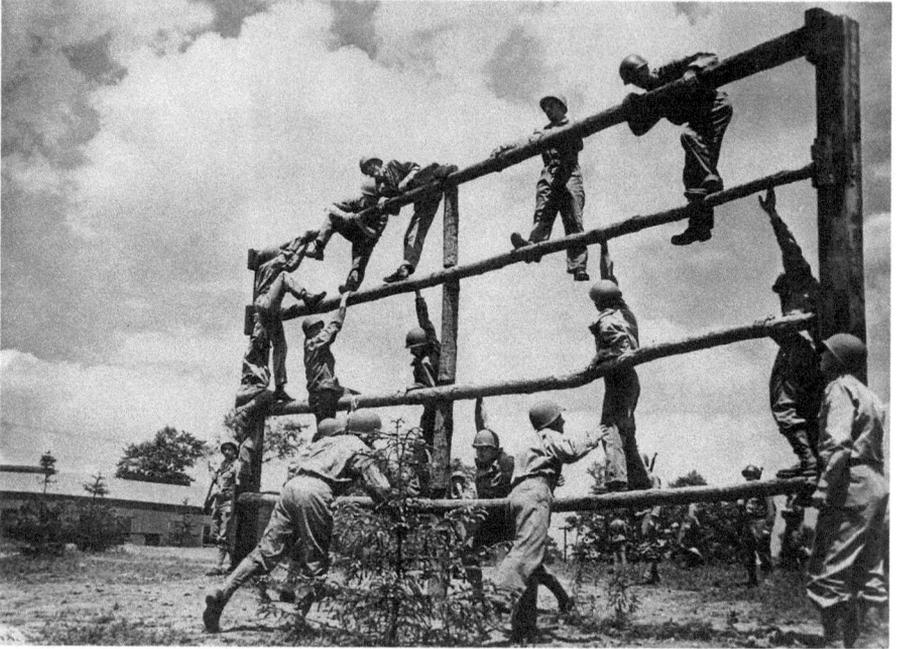

During their processing period, soldiers participated in drills to hone their physical skills. *Courtesy of the Orangetown Historic Museum and Archives. Photograph by the U.S. Army Signal Corps.*

The U.S. Army adopted Camp Shanks's method of cutting and freezing meat and began to employ the procedure at other bases. Supply officer Lieutenant Colonel Harry L. Calvin, left, and Captain Frayne are shown in this photograph. *Courtesy of the Orangetown Historic Museum and Archives. Photograph by the U.S. Army Signal Corps.*

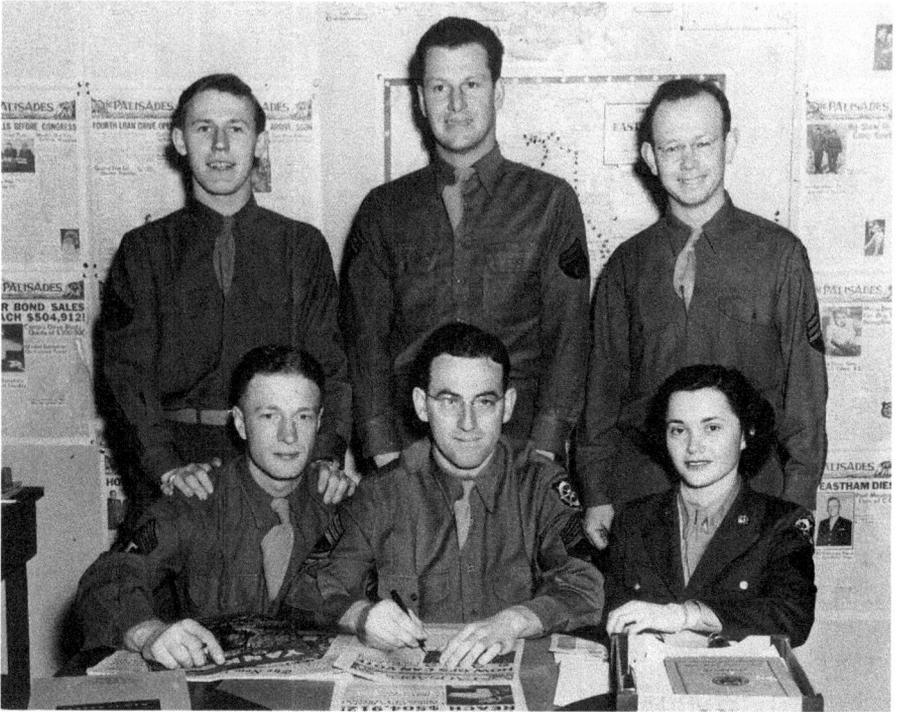

The *Palisades* was Camp Shanks's weekly newspaper from May 1943 to February 1946. The staff of the publication poses for this 1944 photograph. *From left to right, front row*: Ken Johnston, Master Sergeant George I. Bernstein and Barbara Herman. *Back row*: Dick Reynolds, cartoonist Bill Wenzel and Michael Sullivan. *Courtesy of the Orangetown Historic Museum and Archives. Photograph by the U.S. Army Signal Corps.*

Pictured here is a typical banner from the *Palisades*. This edition was volume I, number 32, published on December 24, 1943. The newspaper covered local events at Camp Shanks and reported on the war effort overseas. *Courtesy of the Orangetown Historic Museum and Archives.*

"This isn't that kind of Post Office, Reilly!"

Bill Wenzel's risqué cartoons relating to military life were such popular inclusions in the *Palisades* that many soldiers had the newspaper sent to them overseas just to view his humorous work. Famed cartoonist Milton Caniff, who inked *Terry and the Pirates*, was also a contributor, along with other local artists. *Courtesy of the Orangetown Historic Museum and Archives.*

Camp Shanks

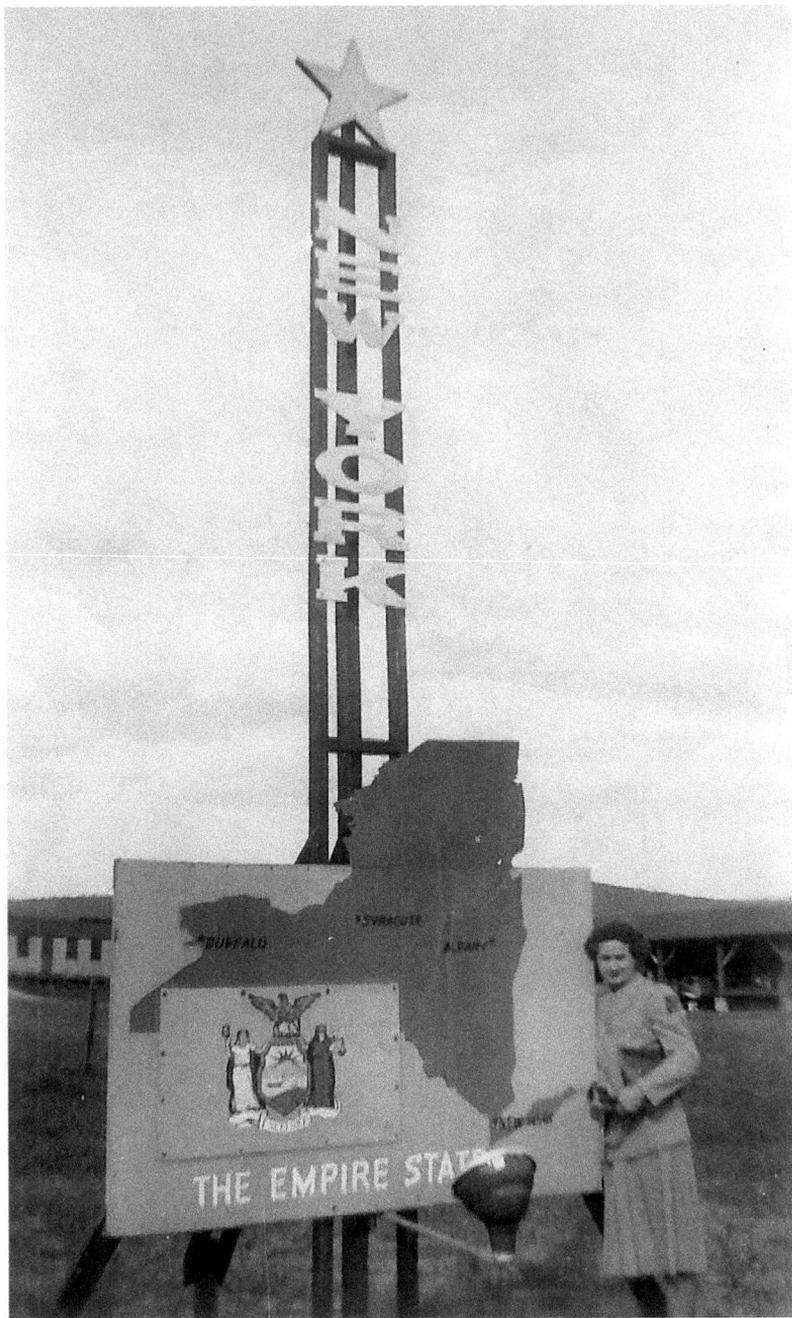

This photograph of a New York sign from the Avenue of the States at Camp Shanks was taken in September 1945. *Courtesy of the Orangetown Historic Museum and Archives, Scott Webber Collection.*

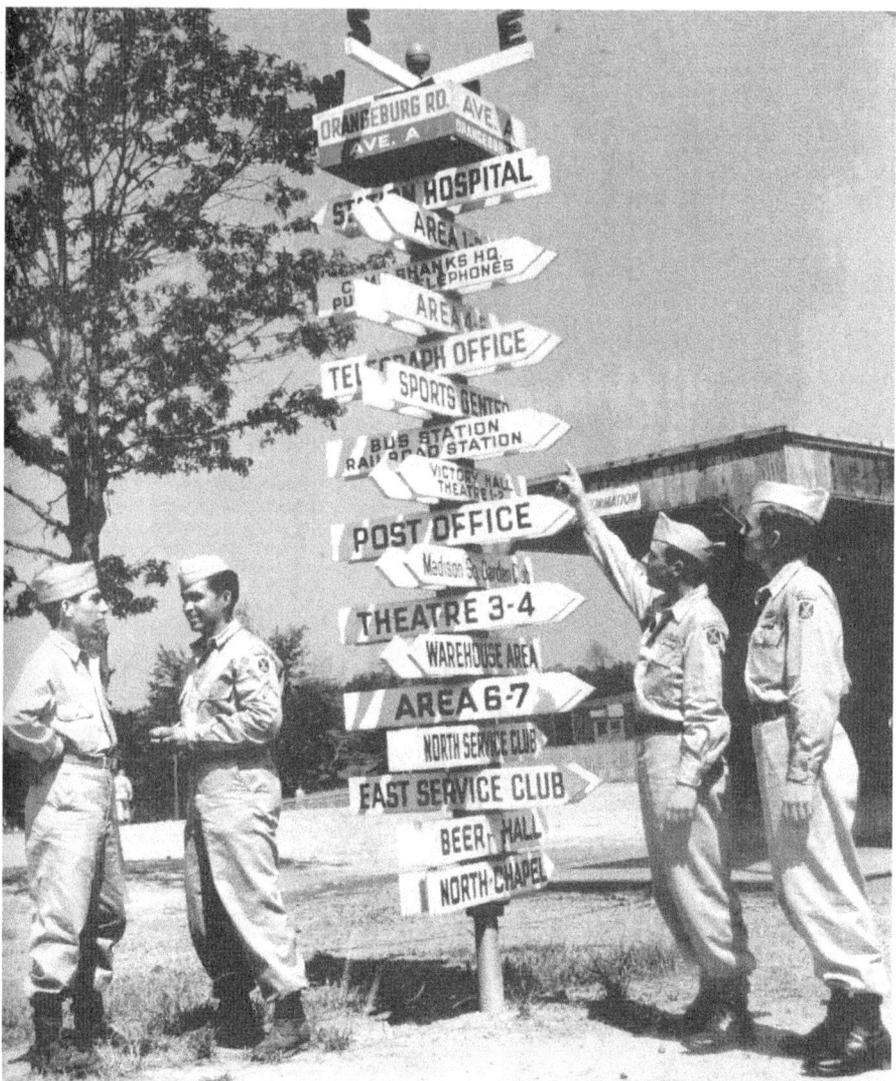

This directional sign located at Orangeburg Road and Avenue A helped the troops navigate the small city. Avenue A was later renamed Lester Drive. *Courtesy of the Orangetown Historic Museum and Archives. Photograph by the U.S. Army Signal Corps.*

Camp Shanks

Several water towers were part of the camp's complex infrastructure. Roads, sewers, pumping stations, pipes and electric lines added greatly to the $43 million in total construction costs. The towers also served as platforms for photographers looking for panoramic shots. *Courtesy of the Orangetown Historic Museum and Archives. Photograph by the U.S. Army Signal Corps.*

Troops had myriad options for entertainment during their stay at Camp Shanks. Ball fields, a bowling alley, a swimming pool, theatres, gymnasiums, lounges and concerts by celebrities were among those available. Four USO clubs served the military personnel. They were located in Nyack, Orangeburg, Pearl River and Tappan. This 1944 photograph shows the club at Tappan, the old Manse Barn building, located near the railroad station. The soldiers could avail themselves of special holiday events, dances, parties, billiards and lounges. Thanks to the dedicated assistance of individuals and groups from surrounding communities, the club was able to operate seven days a week from 1943 to 1946. The Nyack USO Club, located at 37 North Broadway, was a boon to the river town's economy. It is estimated that sixteen hundred soldiers made the journey each evening to enjoy the club and surrounding facilities. *Courtesy of the Orangetown Historic Museum and Archives, Scott Webber Collection.*

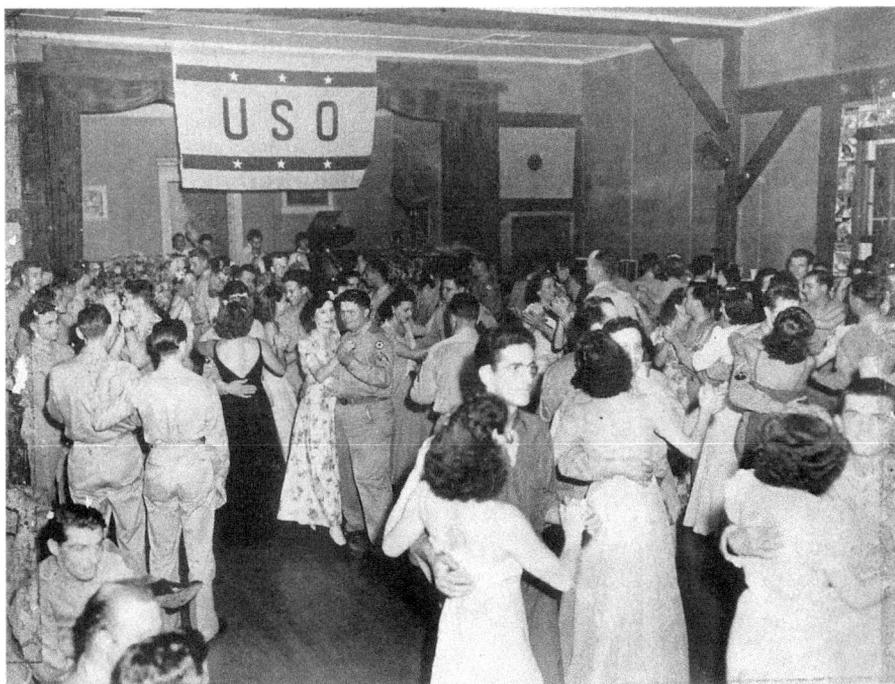

The dance floor is busy at the Tappan USO Club in this 1944 photograph. *Courtesy of the Orangetown Historic Museum and Archives, Scott Webber Collection.*

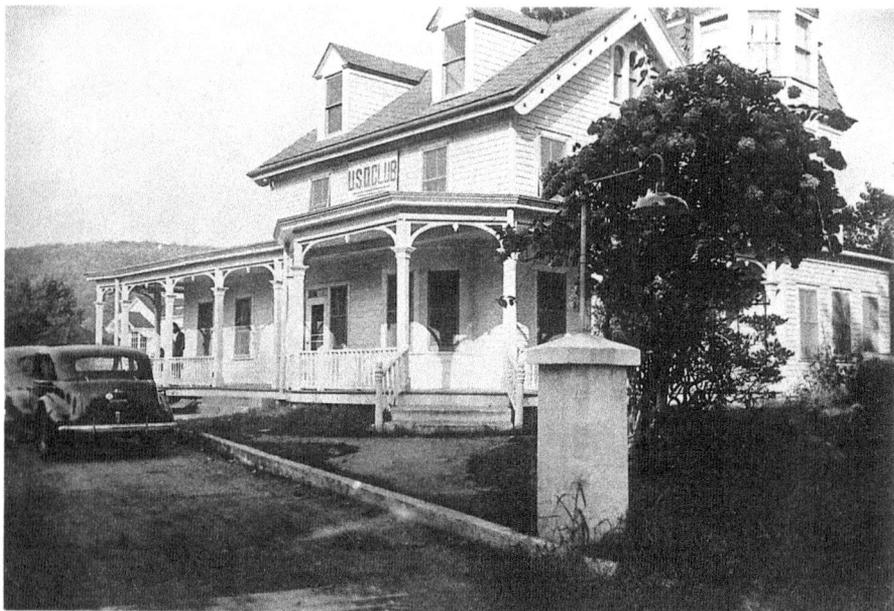

African American soldiers attended the USO Club in Orangeburg. It was located at the four corners intersection by Route 303. Heavyweight champion Joe Louis was a frequent visitor. *Courtesy of the Orangetown Historic Museum and Archives, Scott Webber Collection. Photograph by Elnora Minniefield.*

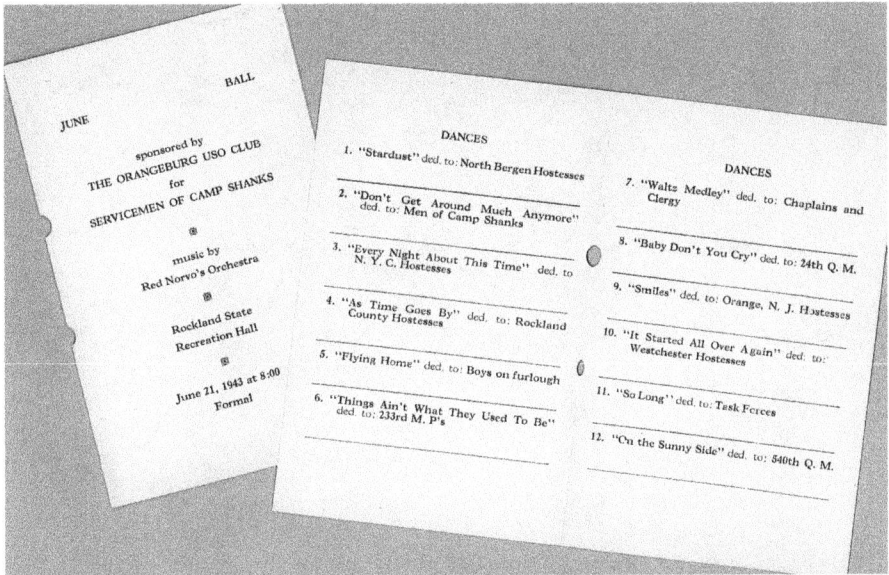

Dance cards were popular at the USO clubs. This one was printed for the June Ball at the Orangeburg USO Club in 1943. Ladies wore the cards on their wrists. Gentlemen wishing the favor of a dance would sign the card next to the song of their choice. *Courtesy of the Nyack Public Library.*

A modern bowling alley was constructed for the enjoyment of the camp's troops and staff. *Courtesy of the Orangetown Historic Museum and Archives. Photograph by the U.S. Army Signal Corps.*

Camp Shanks

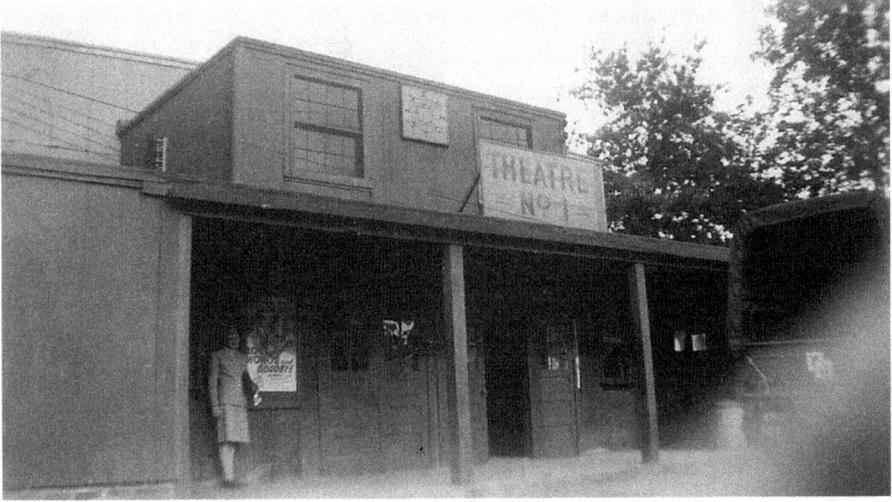

A WAC poses in front of Theatre Number One. It was one of six theatres that not only showed films but also provided venues for lectures. An amphitheatre was located on Oak Street. It hosted concerts and appearances by many of the biggest names in show business. *Courtesy of the Orangetown Historic Museum and Archives. Photograph by the U.S. Army Signal Corps.*

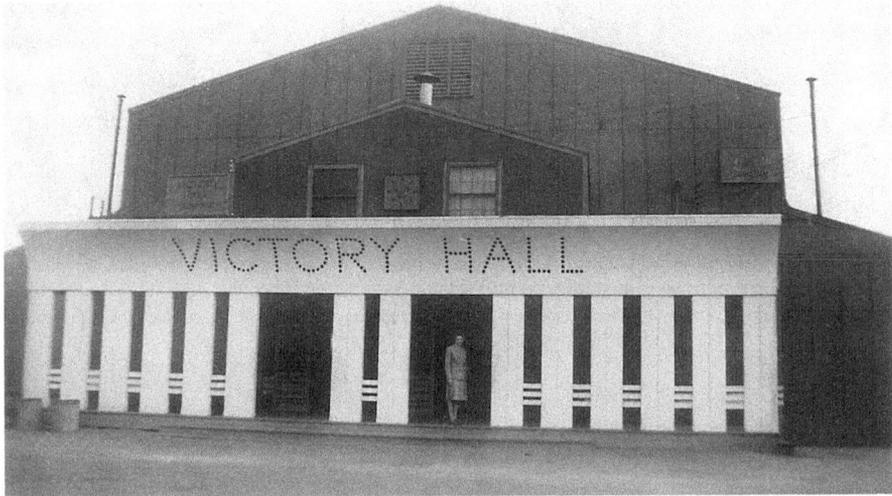

Victory Hall opened in March 1944. The service club was housed in a renovated Area 5 building. The auditorium hosted movies. Additional amenities included a soda fountain, a lounge, a pool table, a ping-pong table, jukeboxes, vending machines and a library. Its cafeteria provided an alternative to mess hall food. *Courtesy of the Orangetown Historic Museum and Archives, Scott Webber Collection.*

This library and lounge were part of the main service club. These rooms provided a peaceful environment so that soldiers could relax, read, reflect and write letters to loved ones back home. *Courtesy of the Orangetown Historic Museum and Archives, Scott Webber Collection.*

Chicago Cubs
vs.
Camp Shanks

POST ATHLETIC FIELD
AUGUST 23rd 1943 3 P.M.

★ ★ ★ ★

"If you can't participate in sports, be one."

—*Christy Mathewson*

★

SCORE CARD

BILL NICKELSON
Home Run Leader

Camp Shanks attracted not only show business celebrities but also Major League baseball teams. The Chicago Cubs, the St. Louis Cardinals, the Brooklyn Dodgers, the Philadelphia Athletics, the New York Yankees and the Philadelphia Phillies all played exhibition games against the camp's team between 1943 and 1945. *Courtesy of the Nyack Public Library.*

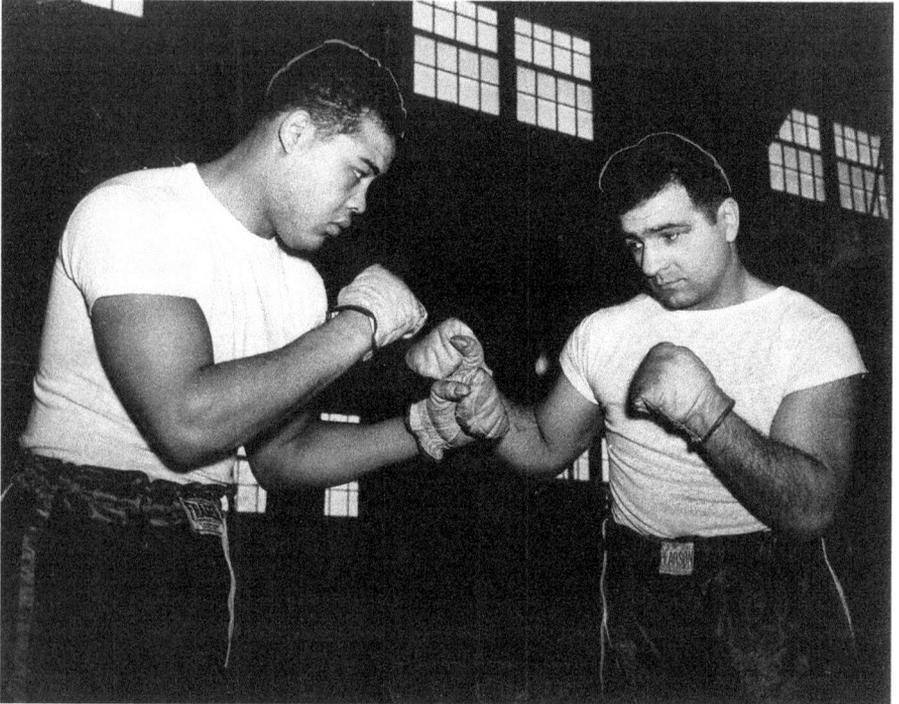

Sergeant Joe Louis, heavyweight champion of the world for almost twelve years, spent time at Camp Shanks during the war years. As part of the Special Services Unit, Louis boosted troop morale just by his mere presence, not only at Shanks but also at other bases around the country and in Europe. A quiet man, Louis often kept in shape by jogging around the streets of Orangeburg. In this photograph, he spars with light-heavyweight Melio Bettina at Camp Shanks. Bettina had a fairly successful career as well. *Courtesy of the Orangetown Historic Museum and Archives. Photograph by the U.S. Army Signal Corps.*

Camp Shanks

This picture shows popular entertainer Pearl Bailey performing with the Cootie Williams Band in 1944 at Rockland State Hospital's large auditorium. The hospital facilities were leased from New York State. A long list of celebrities passed through the camp throughout the war years, including Frank Sinatra, Jackie Gleason, Shirley Temple, Betty Grable, Mickey Rooney, Jack Benny, Humphrey Bogart, Lionel Hampton, Dinah Shore, Judy Garland, Ethel Merman, Benny Goodman and Henny Youngman. *Courtesy of the Orangetown Historic Museum and Archives, Scott Webber Collection.*

Frank Sinatra visited Camp Shanks in 1944. The popular singer visited many bases at home and abroad to support the troops and the war effort. *Courtesy of the Orangetown Historic Museum and Archives. Photograph by the U.S. Army Signal Corps.*

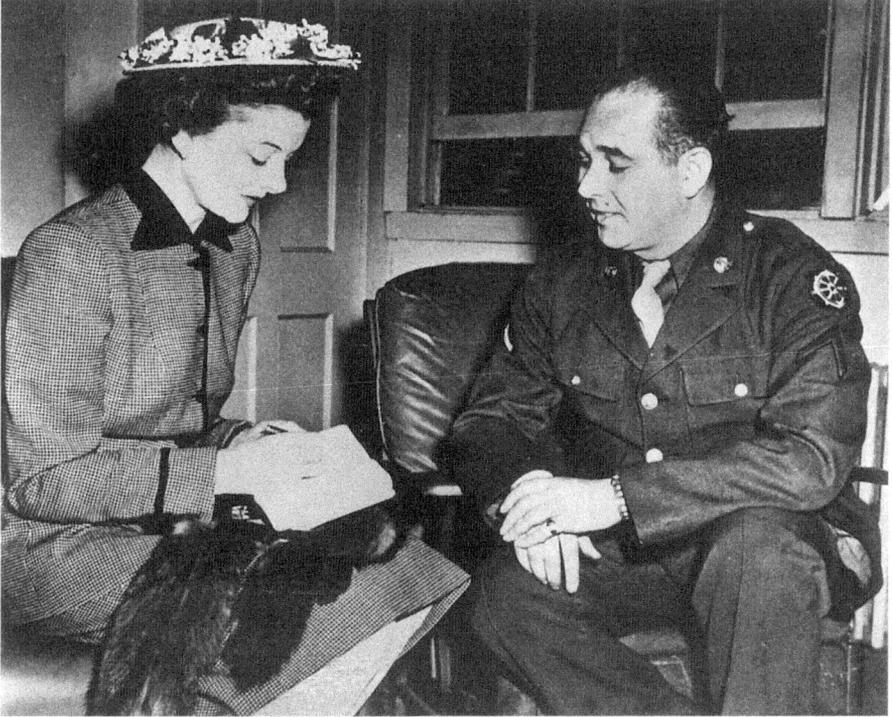

In this photograph, actress Myrna Loy signs an autograph on a visit to the camp. *Courtesy of the Orangetown Historic Museum and Archives. Photograph by the U.S. Army Signal Corps.*

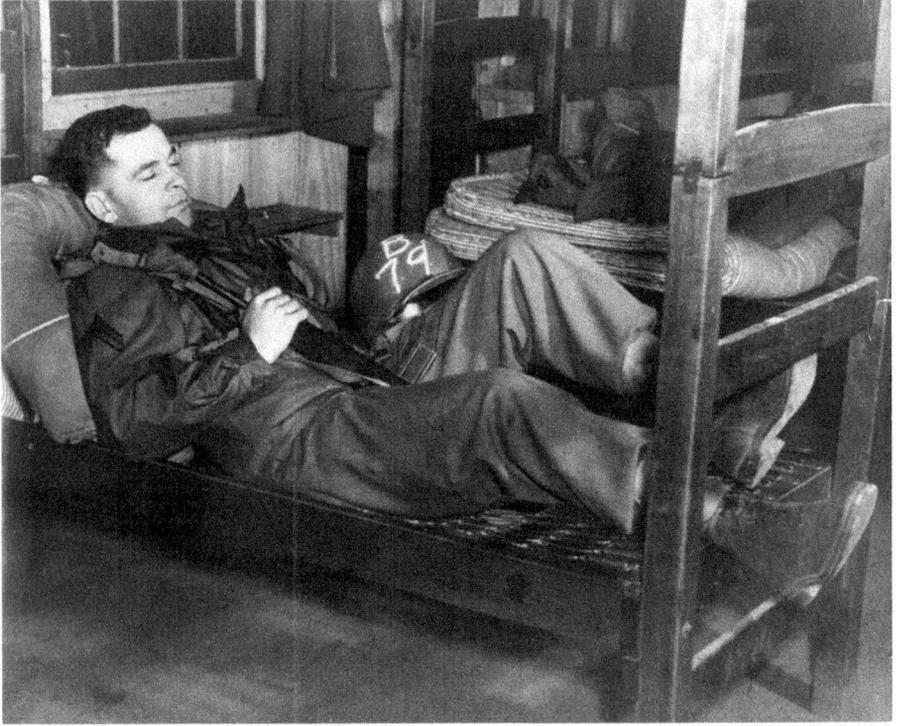

Corporal James Fitzgerald was designated the millionth soldier housed at Camp Shanks. The corporal arrived at Camp Shanks with his field artillery unit on December 9, 1944, and left the camp on December 16, 1944. He was thirty years old, having been born in Lisbon Falls, Maine, on April 29, 1914. During the war, Corporal Fitzgerald manned an eight-inch howitzer gun. *Courtesy of the Orangetown Historic Museum and Archives. Photograph by the U.S. Army Signal Corps.*

Soldiers returning to Camp Shanks were treated to a steak dinner and all the milk they could drink. *Courtesy of the Orangetown Historic Museum and Archives. Photograph by the U.S. Army Signal Corps.*

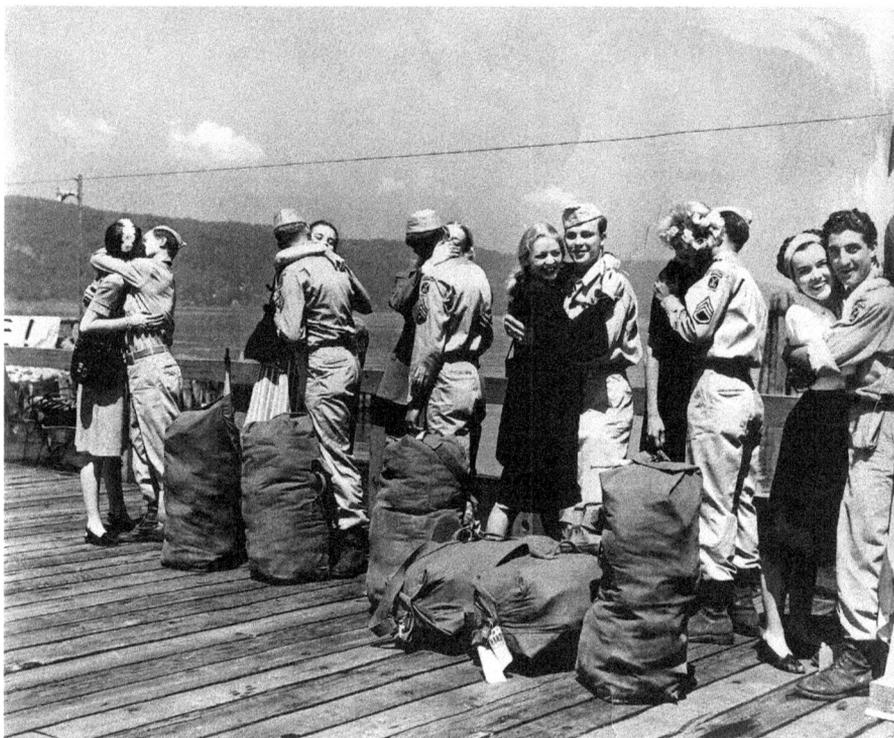

After the war ended, United States soldiers passed through Camp Shanks before being sent to bases near their homes. This photograph depicts a typical scene of returning soldiers being greeted by happy girlfriends or wives at Piermont along the Hudson River. *Courtesy of the Orangetown Historic Museum and Archives. Photograph by the U.S. Army Signal Corps.*

Camp Shanks

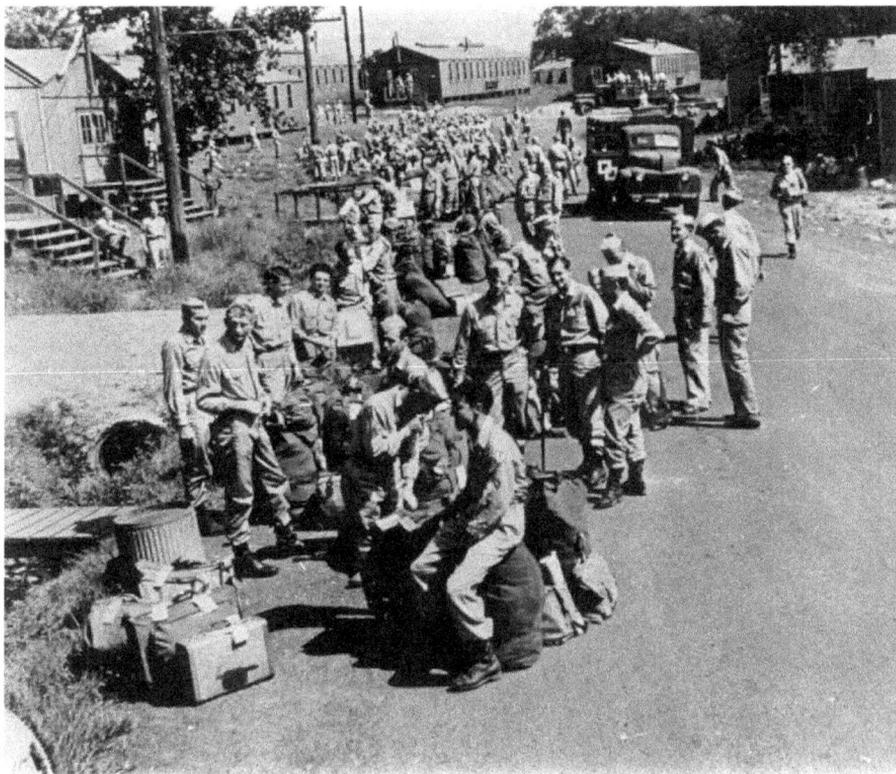

This photograph was taken in August 1945. It shows troops from the Eighty-fifth Infantry Regiment, Tenth Mountain Division, awaiting transfer to Camp Meade in Maryland. *Courtesy of the Orangetown Historic Museum and Archives. Photograph by the U.S. Army Signal Corps.*

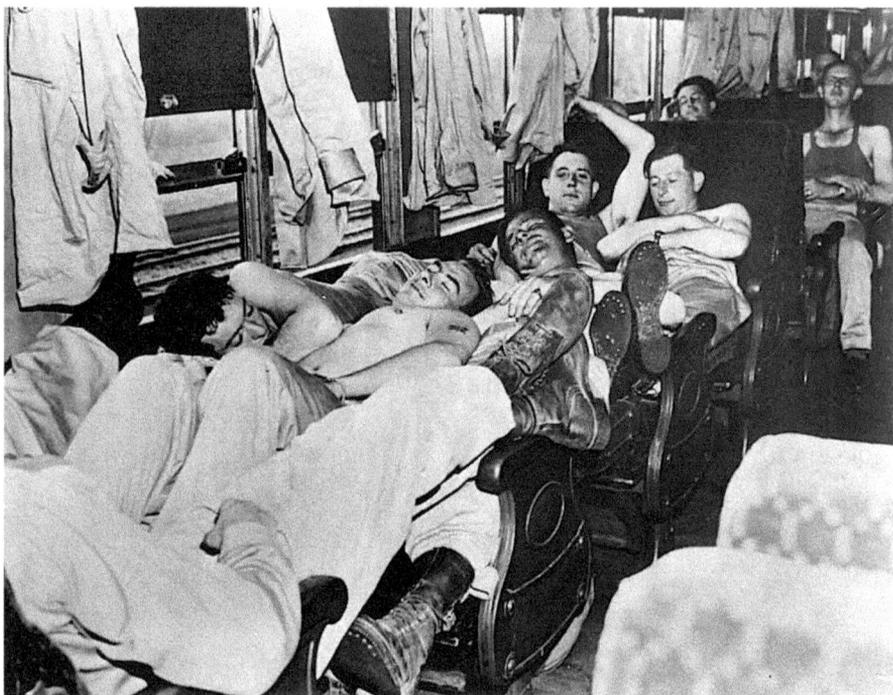

War veterans relax aboard a train leaving Camp Shanks in July 1945. The train will take them to Camp Lewis in Washington. The uncomfortable sixty-five-hour journey was probably well tolerated by the troops considering all that they had been through. These trains were scheduled to leave from the camp several times a day at the war's conclusion. *Courtesy of the U.S. Army.*

Camp Shanks

The first prisoners of war (POWs) to arrive at Camp Shanks were Italian. When Italy surrendered in September 1943 and became an ally, these prisoners were given special privileges. Many of them had relatives in New York City and Westchester County who were allowed to visit the camp on weekends. This picture shows Italian POWs picnicking with relatives. *Courtesy of the Orangetown Historic Museum and Archives. Photograph by the U.S. Army Signal Corps.*

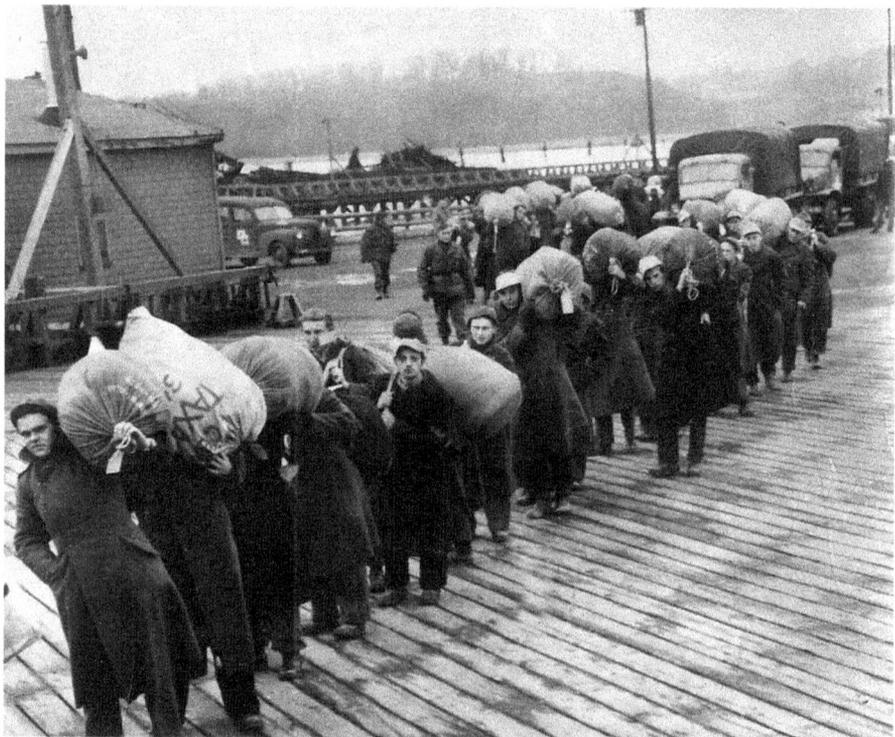

Over 400,000 POWs were held in the United States during World War II. Many of them were processed at Camp Shanks before being sent to detention centers throughout the country. Arriving German prisoners are shown here. *Courtesy of the Orangetown Historic Museum and Archives. Photograph by the U.S. Army Signal Corps.*

Camp Shanks

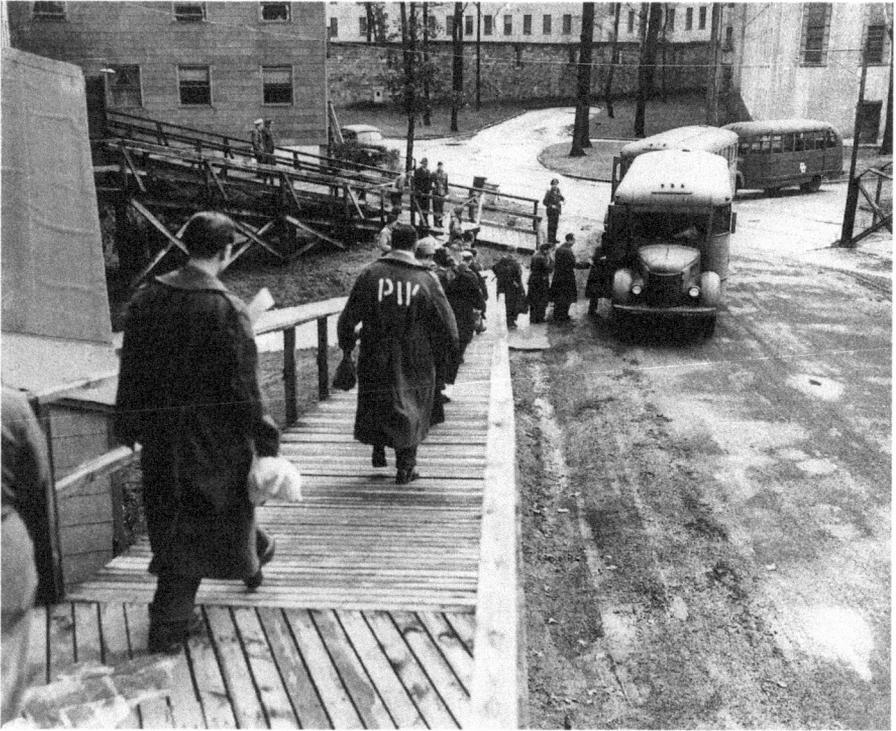

Camp Shanks was never a permanent POW camp. Prisoners spent between two weeks and several months at the camp. German prisoners, wearing PW jackets, are leaving their barracks to be transported by bus. At the end of the war, 290,000 prisoners were processed at Camp Shanks before they were sent back to Europe. At the same time, American troops were returning to Camp Shanks for redeployment to their home bases. Camps Shanks was now ready for its next transformation. *Courtesy of the Orangetown Historic Museum and Archives. Photograph by the U.S. Army Signal Corps.*

CHAPTER 5

SHANKS VILLAGE

The PhD Pad

Barely had the last prisoners of war departed for repatriation when the War Department began formulating ideas for Camp Shanks's next phase. Some discussions centered on converting the property into a national cemetery similar to the one in Arlington. While the idea received some support among the nearby communities, another plan quickly evolved.

Columbia University's enrollment started to spiral as veterans enrolled under the GI Bill. The housing shortage surrounding the campus forced its administrators to seek housing outside of the city. In July 1946, Columbia agreed to sponsor emergency housing for matriculates and their families at the camp's site. Roughly fifteen hundred of the original twenty-four hundred Camp Shanks barracks would be allocated for some four thousand families. The site would be managed by the federal Public Housing Administration. In addition, some of the remaining barracks were intended for returning veterans who did not attend college. Camp Shanks was now a memory. Baby carriages had replaced guns.

In September 1946, the transformation from Camp Shanks to Shanks Village came to fruition when the first residents moved into their new homes. The barracks were subdivided into three apartments, most consisting of two bedrooms, a living room, a kitchen and a bathroom, although some studio and three-bedroom units were offered. Life at the new village was lively. Families grew at a rapid rate. Tennis courts, ball fields and playgrounds were constructed. Club activities, a community center and a library provided opportunities for socializing. The village had its own theatre group and newspaper. A post office, a firehouse, a supermarket, a bakery and other shops sprang up to provide for essential needs. The village thrived.

The community was integrated—and not only racially. Former officers now lived side by side with former enlisted men. Crime was almost nonexistent.

Children frolicked in open areas, and many enjoyed the activities in the village's nursery school. From a sociological standpoint, the village was intriguing enough to lure famed anthropologist Margaret Mead to pay a visit.

But by 1951, Columbia had withdrawn its sponsorship, as most of the veterans had completed their studies. The writing was on the wall. With the opening of the Palisades Interstate Parkway and the scheduled completion of the Tappan Zee Bridge, the area was considered a prime location for suburban development. Shanks Village managed to exist until 1956, when its last tenants were asked to leave. The "PhD Pad" or the "Baby Factory," as the village was affectionately called, was sold to developers. But many residents chose to remain in Rockland County. The now lost town had provided thousands with opportunities to improve their lot in an environment of safety and affordability.

Today, a veteran, a former villager or their family members who return to visit the past will find suburban development overwhelming the few reminders of the once bustling area that comprised Camp Shanks and Shanks Village. Perhaps the most imposing of these memorials is the Camp Shanks Museum in Orangeburg, built through the efforts of a number of dedicated individuals. It is located adjacent to the Orangeburg Library, originally the Orangeburg School, where it all began in 1942. It is hard to imagine another area that had an impact on so many lives in such a short span of time.

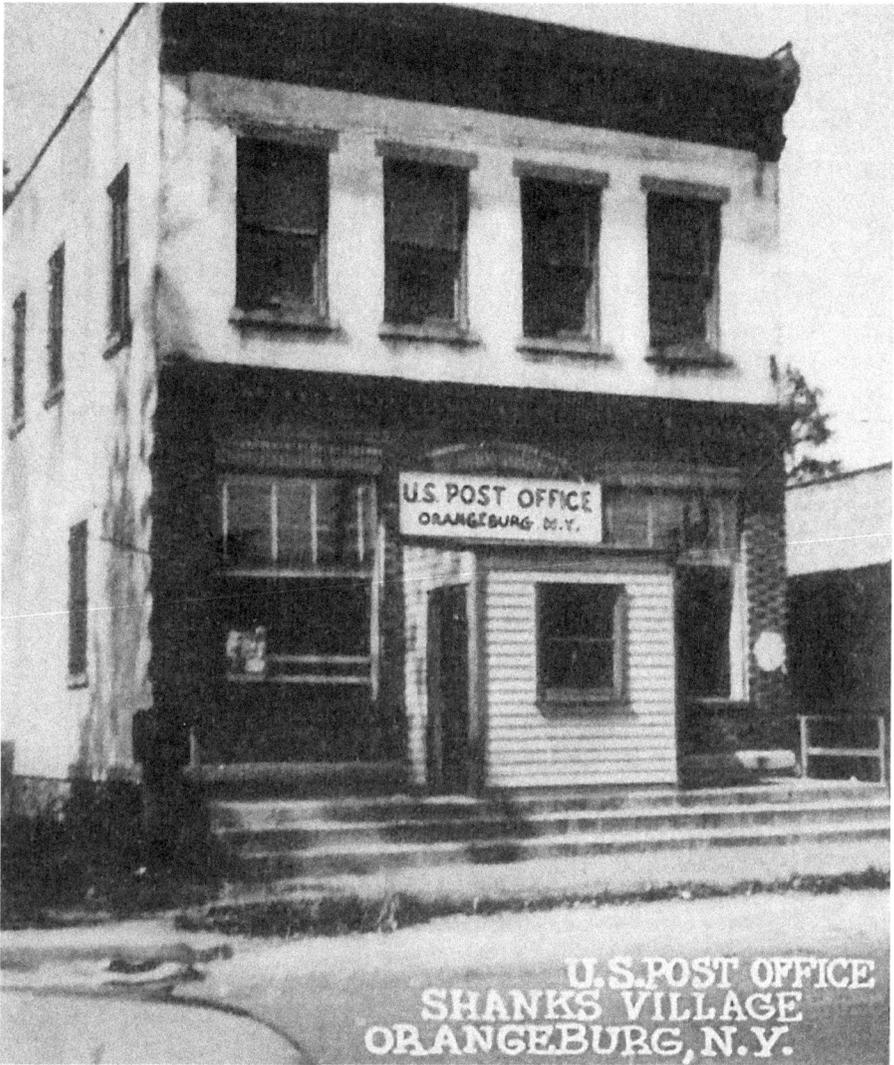

The population of Shanks Village quickly soared as the "Baby Boom" took hold. Half of the total population represented an ever-growing number of children. Shanks Village merited its own post office, as pictured here. The village also had a fire department. *Courtesy of the Orangetown Historic Museum and Archives.*

SHANKS VILLAGE

I JUNE 1948

SCALE IN FEET ~

0 500' 1000'

AREA 1

WEST GREEN LANE

WEST LANE

W. 101 ST.

W. 102 ST.

W. 104 ST.

W. 105 ST.

GREEN LANE

W. 106

W. 107 ST.

W. 108 ST.

FIRE HOUSE #2

TAPPAN

BUSH HILL R

BURG

ORANGE-

W. 2

AVENUE A

AVENUE A

WASHINGTON AVE.

AVENUE B

COMMUNITY CENTER

SCHOOL DIST #5

SCHOOL DIST #2

INT FAI CH

COMMUNITY

WEATHER

TO TAPPAN

WESTERN HIGHWAY

CEMETARY RD

TO TAPPAN

NYCRR

TO 303

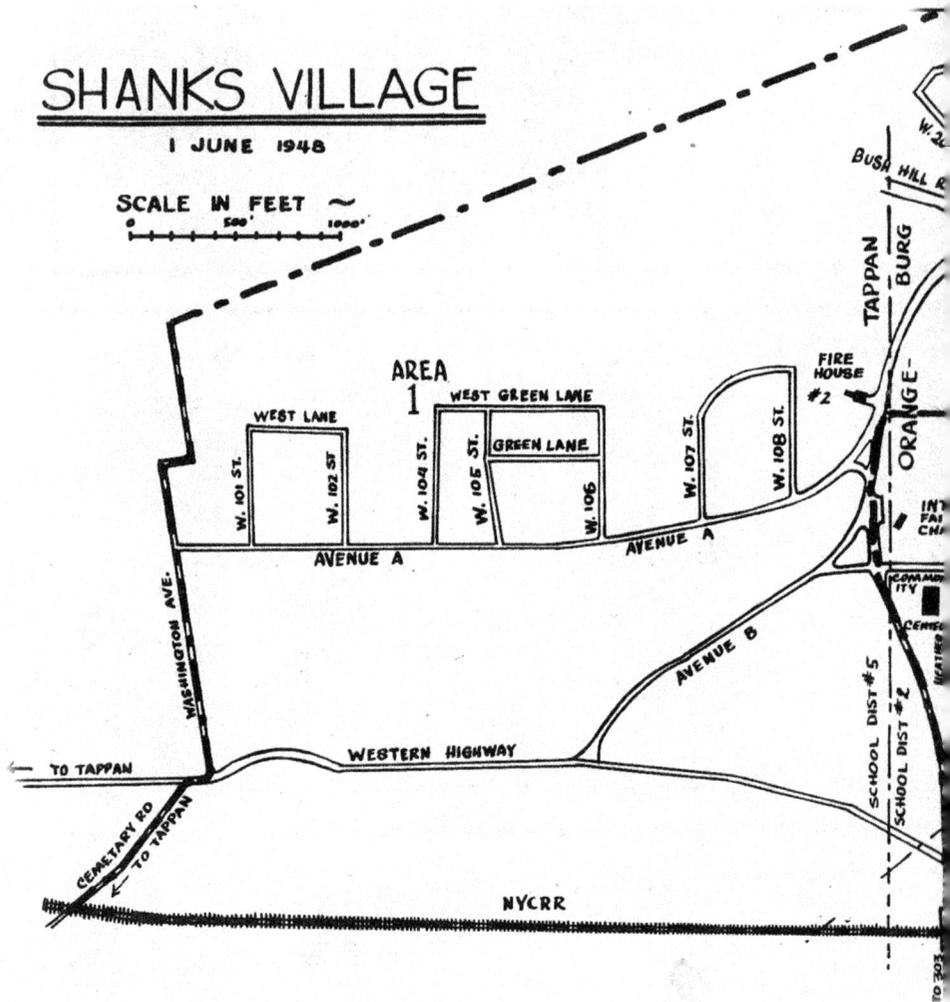

The last prisoners of war left Camp Shanks on July 22, 1946. The compound did not remain virtually deserted for long, however. The War Department began the necessary planning to create Shanks Village. The village would utilize many of the remaining barracks to house its returning veterans and their families. Most of these veterans were now college students studying under the GI Bill. Most attended Columbia University. When bus fares to Manhattan rose, the financially constrained students made carpool arrangements at the village. Many times throughout the day, students could be seen carrying books and their next meal as they piled into waiting cars. Specified blocks in

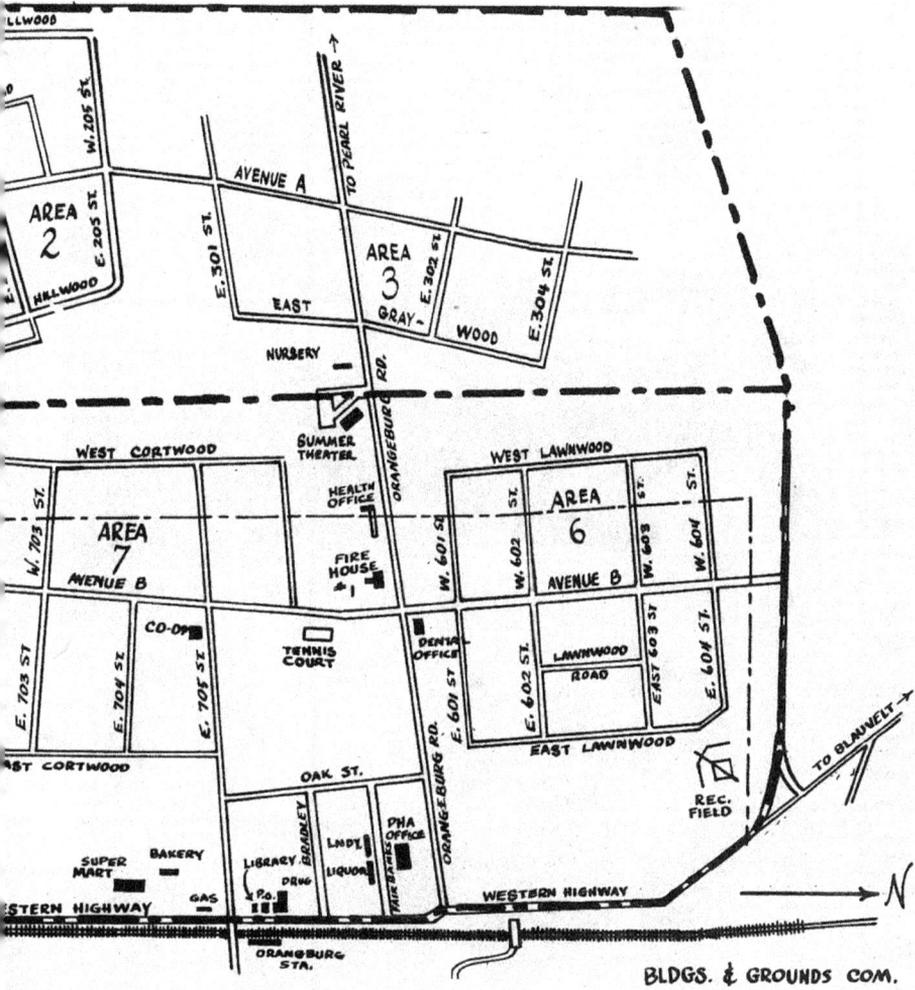

upper Manhattan were pick-up points for the return trip to the village. Accommodations in the village were Spartan. The subdivided barracks were poorly insulated, both against weather and noise. Portable oil heaters worked overtime during the Great Blizzard of 1947. Neighbor could often overhear neighbor. Electric service was marginally acceptable, and the iceboxes frequently leaked. In some units, kitchen sinks became makeshift bathtubs for children. But the starting rent of thirty-five dollars per month for a two-bedroom unit outweighed most inconveniences in the quest to be a part of the American dream. *Courtesy of the Orangetown Historic Museum and Archives.*

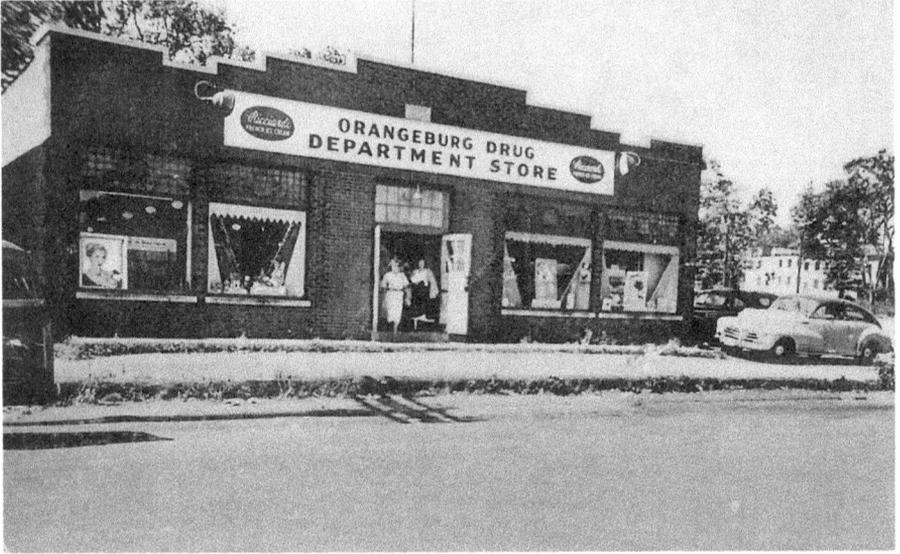

The Orangeburg Drug and Department Store, locally known as "Sid's," serviced residents of the village for years. It replaced the former store, which had operated out of a barracks on Western Highway. The store closed in the mid-1960s. *Courtesy of the Orangetown Historic Museum and Archives.*

Shanks Village

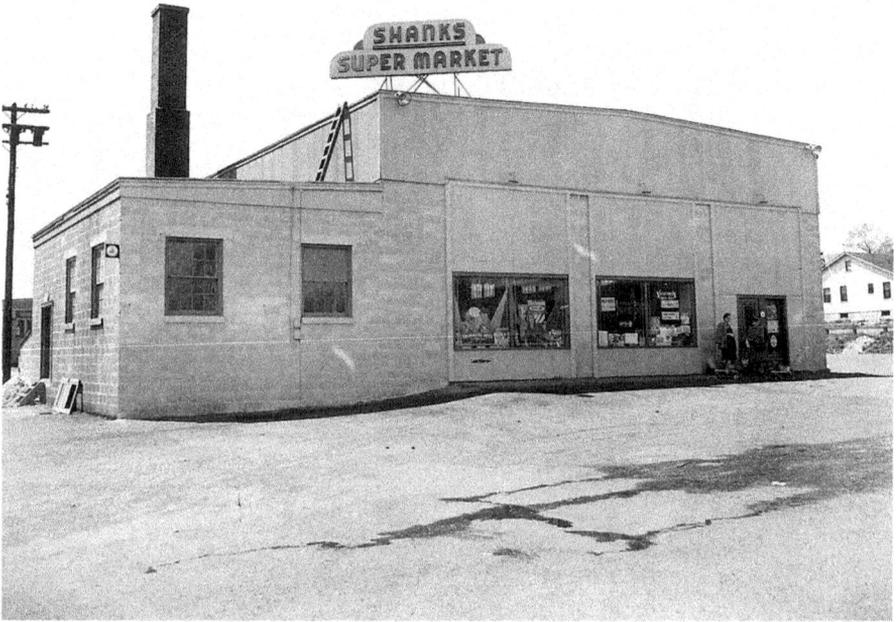

Located on Western Highway opposite the railroad station, the Shanks Super Market offered a variety of items, but not necessarily at the lowest prices. Within one year of its opening, Shanks Village residents organized to form their own co-op food market. The resourceful residents sold shares for five dollars each and ran the enterprise very efficiently. *Courtesy of the Orangetown Historic Museum and Archives.*

This co-op advertisement ran in the *Shanks Villager*, the town's own newspaper. *Courtesy of the Orangetown Historic Museum and Archives.*

Al S. Wilde was the proprietor of Al's Barber Shop, a fixture in the community. His business was located opposite the Orangeburg School, which is now the public library. *Courtesy of the Orangetown Historic Museum and Archives.*

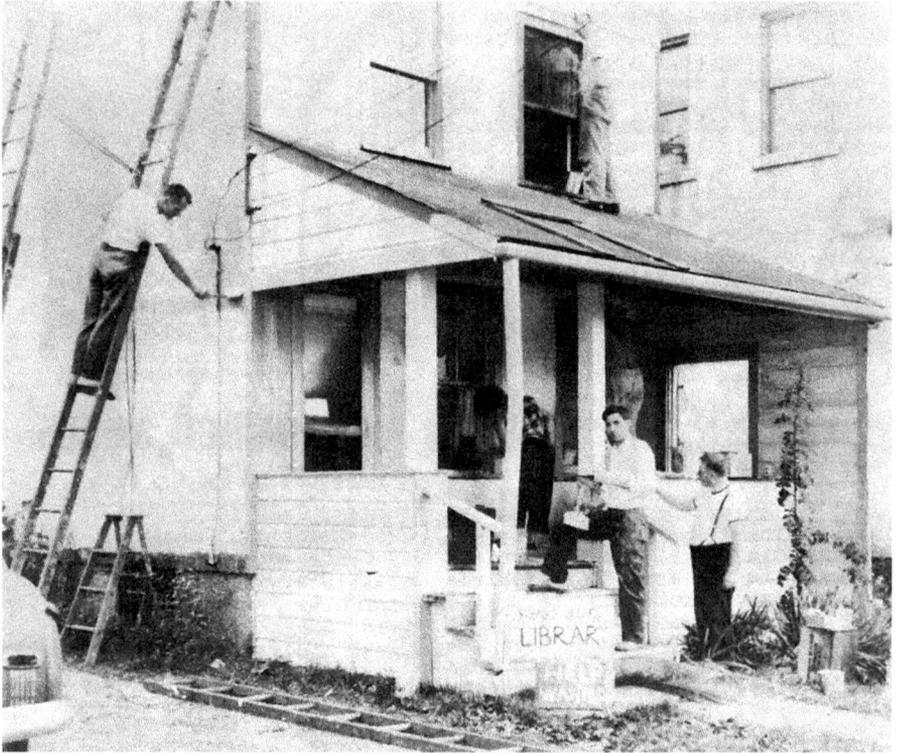

On a sweltering summer day in July 1951, a group of Shanks Village residents volunteered to spruce up the library. About the same time, a housing survey revealed that 63 percent of the residents were planning to make Rockland County their permanent home. *Courtesy of the Orangetown Historic Museum and Archives. Photograph from the* Shanks Villager.

Shanks Village

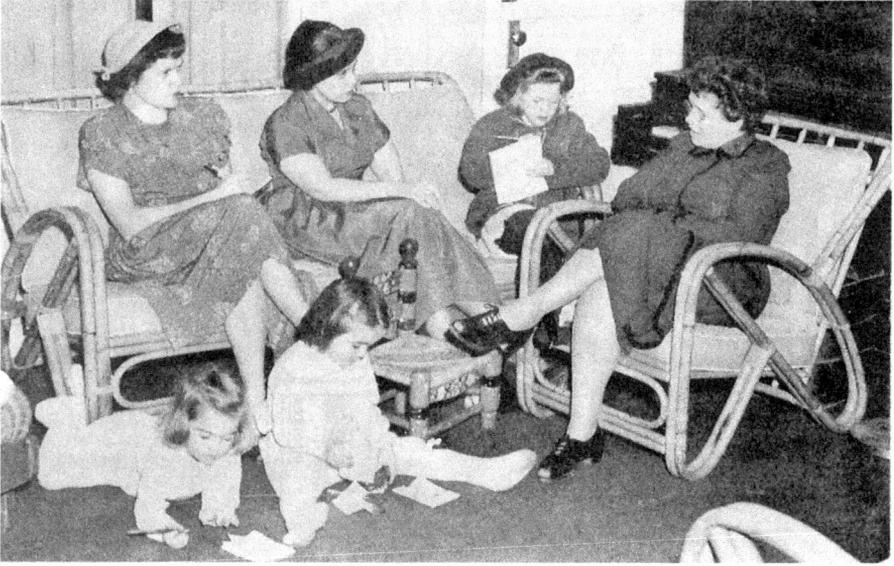

Famed anthropologist Margaret Mead had heard about Shanks Village and paid it a visit. In this photograph, she is seated on the right as she is being interviewed. Mead delivered a lecture to 150 Shanks Village residents in November 1950. She stressed the importance of raising a "flexible" child, one who could readily adapt to a rapidly changing world. Eleanor Roosevelt also delivered a lecture in April 1950. Residents paid one dollar to hear her. Roosevelt called the village "inspiring." *Courtesy of the Orangetown Historic Museum and Archives. Photograph from the* Shanks Villager.

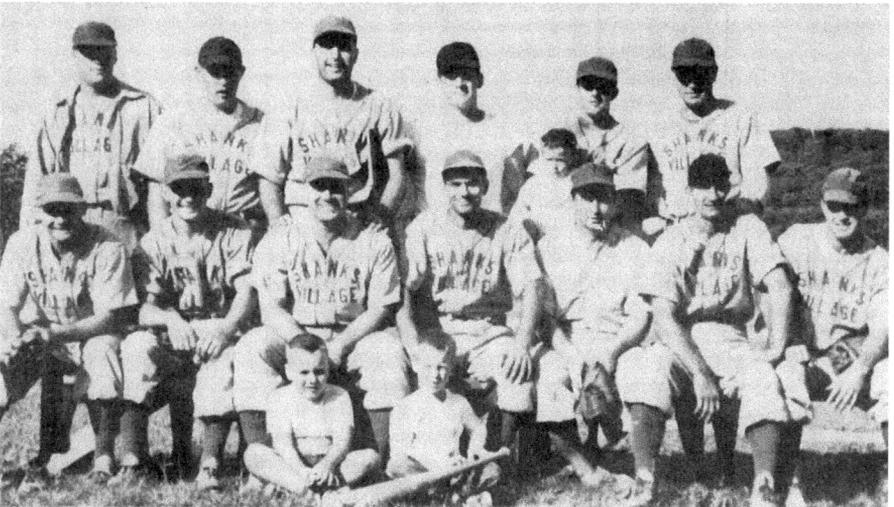

A Shanks Village baseball team poses proudly after it handily defeated a team from Teaneck, New Jersey. Basketball was also very popular at the village. *Courtesy of the Orangetown Historic Museum and Archives. Photograph from the* Shanks Villager.

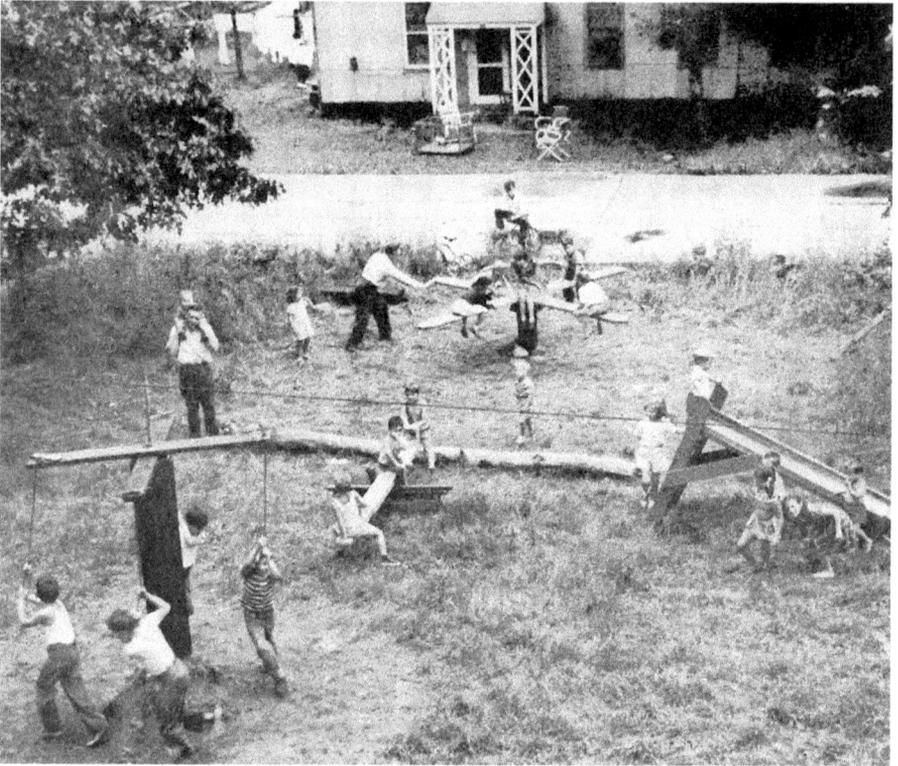

Neighbors got together to create this playground, replete with a merry-go-round, swings, a sandbox, a tire swing, two wading pools, a climbing ladder and a climbing pole. Thanks to volunteers and contributions of materials, the residents were proud to report that the project's cost was held to fifteen dollars. *Courtesy of the Orangetown Historic Museum and Archives. Photograph from the* Shanks Villager.

Shanks Village

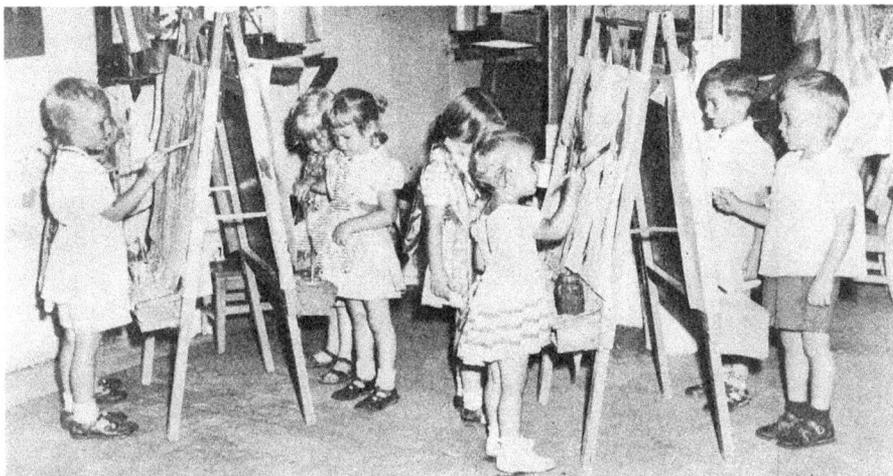

Children hone their painting skills at the Shanks Village nursery school. The nursery was formed in the fall of 1946. Its director was Mary Prager. Teachers were paid seventy-seven dollars per month. Parents paid four dollars per month for each child enrolled in the program. By 1949, fifty children attended the school, which was housed in the old Camp Shanks library building. Dwight D. Eisenhower, when he was president of Columbia University, paid a visit to the school in October 1948. *Courtesy of the Orangetown Historic Museum and Archives. Photograph from the* Shanks Villager.

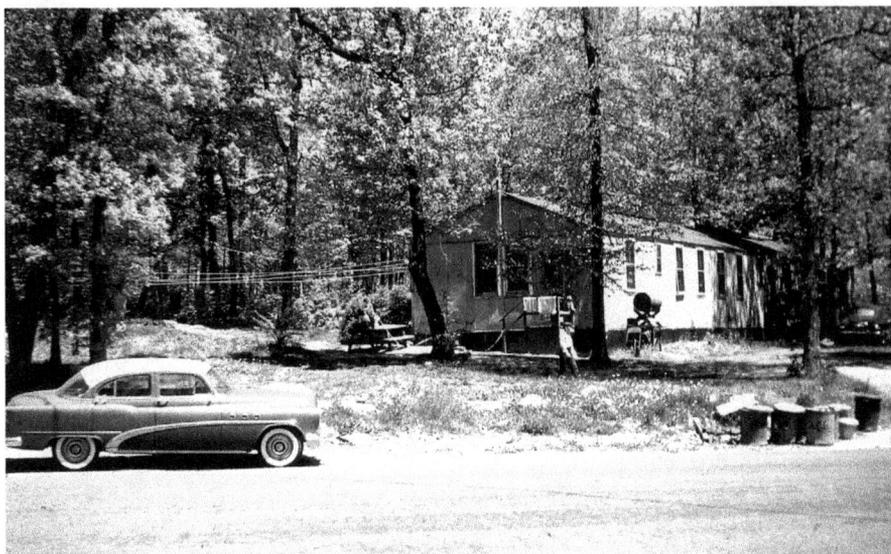

This photograph shows a typical converted barracks. Each was home to three Shanks Village families. This one was located on Avenue A, which is presently Lester Drive. Notice the oil tank adjacent to the building. It fueled the building's oil heater. *Photograph by Paul D. Guttman.*

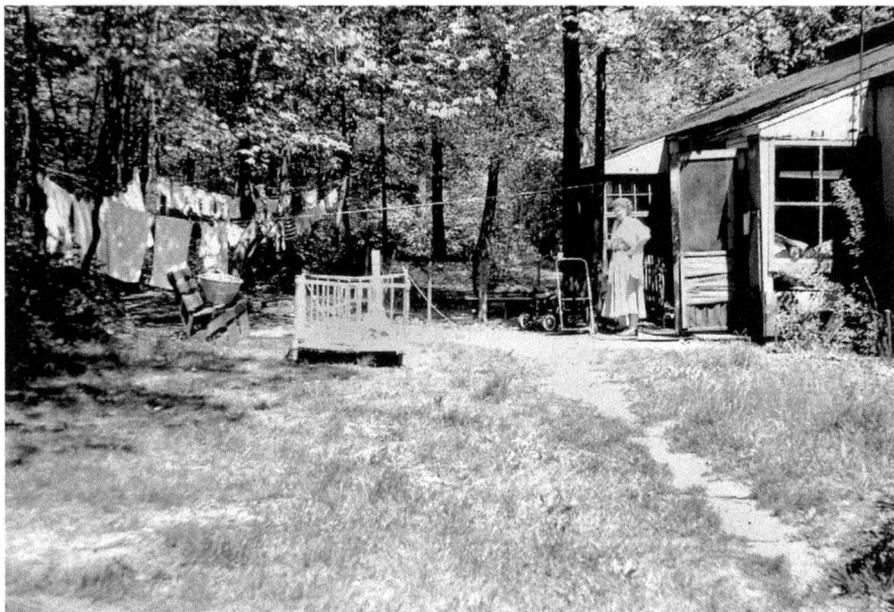

Shanks Village resident Lee Guttman watches over her daughter, Nancy, from the front entrance to their home. The Guttman family lived at two different locations in the village between 1952 and 1955. Paul Guttman saw action as a World War II photographer. He attended Columbia University while he and his growing family lived in the village. *Photograph by Paul D. Guttman.*

Shanks Village

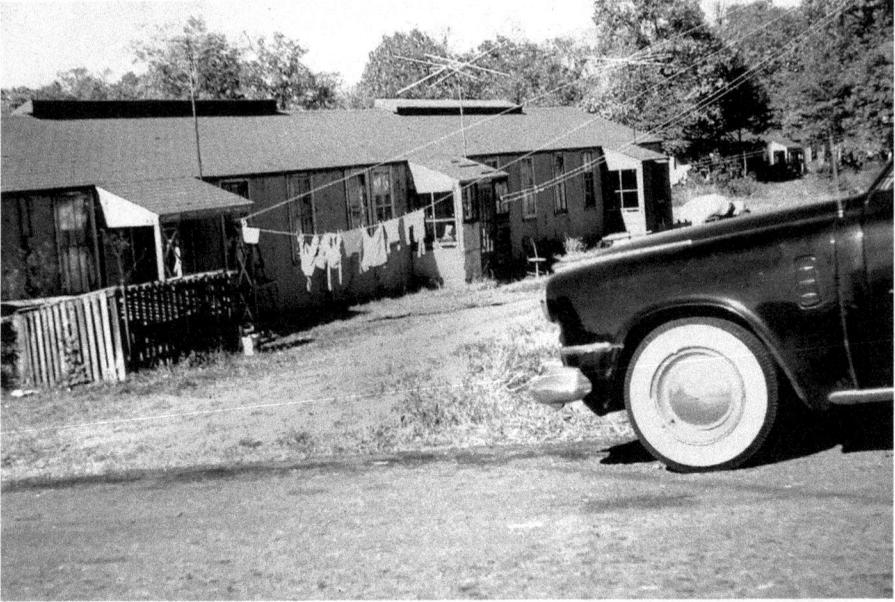

The pen to the left of this picture was built as a play area for little Jon Guttman. The family recollects that his head got stuck between the posts one time. Few of the first Shanks Villagers owned televisions, as radio was still king. But just a few years later, when this photograph was taken, television antennas began springing up. *Photograph by Paul D. Guttman.*

The units had neither clothes washers nor dryers. A community room contained washers and wringers. Clotheslines served admirably as dryers. The barracks were painted prior to Dwight D. Eisenhower's visit in 1948, but notice that the paint was already peeling in this 1952 photograph. *Photograph by Paul D. Guttman.*

Young Robert Guttman seems happy with his bath in the kitchen sink. Some units lacked bathtubs. Robert eventually went on to travel the world as a merchant seaman officer. *Photograph by Paul D. Guttman.*

Shanks Village

Right: Elizabeth Guttman holds her granddaughter, Nancy, as she maintains a firm grip on her grandson, Jon, near the Avenue A barracks. *Photograph by Paul D. Guttman.*

Below: Shanks Village children frolic on the swing set. Wildflowers bloom in the foreground. The village contained 691 acres, about one-third the area of Camp Shanks. *Photograph by Paul D. Guttman.*

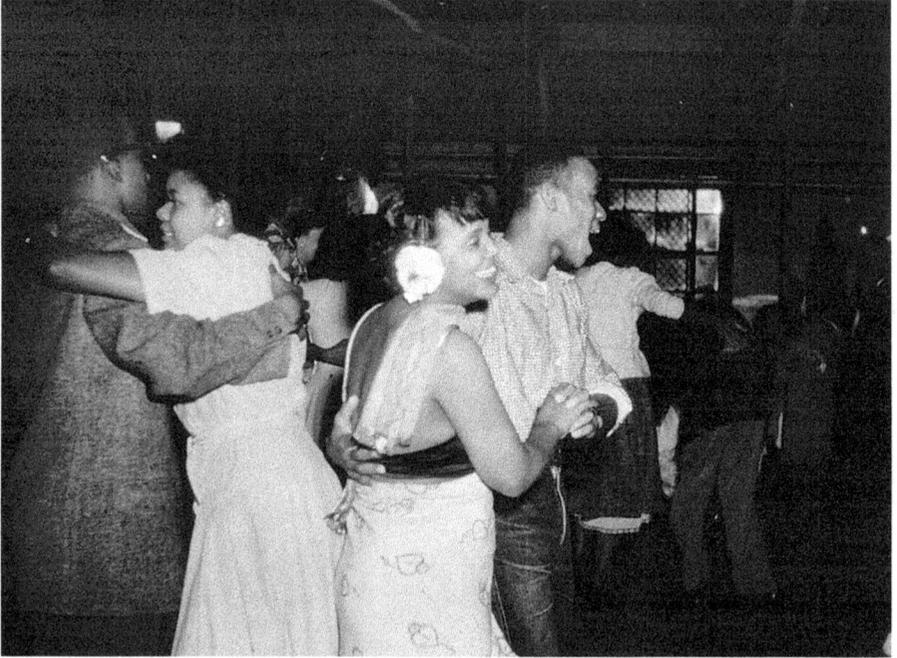

Parties and dances were held on a regular basis at the village, often in the community room pictured here. The Village Players, the village's theatrical troupe, performed regularly. One of their shows presented in 1949, *Thanks to Shanks*, parodied life at the complex. *Photograph by Paul D. Guttman.*

Shanks Village

The Shanks Villager

Vol. 5, No. 10 — Shanks Village, Orangeburg, New York — Thursday, June 14, 1951

Smitty At The Bat

Despite the hefty swing and gnashing of teeth Blue Sox Catcher Gene Smith failed to collect that hit. Umpire Tony Bevo keeps a watchful eye from behind F. Smith, Pearl River receiver. See story page 8
Photo by Guerin

CO-OP ANNOUNCES BOARD REORGANIZES NEW DIRECTORS

The Co-op Board of Directors announced the election of six new directors in their meeting Sunday, June 3rd. Those elected for six months terms are Bob Condon, Chet Lubbeck, Doris Matson, Eric McKittrick, Bruce Reynolds, and Osborne Scott.

The council also considered the resignation of Win Spence, Co-op manager, elected officers of the board.
(continued on page 6)

Dr. Wright to Speak on Food Economies

Dr. Carlton E. Wright, food economist in marketing, will be next guest speaker of the Health Committee's lecturer series on June 19, at 8:30 PM, at the Health Center on Orangeburg Road. The title of this free lecture is "How to Save Money on Food."

Dr. Wright is from the New York Metropolitan Area office of the extension service of the State Colleges of Agriculture and of Cornell University.

His pertinent topic will deal with a variety of foods, including meats, milk, canned vegetables vs
(continued on page 6)

CALENDAR

June 14 - Dr. Frederick Birnberg will speak on Dental Health Insurance Plans, at Health Center, 8:30 p.m., at Health Committee meeting.

June 16 - Tappan Public Health Nursing Committee Bake Sale, 9:00 a.m.-3:00 p.m.

June 16-17 - Nursery School Bake Sale, Co-op, 7:00-9:00 p.m. Friday, opening, 9:00 a.m. Saturday.

June 17 - Mr. Knudsen will speak on "Fathers Do Not Belong in Parentheses" at the Interfaith Chapel at 11:00 a.m.

St. George Will Help Shanks Representatives

In a phone interview last Friday, Katherine St. George, Congresswomen, told Council President Raymond W. Schulz that she would do her best to get Shanks Village representatives a hearing before the House Banking and Currency Committee when Housing Bill S 349 is taken up. This will give the Villagers an opportunity to present their case for a continuation of Shanks Village beyond the 1952 deadline.

COUNCIL PRESIDENT DENIES RESOLUTION CENSORS VILLAGER

The resolution setting forth a policy statement for the guidance of the Editor of the Shanks Villager which was passed at the June 3 Council meeting is in no way constitues a drastic change of Villager policy in accepting letters to the editor, Council President Raymond W. Schulz said this week in an interview with the Villager.

"Under the resolution passed by Council on April 30, 1951, as amended, the Editor of the Villager was given the discretion usual to newspaper editors, within the policies set down by the Council," Mr. Schulz said. "The statement of policy adopted in the resolution is, as stated in the measure, an expression of general policy, giving some general considerations for the guidance of the editor."

The portion of the resolution causing the most dissension at the recent Council meeting was as follows:

"Letters to the Editor shall be selected for publication upon the basis of their content and their timeliness. In selecting letters for publication on the basis of their content, the same considerations governing selection of material for publication in the straight news column of the Shanks Villager and set out in part III hereof shall apply,
(continued on page 4)

VANCE ELECTED BY REPUBLICAN CLUB

The Shanks Village Republican Club held its annual meeting on May 25. Major items on the agenda were the election of officers and the appointment of committees for the coming year. Officers were elected as follows: Wellington Vance, president; John Horgan, vice-president; Mrs. Eason Leonard, secretary; Ed McClausland, treasurer. Mr. Vance then appointed the following committees: Executive, Alfred Garrabrant, Arthur Becker, Frank Kearsey, Daniel Cash and Mrs. Walter Wanick; Entertainment, Albert Mitchell, Gilbert McCormack, Robert Jillson and Daniel Cash. Publicity, Mrs. William Morse and O. H. Taylor, Membership, Arthur Becker, Alfred Garrabrant, Mrs. Dana Tholts and Mrs. Eason Leonard.

Plans were made to study the possibilities of working for permanent housing at Shanks through the Orangetown Housing Authority.

The next meeting of the club, to
(continued on page 8)

The *Shanks Villager* was the community newspaper from 1946 to 1951. The first issue was called *News Letter*. At first the paper was mimeographed, but soon the staff switched to offset printing. It was printed in New York City and distributed in the village each Friday. Each issue contained news, cartoons and photographs of interest to the community. *Courtesy of the Orangetown Historic Museum and Archives.*

155

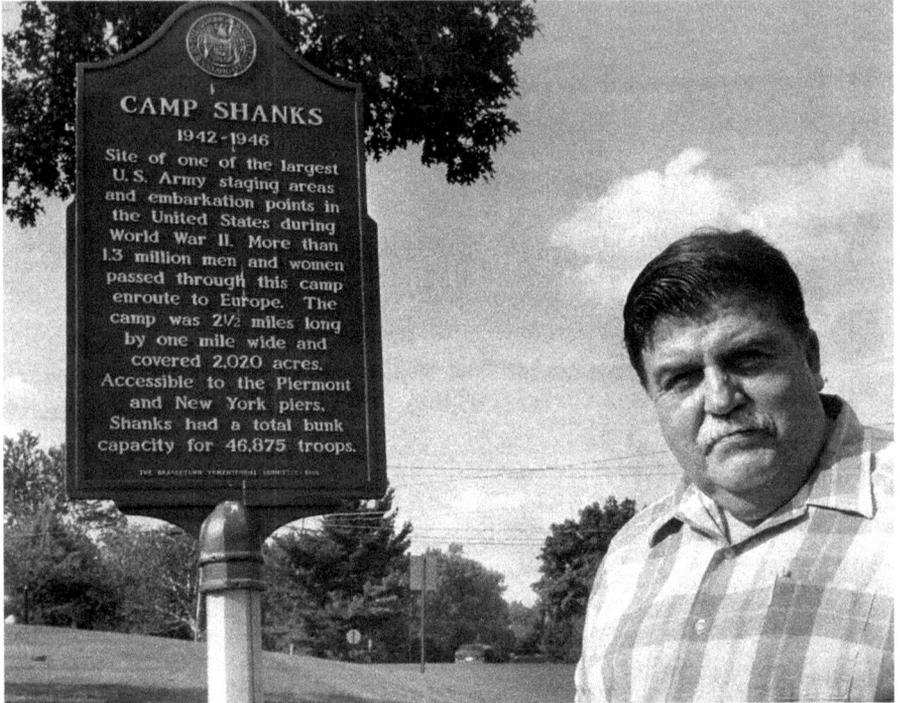

Camp Shanks historian Scott Webber stands adjacent to a historic marker in Orangeburg. Scott, a Korean veteran, journalist and photographer, devoted over twenty-five years to researching Camp Shanks and Shanks Village. His tireless efforts have helped preserve a time in history when so many Americans sacrificed so much to ensure freedom and democracy both at home and abroad. *Courtesy of the Orangetown Historic Museum and Archives, Scott Webber Collection.*

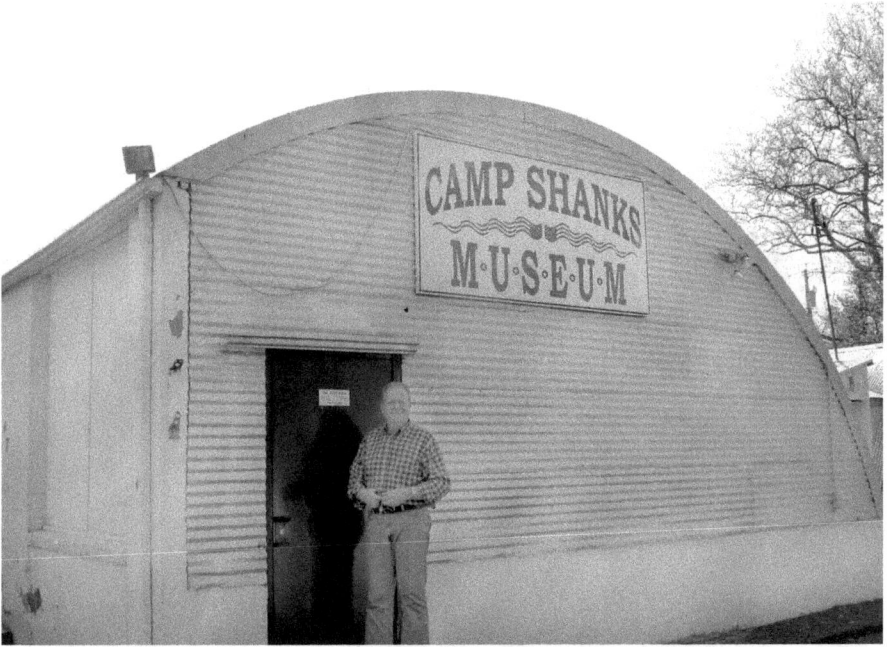

Above: Jerry Donnellan, director of the County of Rockland Veterans Services Agency, stands in front of the Camp Shanks Museum in Orangeburg. Jerry, a Vietnam War veteran, was a driving force in the establishment of the museum. The museum is housed in a Quonset hut formerly used as a school for children of military personnel who were permanently assigned to the base. *Photograph by Wesley Gottlock.*

Right: The Camp Shanks Museum opened in June 1994 to coincide with the fiftieth anniversary of the Normandy invasion. Its wonderful exhibits include posters, memorials, a scale model of the site, military memorabilia, maps and photographs, in addition to bunk beds in a simulated barracks. *Photograph by Wesley Gottlock.*

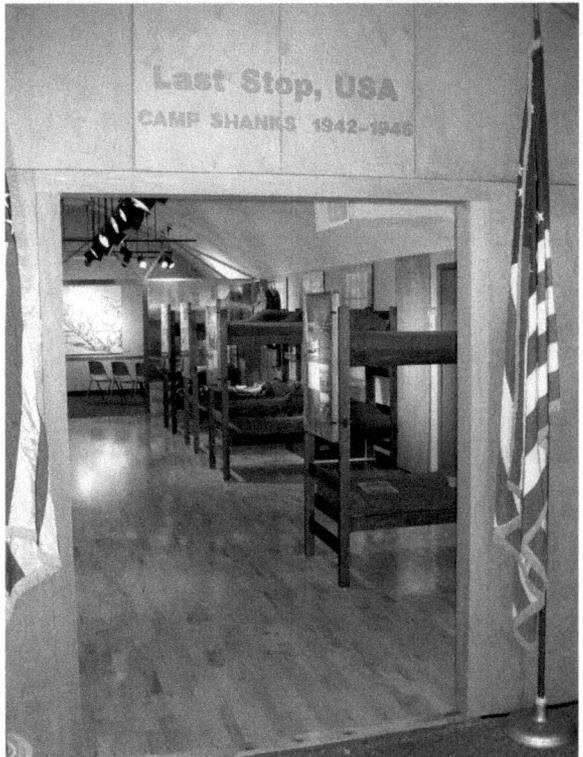

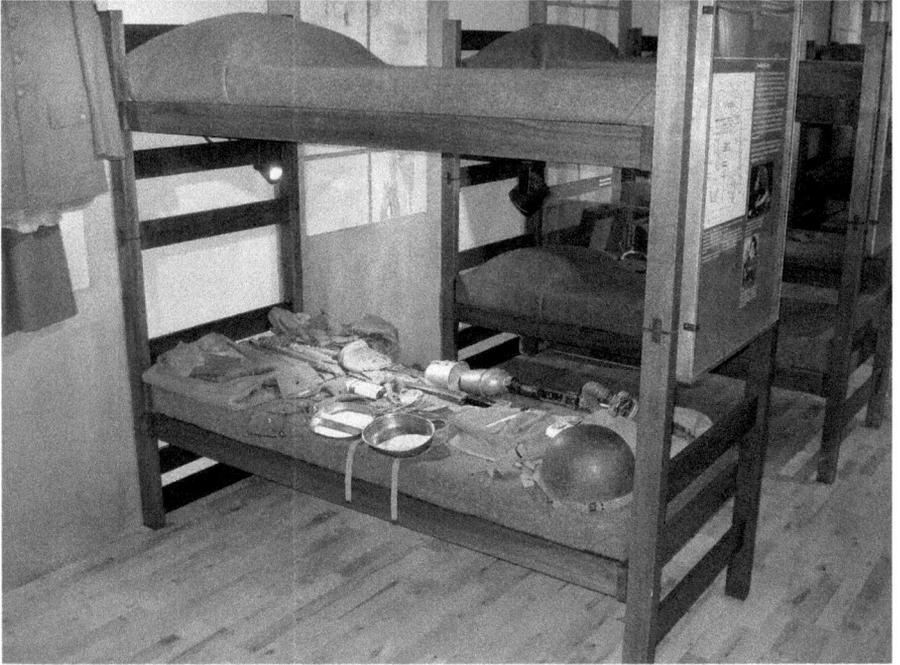

The Camp Shanks Museum recreates a typical bunk bed scenario that existed in its more than two thousand barracks during the war. *Photograph by Wesley Gottlock.*

Shanks Village

This monument stands at the end of Piermont Pier to mark the spot where hundreds of thousands of American soldiers departed and returned during World War II. Its dedication was in 1985. *Photograph by Wesley Gottlock.*